50 GEMS
The Isle of Wight

ANDREW POWELL-THOMAS

AMBERLEY

*For my mum and dad – with many happy memories of
childhood holidays here!*

First published 2025

Amberley Publishing
The Hill, Stroud
Gloucestershire, GL5 4EP

www.amberley-books.com

British Library Cataloguing in Publication Data.
A catalogue record for this book is available from the British Library.

ISBN 978 1 3981 1717 4 (paperback)
ISBN 978 1 3981 1718 1 (ebook)

Typesetting by SJmagic DESIGN SERVICES, India.
Printed in Great Britain.

Appointed GPSR EU Representative:
Easy Access System Europe Oü, 16879218
Address: Mustamäe tee 50, 10621, Tallinn, Estonia
Contact Details: gpsr.requests@easproject.com, +358 40 500 3575

Contents

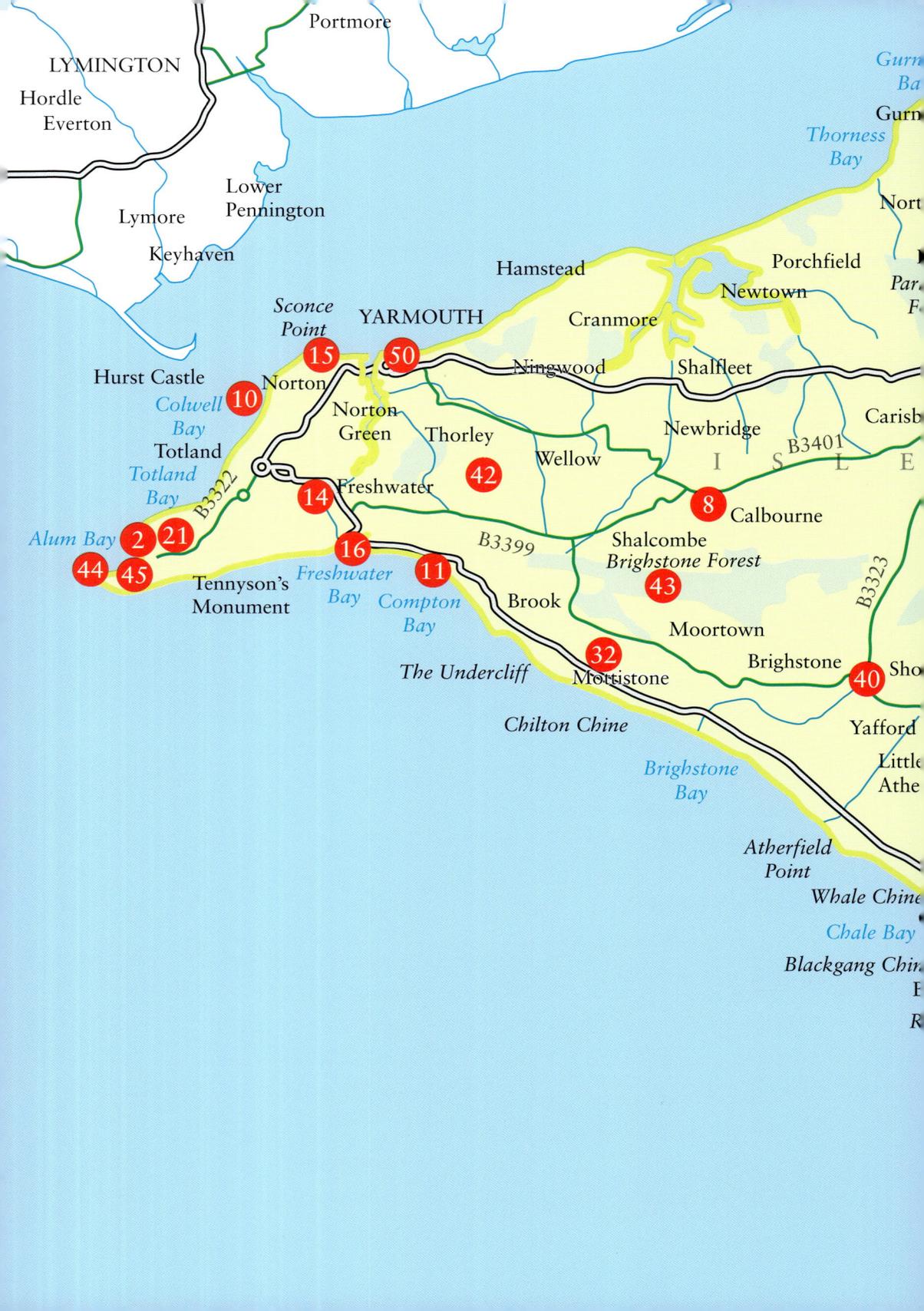

Portmore

LYMINGTON

Hordle
Everton

Lymore

Lower
Pennington

Keyhaven

Hurst Castle

Colwell Bay

10

Totland

Totland Bay

B3322

Alum Bay

2 **21**

44 **45**

Tennyson's
Monument

15

Norton

Norton
Green

14

Freshwater

16

Freshwater Bay

11

Compton Bay

Sconce Point

YARMOUTH

50

Ningwood

Thorley

42

Wellow

The Undercliff

Brook

Chilton Chine

32

Mortistone

Brighstone Bay

Hamstead

Cranmore

*Gurn...
Ba...*

Thorness Bay

Gurn...

Nort...

Porchfield

Newtown

Shalfleet

Newbridge

*Par...
F...*

Carisb...

B3401

I S L E

8

Calbourne

Shalcombe

Brighstone Forest

43

Moortown

Brighstone

40

Sho...

Yafford

Littl...
Athe...

Atherfield Point

Whale Chin...

Chale Bay

Blackgang Chin...

B3323

B3399

Ferries

22
12

East Cowes

29 Osborne House

Osborne Bay

R Medina

SPITHEAD

Whippingham

41

Woodside

Fishbourne

30 Quarr Abbey

33 **RYDE**

Puckpool Point
Nettlestone Point

36 Seaview

Nettlestone

B3330

46

R Medina

Wootton

Wootton Bridge

Binstead

19

Staplers

18

24

25

26

9

NEWPORT

23

Havenstreet

St Helen's Fort
Bembridge Point

B3395

St Helens

31 Downend

Nunwell House

27

20 Brading Hillway

5

I G H T

*Castle
ombe*

be

Blackwater

39

Arreton

River

Alverstone

Yar

7

Whitecliff Bay

ton

Merstone

3

Newchurch

Winford

49

13

34

35

4

Yaverland

Culver Cliff

SANDOWN

Rookley

Branstone

Sandford

Apse Heath

Sandown Bay

Kingston

Godshill

17

Roud

Appuldurcombe House

1

Whiteley Bank

Wroxall

37 **SHANKLIN**

38

Shanklin Chine

Luccombe Village
Luccombe Chine

Chale Green

Bierley

St Catherine's Oratory

Stenbury Down

Whitwell

B3327

DUNNOSE

Bonchurch

B3399

6

Niton

28

47

48 **VENTNOR**

St Lawrence

The Undercliff

g
End

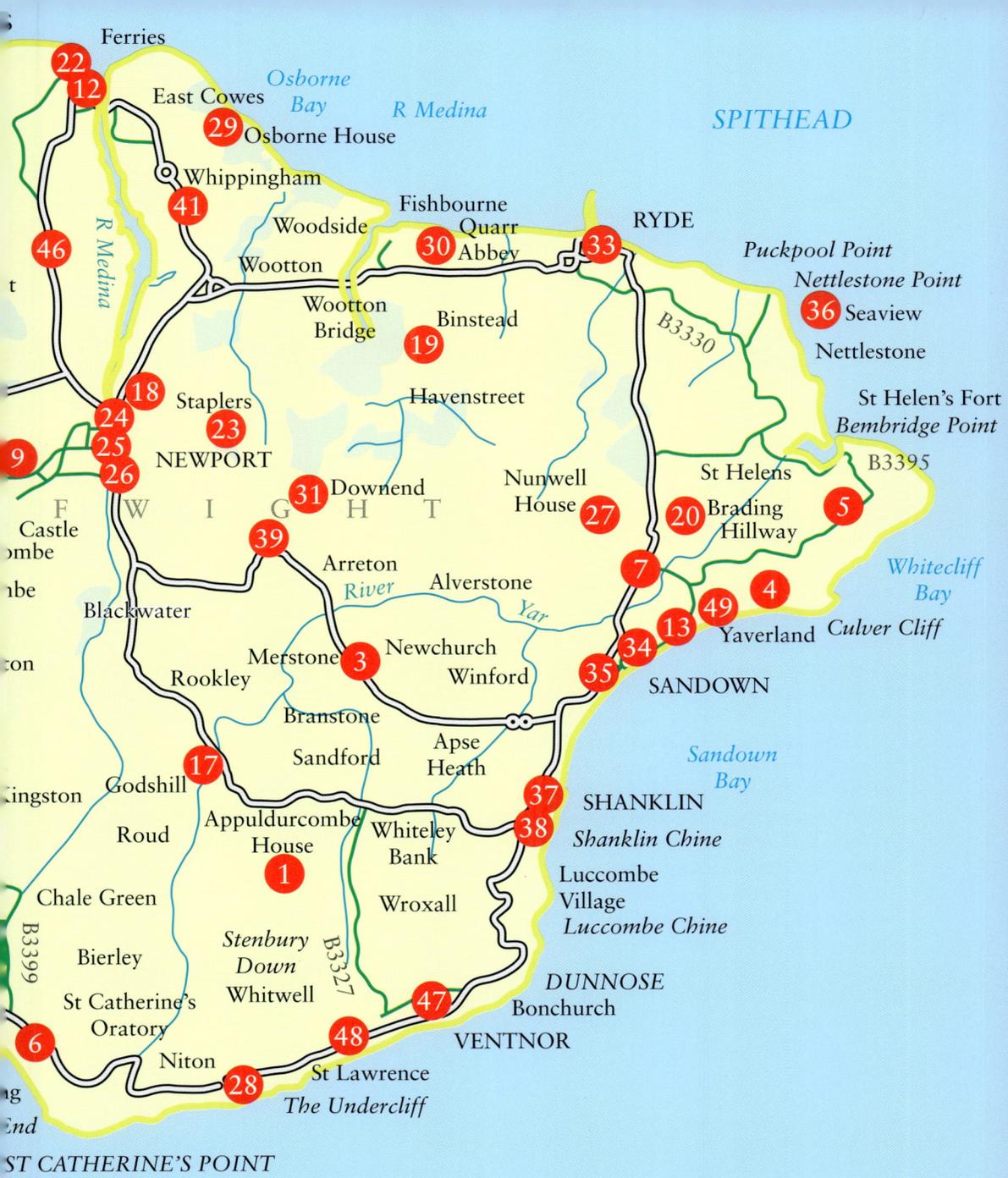

ST CATHERINE'S POINT

Introduction

The Isle of Wight is just a stone's throw from the coast of Hampshire, with around 140,000 people calling this 145-square-mile island home. Stretching 22 miles from east to west and 13 miles north to south, the diamond-shaped Isle of Wight provides a protective buffer to the 20-mile-long strait of water known as the Solent, which separates it from the mainland. For most of its history the Isle of Wight was a largely rural place, but its location made it a guardian to the ports of Southampton and Portsmouth, with various defensive positions being built here, as well as boat building and marine industries developing over the centuries. When Queen Victoria established her summer residence at Osborne House in 1845, and with the idea and affordability of tourism becoming more commonplace and achievable, the Isle of Wight became something of a hotspot for Victorian holidays – with the chines taking centre stage. Resorts quickly developed along the island's coast, and they have been welcoming visitors from across the country ever since. The Isle of Wight offers an extraordinary variety of landscapes: from sandy beaches to pebbly coves; and from coastal paths that wind their way over headlands and around dramatic clifftops to charming villages and seaside resorts. Open fields and rugged coastline are only ever a few miles away, and that dramatic coastline is exemplified at the iconic Needles. Remnants of dinosaurs have been found at multiple locations on the island, and evidence of Roman occupation can be found at several ruined villas with their mosaics. Add to this grand castles to explore and more recent fortifications dotted across the island, and you can always find something new to do. It has been a challenge condensing so much history, heritage and natural splendour into just fifty gems, and I have endeavoured to include a range that will appeal to everyone: young and old, active and relaxing. The Isle of Wight really does have something to offer everyone.

1. Appuldurcombe House

Located towards the south of the island on the outskirts of the village of Wroxall, just a few miles from Ventnor, Appuldurcombe House was built in the early eighteenth century for the Worsley family. However, its heritage dates back much further.

A priory is known to have stood on the site in 1100, followed by a convent, before it later evolved into large Tudor mansion, which had numerous features including a dining room, library, chapel and bowling green. Although grand for its time, it came into the hands of British MP Sir Robert Worsley, 4th Baronet, in 1690, who wanted to completely redevelop the site – and this is the building we see standing today.

Designed by architect John James, the old mansion was torn down brick by brick and the new building commenced in 1702. Extended in the 1770s, Appuldurcombe became one of the finest houses on the Isle of Wight, with the renowned English gardener and architect, Capability Brown, being commissioned in 1779 to design some ornamental grounds, and Sir Richard Worsley, 7th Baronet, did much entertaining here.

It would seem his wife, Lady Seymour Dorothy Fleming, whom he married when she was just seventeen, did much entertaining here as well. In 1781, she eloped with a man named George Bisset, a friend of her husbands who was actually made captain of the local militia by him and brought about one of the biggest scandals of the time. Sir Richard decided to sue Bisset for a huge amount of money for having 'damaged his wife', but his defence stated that he couldn't have damaged Lady Worsley due to the seemingly widespread rumours that he was her twenty-eighth sexual conquest. Past and present lovers gave testimony leading to the judge to agree with the defence. Sir Richard was awarded compensation of just a single shilling, and every detail of the trial was covered by the press – much to the delight of an eager public, keen to hear about such goings on!

Appuldurcombe House. (Courtesy of Victor Ochieng, CC BY-SA 2.0 with permission from English Heritage)

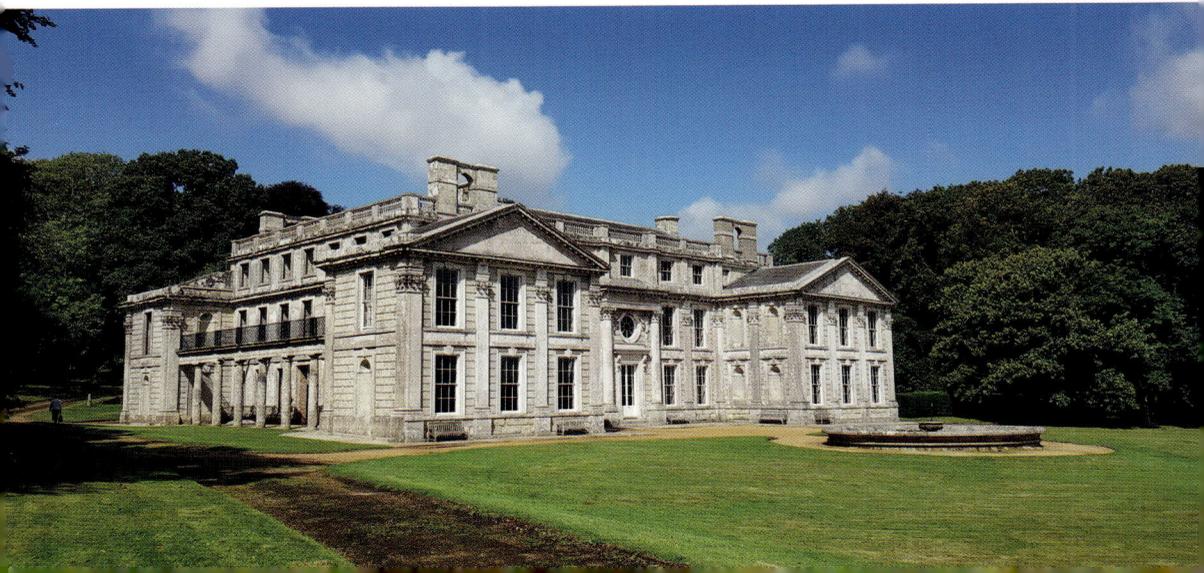

In 1855 the house and its estate were sold. Appuldurcombe became a hotel for a short period, then Dr Pound's Academy for young gentlemen, and had a number of Benedictine monks living there in the early twentieth century, before they then settled at Quarr Abbey.

The size of the house and estate meant it was a financial burden for those who owned it. The First and Second World War saw troops billeted here, and on 7 February 1943, the German Luftwaffe dropped a mine nearby which blew out the windows and caused the partial collapse of the roof. This marked the end of the habitable life of Appuldurcombe, with the owners selling off anything and everything of any value inside the building, and this is how the house has remained. English Heritage are now the custodians, with the shell of the house acting as a rather imposing reminder of its more illustrious, and scandalous, past.

2. Alum Bay Beach

One of the most picturesque beaches on the Isle of Wight, with the iconic Needles just in the distance, Alum Bay beach is well worth a visit.

How you get there, however, really depends on how adventurous you are feeling! The Needles Landmark Attraction is situated at the top of the cliff above Alum Bay beach, and from here you can get a chairlift that takes you over the side and downwards, with stunning views available – for those who keep their eyes open. For those preferring to keep their feet firmly on the ground, a set of steps slope down to the beach from the same point that the chair lift departs, providing a slower, but for some more secure, route down and back.

A view of the beach at Alum Bay. (Author's collection)

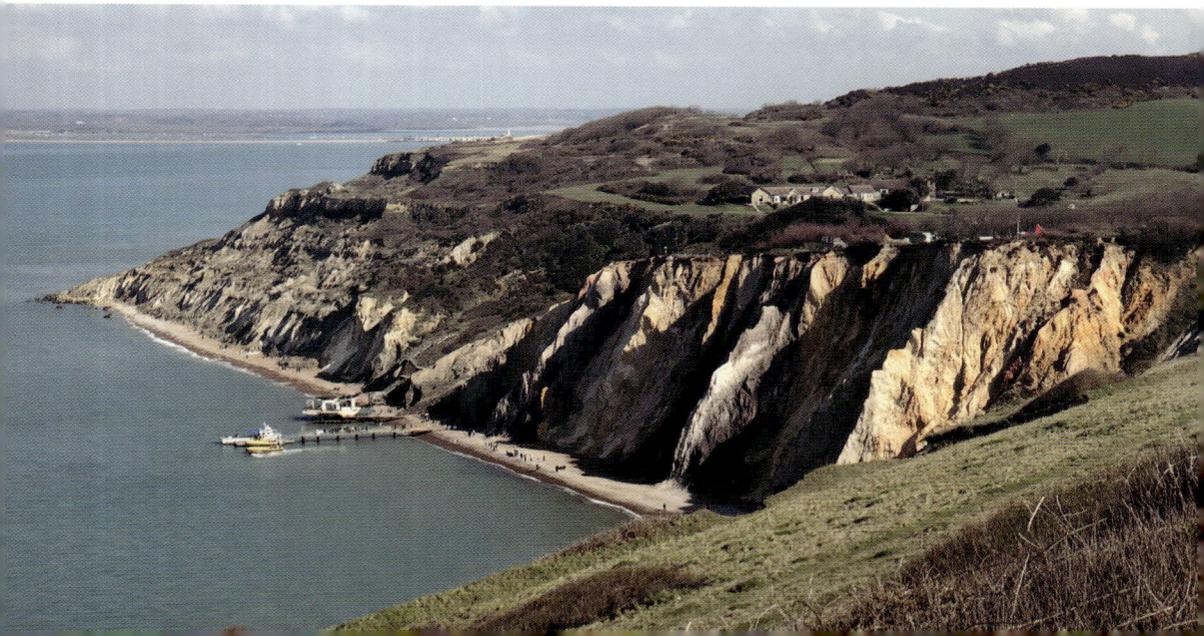

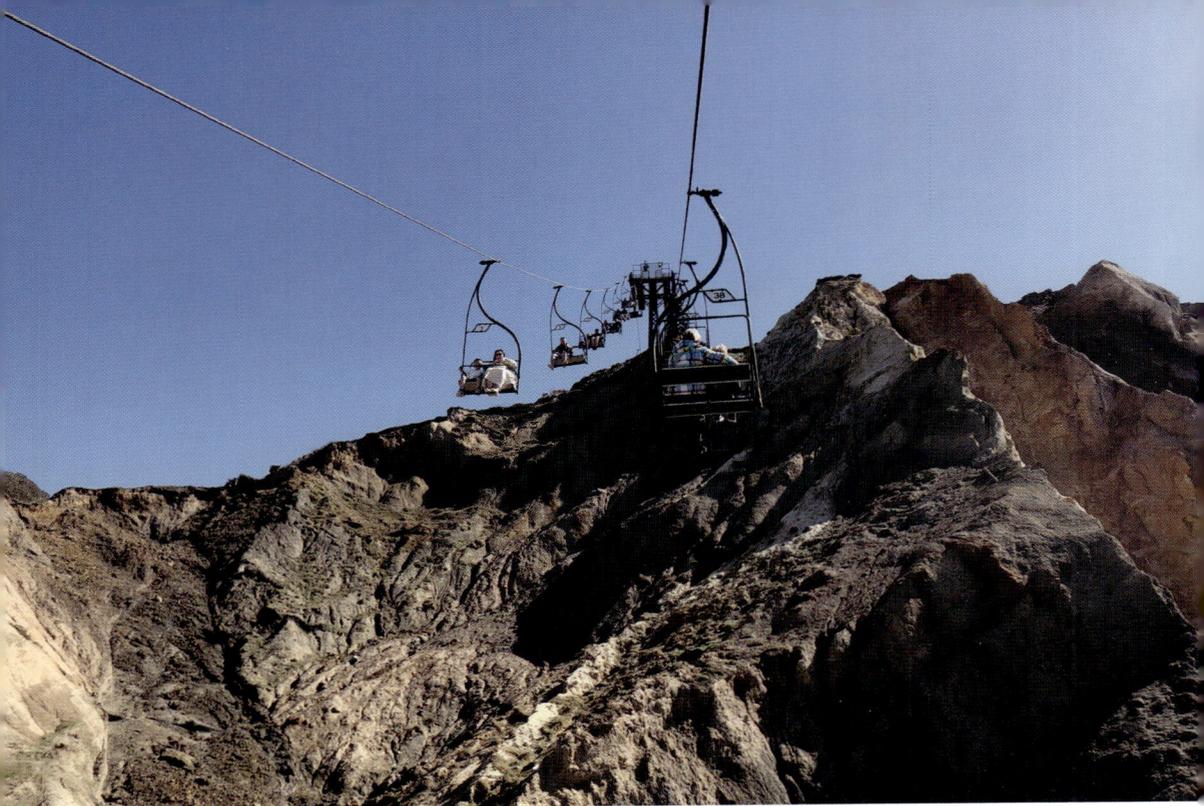

Above: The famous chairlift taking you up and over the cliffs. (Author's collection)

Below: Who knew there were so many different colours of sand? (Author's collection)

Whichever way you go, reaching the shingle beach below is a good reward. Famed for its twenty-one different shades of coloured sands, it is in a sheltered position that can often be a real suntrap. The clear waters are perfect to dip your toes in, or even take a swim, and it is from here that you can take a cruise out to the Needles themselves – either on a slow cruise aboard a traditional vessel or a fast cruise aboard a rigid inflatable boat.

You can easily while away a fair bit of time at this secluded beach as it is full of activity. Whether you're watching the boats, admiring the cliffs and the range of colours you can spot, pebble hunting, or staring at the continual stream of people coming over the near vertical cliff face on the chairlift, Alum Bay beach is a great place to visit. Of course, once you make your way back to the top you have to visit the Sand shop, where you can choose a shape and fill it up with any number of the different coloured sands from the beach – a must have memento from any visit to the Isle of Wight.

3. Amazon World Zoo Park

Opened in 1990, Amazon World Zoo Park is located in Newchurch, and actually began its life as a private collection of birds. However, this hobby soon turned into much more, and a visit to the Amazon Basin spurred on owner Derek Curtis to establish more than just an animal collection – becoming a place for education and

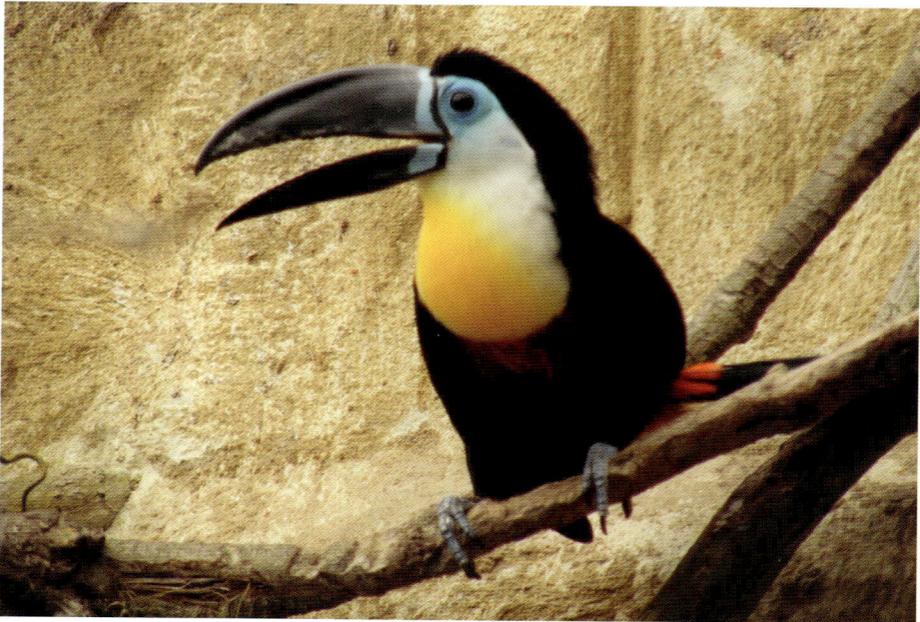

The beautiful channel-billed toucan. (Courtesy of Marie Hale, CC BY 2.0)

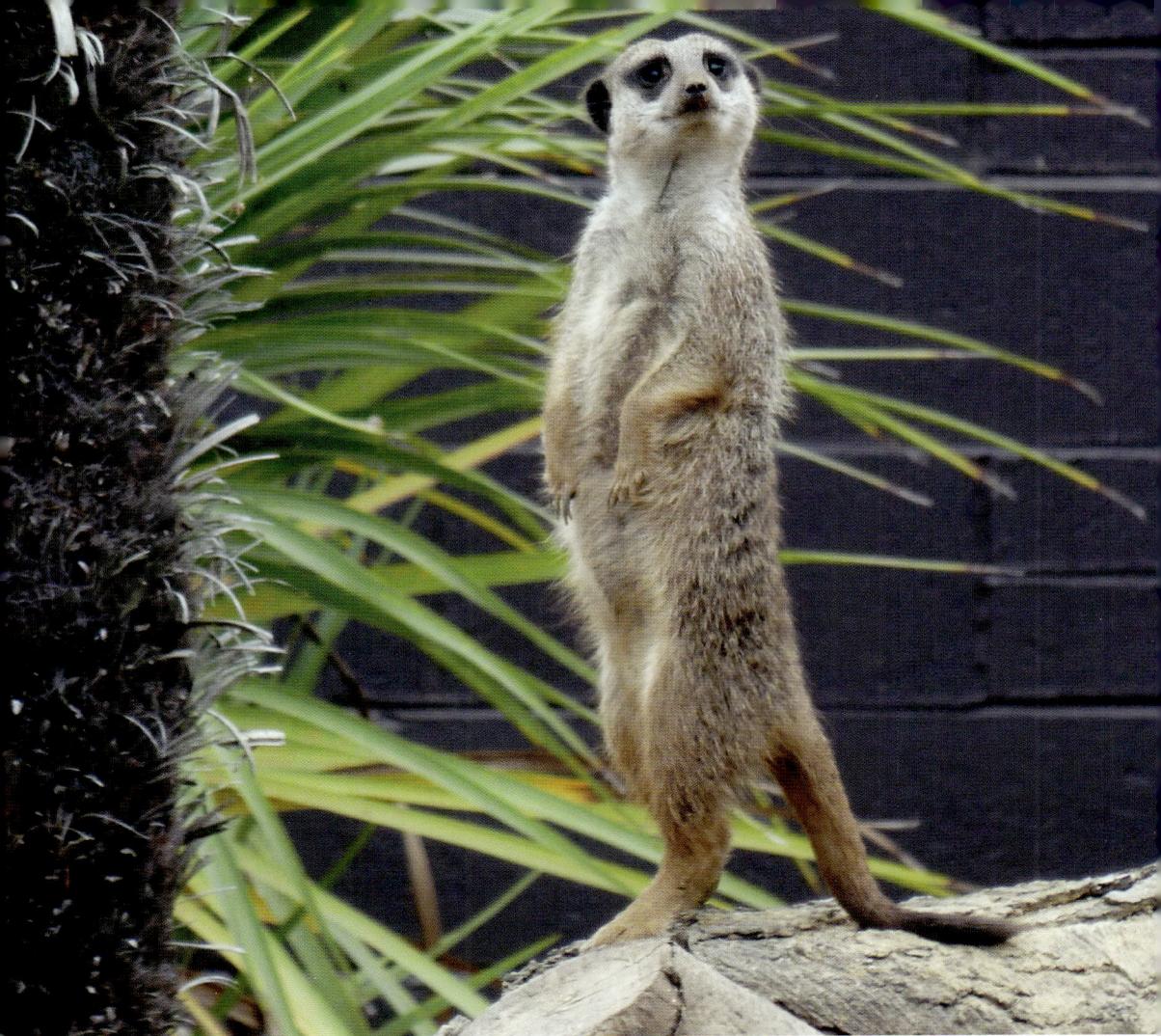

conservation as well. It has a fantastic range of exotic animals here, including giant anteaters, armadillos, tapirs, sloths and parrots to name but a few.

As part of its conservation programme, the zoo is a contributor to a number of international breeding programmes, with the sun bittern, emperor tamarin and squirrel monkey species benefitting from this commitment. The tamandua anteater is another animal that the zoo has been working with the international community to research and develop better husbandry techniques. Understandably, thousands of school children visit the park as part of their learning, and the zoo has an education department that ensures these are fun, engaging and memorable.

Open all year round, there is plenty to do on a visit, with a number of 'Meet the Animals' display talks taking place in addition to simply exploring the park and the animals in their enclosures. With a Dino Dig, a museum, café, soft play area and gift shop, this is a fantastic place to explore, have fun and learn, whilst assisting with the conservation of endangered animals.

4. Bembridge Fort

Built between 1862 and 1867 on the highest point of Bembridge Down to the east of the Isle of Wight, Bembridge Fort was just one of nearly a hundred Palmerston Forts constructed right across the country, as a result of the 1859 Royal Commission which investigated Britain's military readiness to counter a possible foreign invasion. The Commission consisted of six members of the armed forces, along with a representative from HM Treasury, and their published findings in February 1860 concluded that Britain's military forces were insufficient to guarantee that an invasion attempt would fail. They recommended vital facilities and locations right across the coast should be protected by forts, and the proposals were implemented by the government of Lord Palmerston and represented the biggest peacetime military infrastructure project in British history.

Before building commenced, the Yarborough Monument – which was at the top of Bembridge Down – had to be moved stone by stone to create the space required for this considerable fort. Costing just under £50,000 – a vast sum of money in 1867 – Bembridge Fort was constructed with the intention of being the main defensive position along the east coast of the island and the final bastion should an invasion of the Isle of Wight ever happen.

By 1871, the first garrison was stationed here, not only protecting the island, but overlooking the eastern Solent approach to the strategically critical naval base at Portsmouth. The fort was able to accommodate just over 100 men, operating the six RBL 7-inch Armstrong guns that were installed here.

In 1880, the secluded location along with the access to the sea it had meant that Bembridge was used to carry out anti-submarine and anti-torpedo experiments – one of which saw two cables run out into the water, with any metallic objects (namely a submarine) breaking the magnetic field that was created, indicating something was there. In 1890, the guns were removed from the site as it became just a barrack, command centre and store.

The year 1892 saw the construction of a Royal Artillery office for commanding the east Wight defences, becoming the command centre for various batteries on the Isle of Wight, including Redcliff Battery, Sandown Fort, Sandown Barrack Battery and Yaverland Battery. Used as a training facility at the turn of the century, the First World War saw a heavy artillery unit stationed here until 1920, at which point the fort became an observation post and a summer camp for visiting army units, and by 1930 the fort was unused and empty.

However, this didn't last long, as the onset of the Second World War saw Bembridge Fort receive a number of modifications as an anti-aircraft squadron was stationed here – as well as the headquarters for the local Home Guard being placed here. With the bombing of Ventnor radar station, a reserve station was established here.

In 1948 the site was decommissioned, before being purchased by the local council, and then the National Trust in the 1960s. The hexagonal fort has a central parade ground which is surrounded by barrack blocks – all of which are in good condition, as well as various passageways, bunkers and rooms.

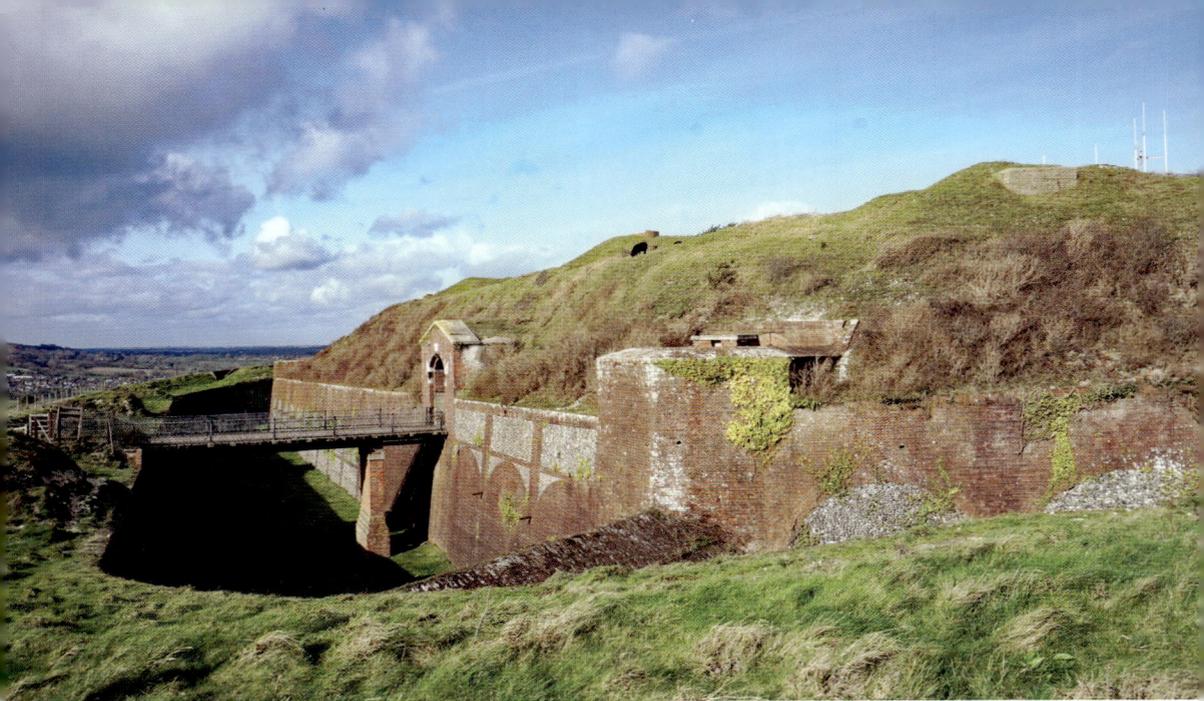

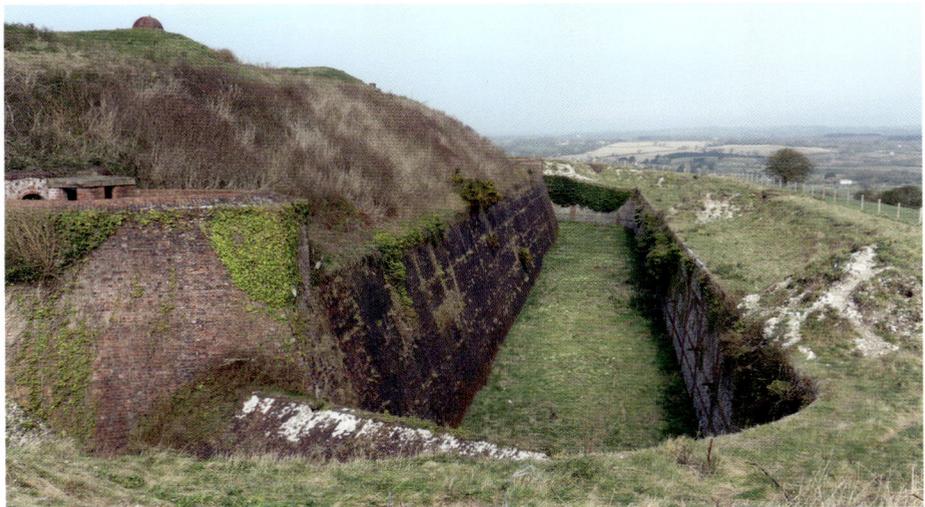

The fort is now a Scheduled Monument, and work takes place on a regular basis clearing and cleaning different areas and ensuring key features are maintained and restored. Although not open to the public all of the time, the National Trust do operate tours around the fort at various times in the year – and it is well worth keeping an eye out for them.

5. Bembridge Windmill

The Grade I listed Bembridge Windmill was constructed around 1700 when the village of Bembridge was almost completely cut-off from the rest of the Isle of Wight. For over 200 years, the windmill produced flour for the local population, but the draining of Brading Haven in the late 1800s meant that Bembridge was no longer isolated from the rest of the island, and the installation of a railway track into the village spelt the beginning of the end for the windmill, with cheap flour becoming easily accessible.

It last operated as intended in 1913, as by the following year most of the local men had gone to serve king and country in the First World War. Sadly, the windmill never reopened. During the First World War, it was used as a nighttime shelter by the Volunteer Reserve, and in the Second World War it became a lookout point and a headquarters for the local Home Guard.

After the war, some repair work was carried out by locals, before the National Trust took possession in 1961, restoring the windmill to what we see today.

Now the only remaining windmill on the island, it stands tall and proud overlooking the local landscape. It has been an inspirational place to visit for years; the artist J. M. W. Turner came in 1795 and began a watercolour of the windmill with the sea, then lapping at the bottom of the hill.

Bembridge Windmill. (Courtesy of Barry Skeates CC BY 2.0 with permission from the National Trust)

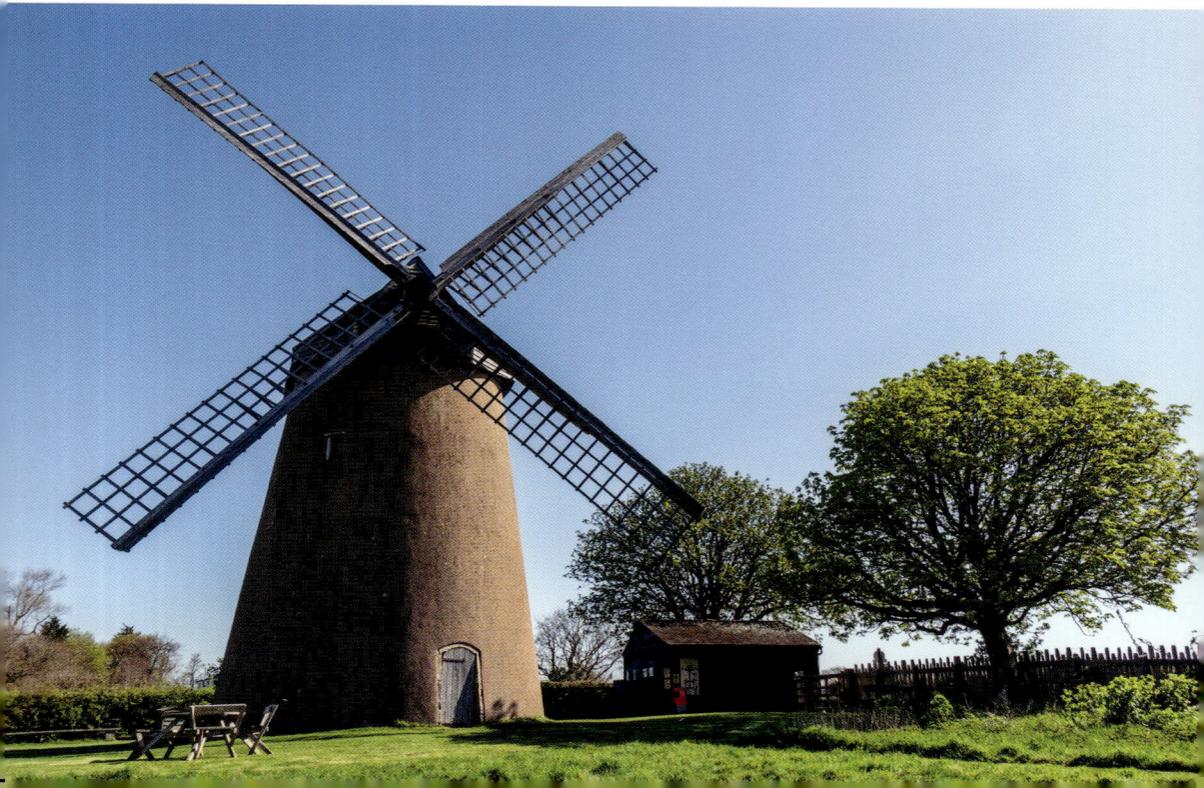

6. Blackgang Chine

Blackgang Chine is another of those places that is synonymous with a family holiday on the Isle of Wight. Known as the oldest theme park in the UK, Blackgang Chine first opened its doors in 1843 and is located a few miles from Ventnor near St Catherine's Down, at the southern end of the island. The chine this amusement park is named after was a steep 500-foot ravine sloping down to Chale Bay, and because of its extremely secluded nature, smuggling was believed to have taken place here.

When *Alexander Dabell* acquired the land in 1842, he planted gardens along the cliff top and built pathways down the length of the ravine all the way to the beach below. Sadly, the original chine is no longer here due to the impact of landslides caused by erosion, but during its Victorian opening, Blackgang Chine could boast one major attraction – the skeleton of a giant whale that had become stranded near the Needles!

As the development of the railways made the concept of holidays more achievable to the general population, the park began developing, but when Queen Victoria herself visited in 1853, its desirability soared. Since then, this scenic park has had numerous rides and attractions added to it, catering to all needs and interests. For the thrill-seekers there are pendulum and drop slides; a 100-foot water slide; a variety of *'lands'* to explore; as well as the more traditional haunted house and hall of mirrors, to name but a few. Of course, the site still has to contend with the eroding nature of the cliffs, and over the years some of the attractions have been moved further inland. All in all, a wonderful day out for everyone!

Arrival at Blackgang Chine gives a hint to the smuggling past of the area. (Author's collection)

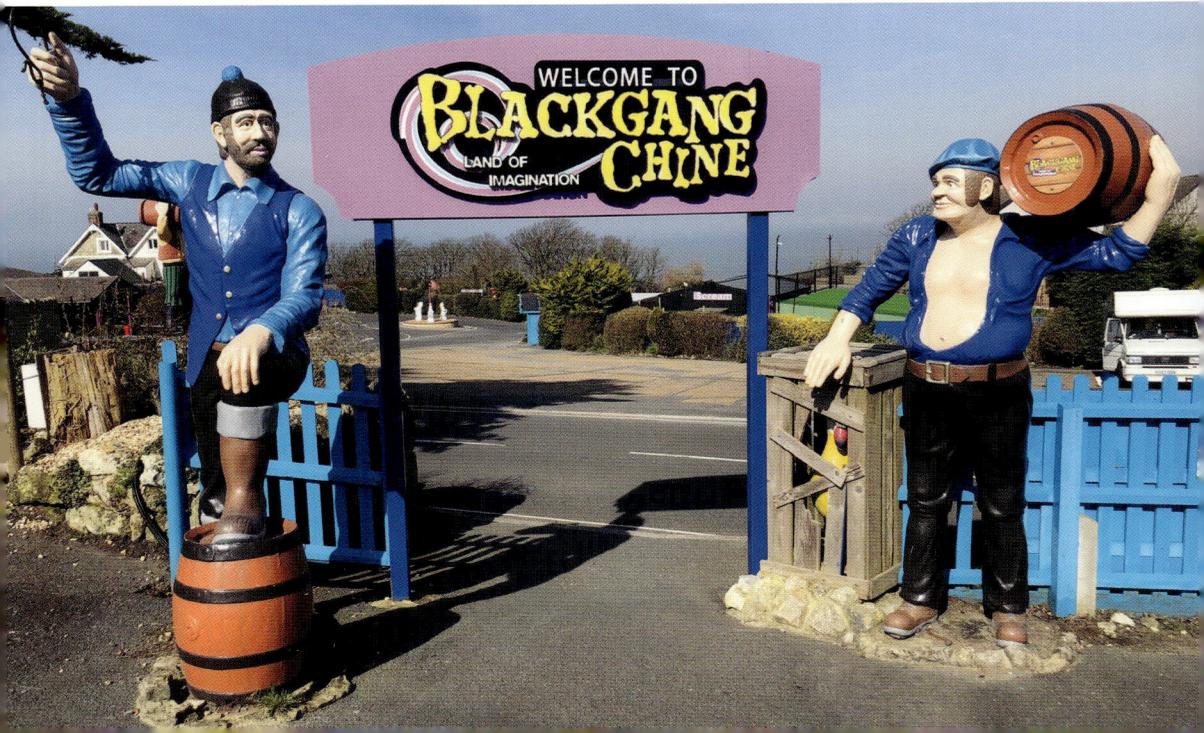

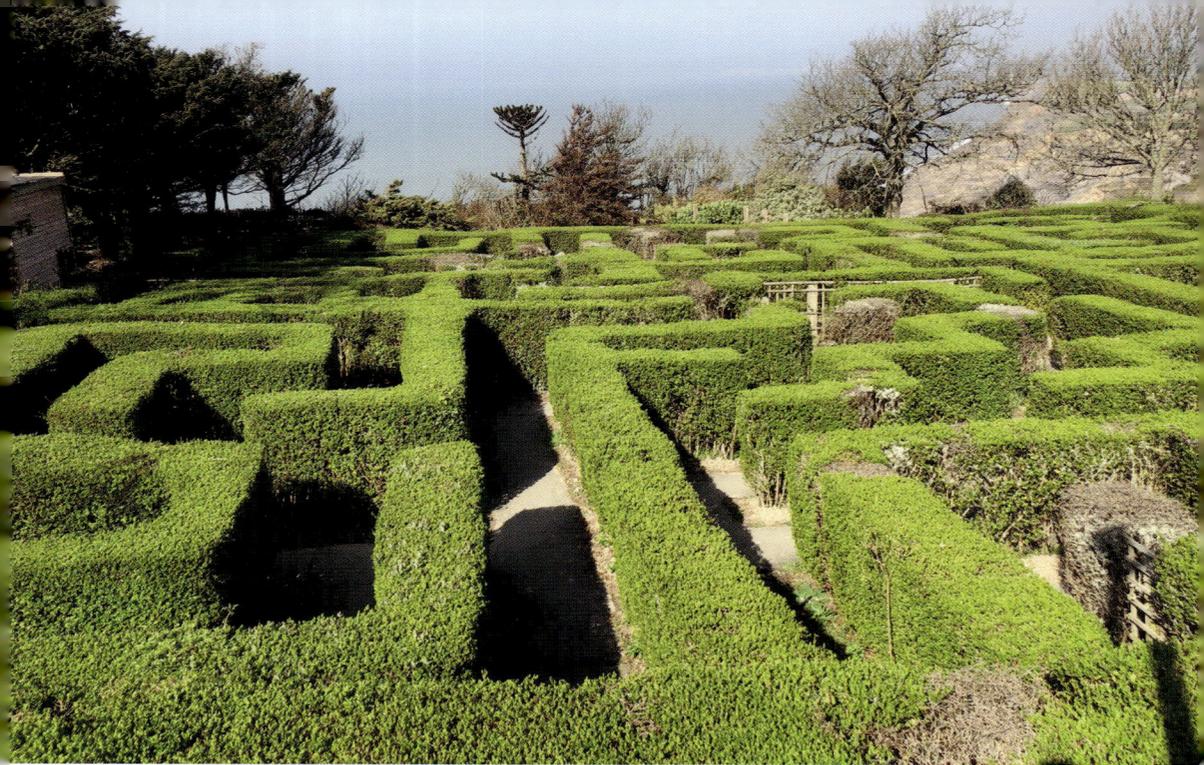

Above: The challenge of finding the middle of the maze is something for all ages to try. (Author's collection)

Below: Who doesn't like getting up close to dinosaurs? (Author's collection)

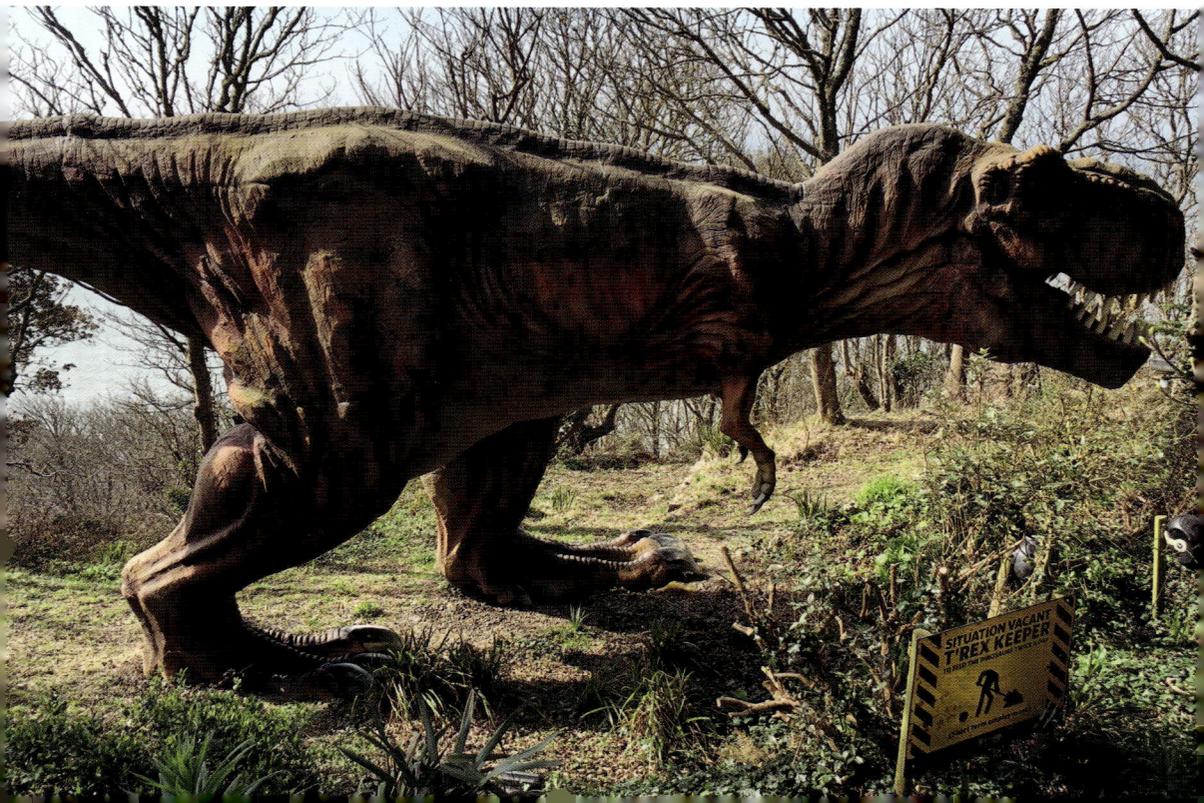

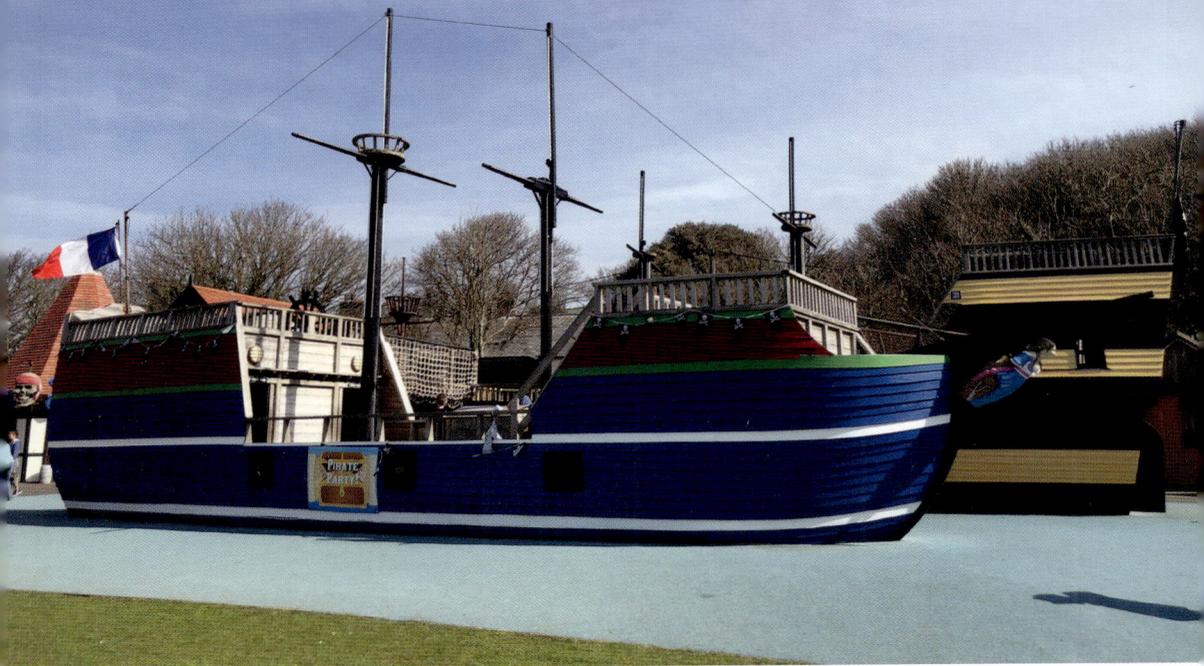

Above: With working water cannons, the children will happily spend hours exploring the boat-themed play area. (Author's collection)

Below: There's plenty to explore in the Wild West frontier town. (Author's collection)

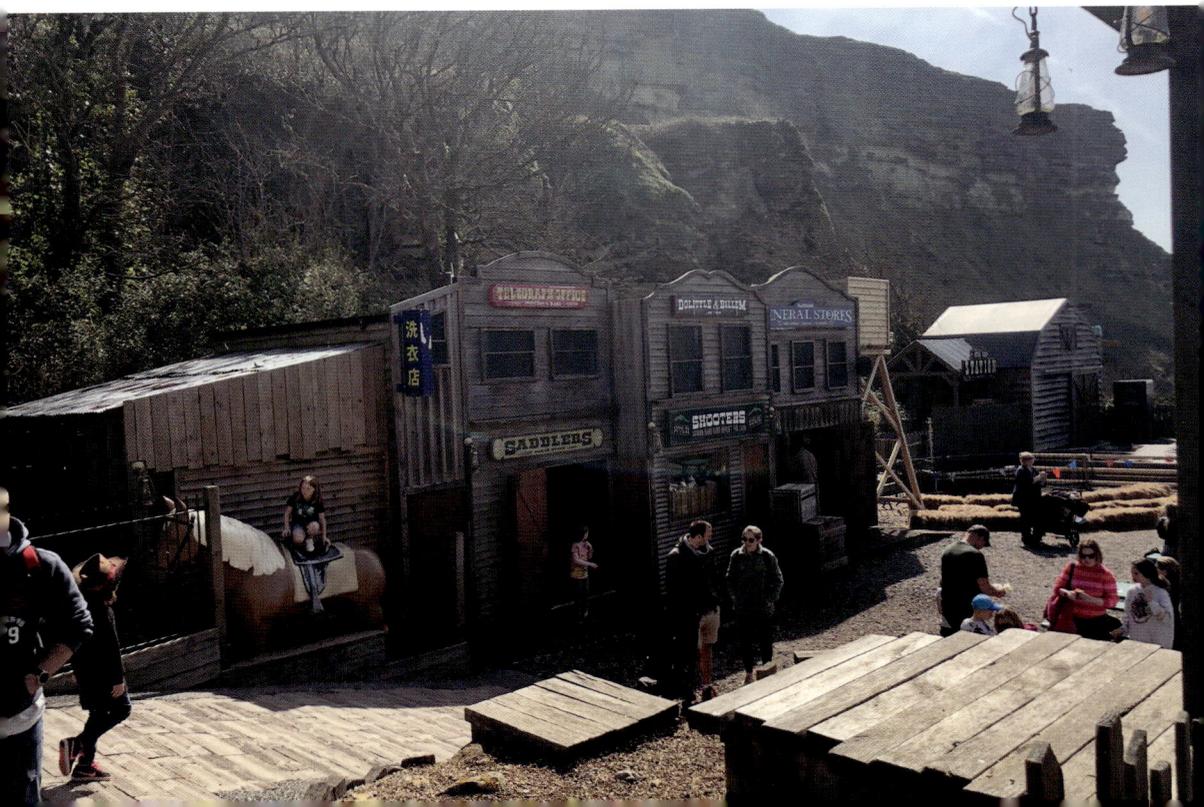

7. Brading Roman Villa

Situated in the east of the island to the south of modern-day Brading, the first hint of a Roman villa being here was when a mosaic was uncovered beneath a farmer's field in 1879. Excavations were carried out promptly and by 1880, half of the villa had been excavated, with the full extent of the site becoming clear in the years that followed. All twelve rooms of the villa's ground floor have survived, and they help to offer a tantalising insight into life on the island, for some, 2,000 years ago.

When the Romans conquered the Isle of Wight in AD 44 a simple villa was soon established at Brading – and it's easy to understand why. The fertile land allowed crops to grow; there were nearby springs offering a constant supply of water; and the location allowed for easy travel and trade between mainland Britain and Gaul. Over the next few hundred years, that simple villa evolved into a grand villa complex, and the pottery and jewellery artefacts that have been found here, together with the stunning mosaics, indicate that it was owned by a family of wealth and importance. By the end of the fourth and fifth centuries, many villas, towns and estates right across southern Britain suffered from Viking raids, and Brading was no different. It became derelict, overgrown, and soon no trace was visible above ground.

Once discovered in 1879, its importance was quickly recognised, with Queen Victoria making a royal visit. In the early twentieth century, a cover building was erected to protect the mosaics from the elements. This did a good job until the villa was flooded in 1994 and a newer building was constructed, along with a new visitor centre in 2004. The mosaics found here are amongst the best in Britain: Medusa,

The remains of Brading Roman Villa are today found inside this modern building – protecting the mosaics from the elements. (Courtesy of Andrew Skudder, CC BY-SA 2.0)

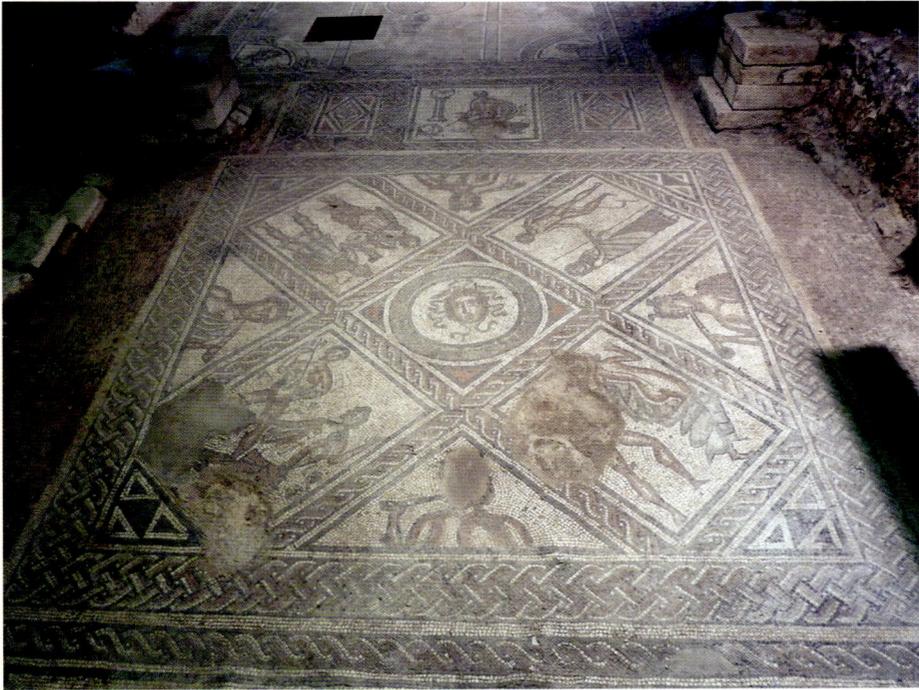

You can't fail to be impressed by the stunning Medusa mosaic – likely placed to ward off evil and protect the home. (Courtesy of Linda Hartley, CC BY 2.0)

Bacchus, Orpheus and Ceres are depicted, and the intricacy of them is absolutely fascinating. As well as the main villa, there are also the remains of a farmhouse and a well, whilst a granary and storerooms are also known to have been present.

8. Calbourne Water Mill

This entry for Calbourne Water Mill is somewhat bittersweet. The mill can trace its origins right back to being mentioned in the Domesday Book in 1086 and it has been producing flour and oats ever since! For decades it has been the only working water mill on the island and has very much been a working attraction – with visitors able to enjoy the environment, explore the mill and purchase items created with the flour it has produced. Surrounded by 35 acres of countryside, a variety of animals can be seen here, with peacocks, doves, ducks and waterfowl all wandering around freely, and it is easily possible to while away an hour or two simply being at one with nature. However, whilst writing up this book, it was announced that the mill will cease to operate in the way it has been, with increased upkeep and maintenance

costs, together with a downturn in visitors, leaving it in a rather precarious position. We can only hope that something can be done to safeguard its long-term future and ensure that this history continues for future generations.

9. Carisbrooke Castle

Situated right in the middle of the Isle of Wight, south-west of Newport and on a hill that overlooks the Medina River, a defensive stronghold has been in this location for thousands of years. It is easy to see why. With its commanding panoramic views, a Saxon enclosure was established here before a wooden motte-and-bailey castle was built in the immediate aftermath of the Norman Conquest of 1066. This is the basis of the Carisbrooke Castle we see today.

When Richard de Redvers was made Lord of the Isle of Wight by King Henry I in 1100, the castle was significantly upgraded, and over the coming centuries, further developments were continually carried out – especially as weapon technology improved. The castle's location, in the middle of the Isle of Wight, which itself sat protecting any approach to the ports at Southampton and Portsmouth, meant that troops were constantly garrisoned here. In the sixteenth century, with the threat of invasion from both France and Spain, over a mile of additional fortifications in the form of a perimeter wall and bastions were added, allowing the castle to install modern artillery for its defence – quite some undertaking.

During the English Civil War, it was also chosen as the prison to house King Charles I between 1647 and 1648 prior to his execution. Whilst there, as well as

trying to escape but getting stuck between the bars of his bedchamber, the eastern earthwork that was established to provide better artillery during the sixteenth century, was actually reshaped to create a bowling green for him to use during his incarceration.

Of course, Carisbrooke Castle has not just been about a great defensive position. It has also been about power and prestige – with the Great Hall and Constable's Lodging being the main residences for numerous lords and island governors – the most recent incumbent being Princess Beatrice, youngest daughter of Queen Victoria, from 1896 to 1944.

In the years since then, Carisbrooke has retained a more ceremonial role, with the chapel of St Nicholas containing the names of 2,000 men from the Isle of Wight who lost their lives during the First and Second World Wars, and with English Heritage now overseeing the site, it is open to tourists all year round. And it is well worth a visit!

Covering a large site, it is easily possible to spend an entire day exploring the walls, towers and museum – and English Heritage also regularly have additional events taking place too! The first thing you notice as you approach the castle is the sheer size of the gatehouse, which has stood as the main entrance for over 900 years. Once inside, and located next to the main gate, is the aforementioned St Nicholas' Chapel, which has Princess Beatrice's Garden next to it. The Great Hall and Constable's Lodging are both accessible, with the Isle of Wight Museum providing

The approach to Carisbrooke Castle. (Author's collection with permission from English Heritage)

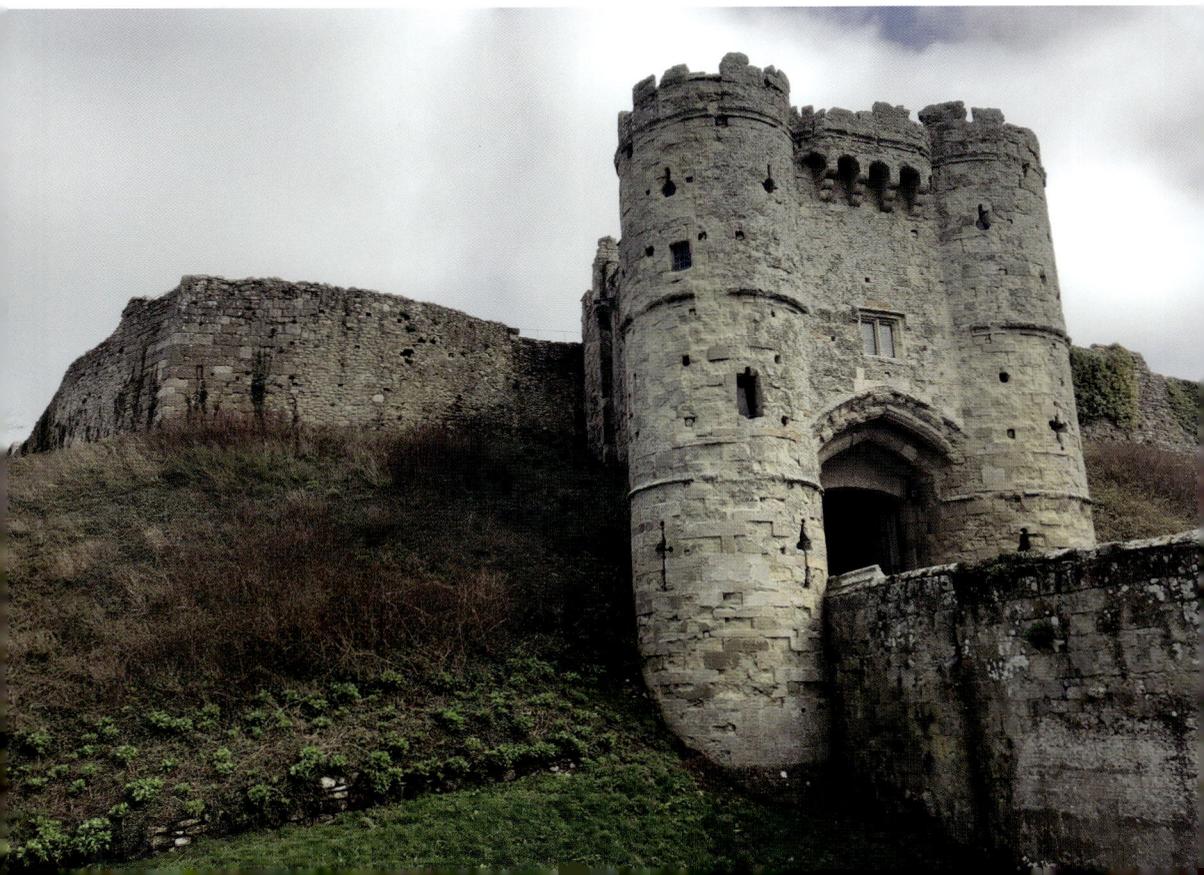

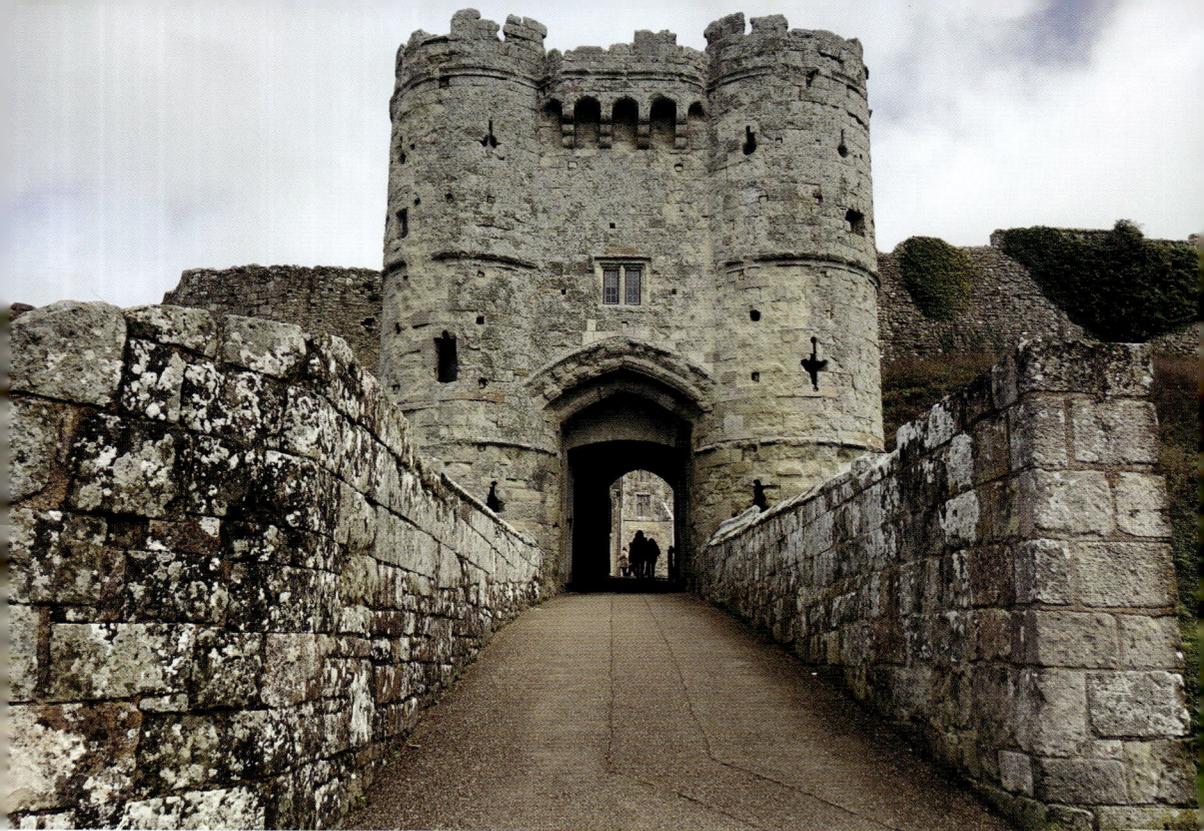

Above: The fourteenth-century drum towers of the gatehouse make this a rather imposing entranceway. (Author's collection with permission from English Heritage)

Below: There are numerous buildings within the Inner Bailey. (Author's collection with permission from English Heritage)

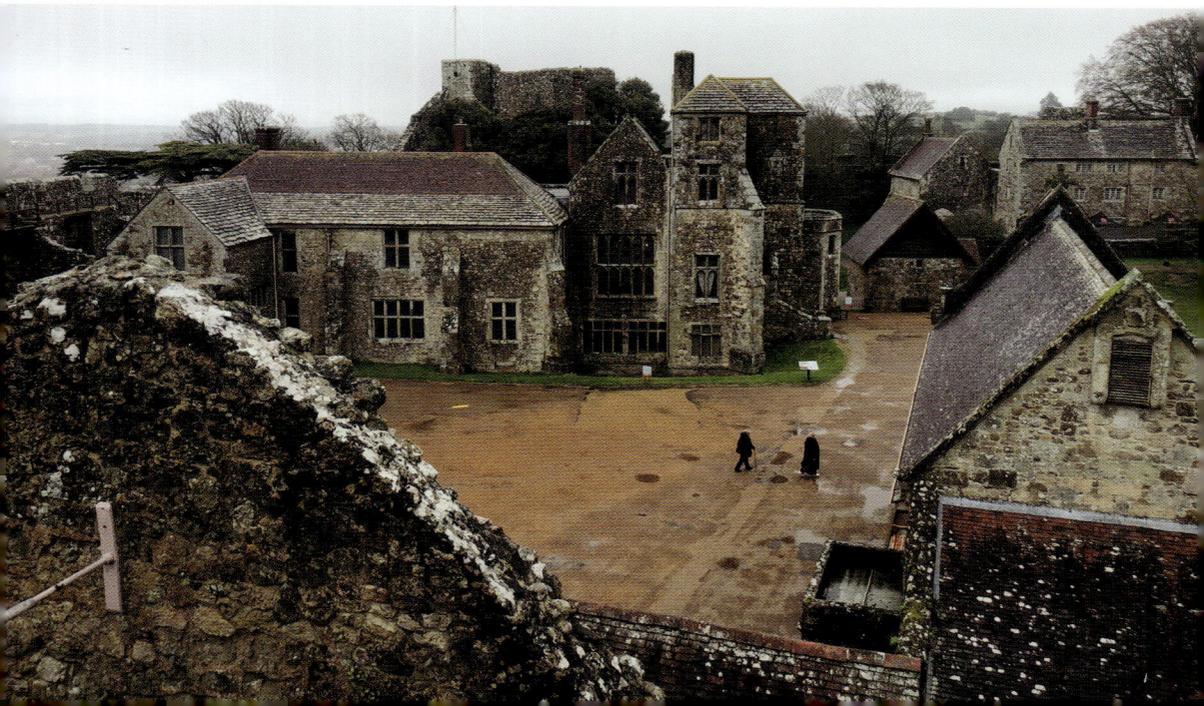

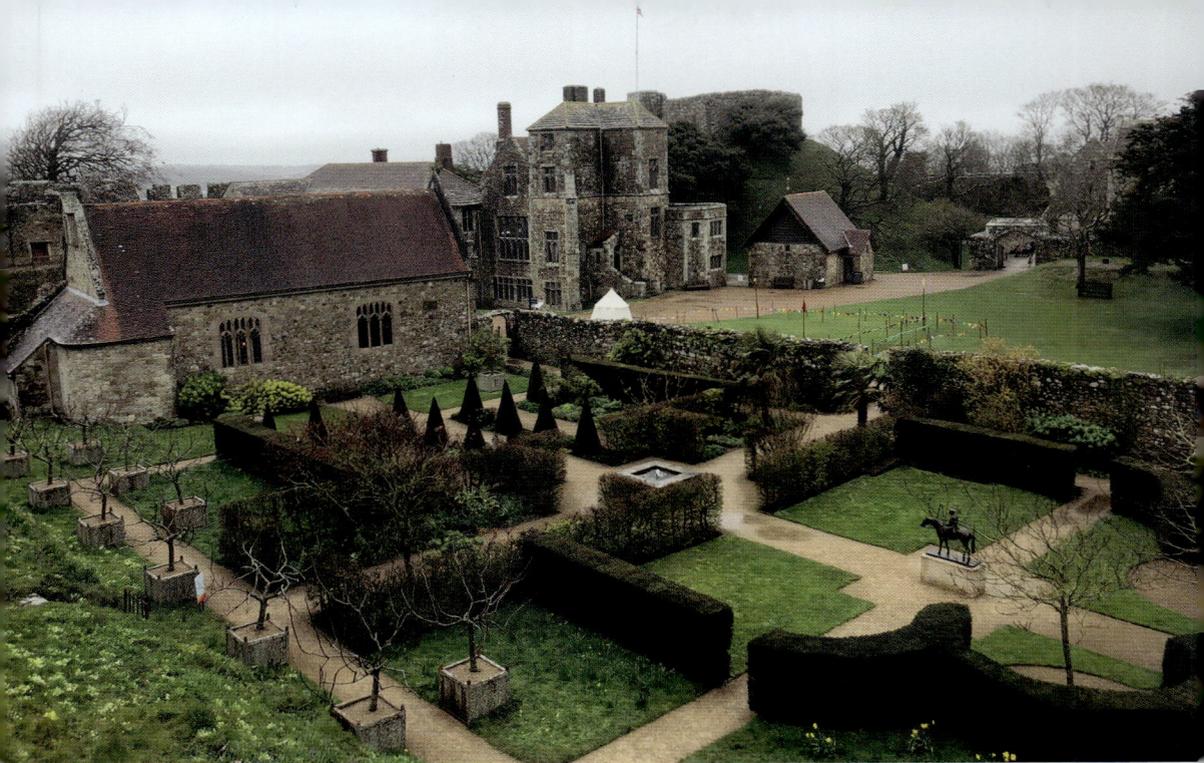

Above: The Chapel of St Nicholas and the Princess Beatrice Garden. (Author's collection with permission from English Heritage)

Below: A view from the wall walk. (Author's collection with permission from English Heritage)

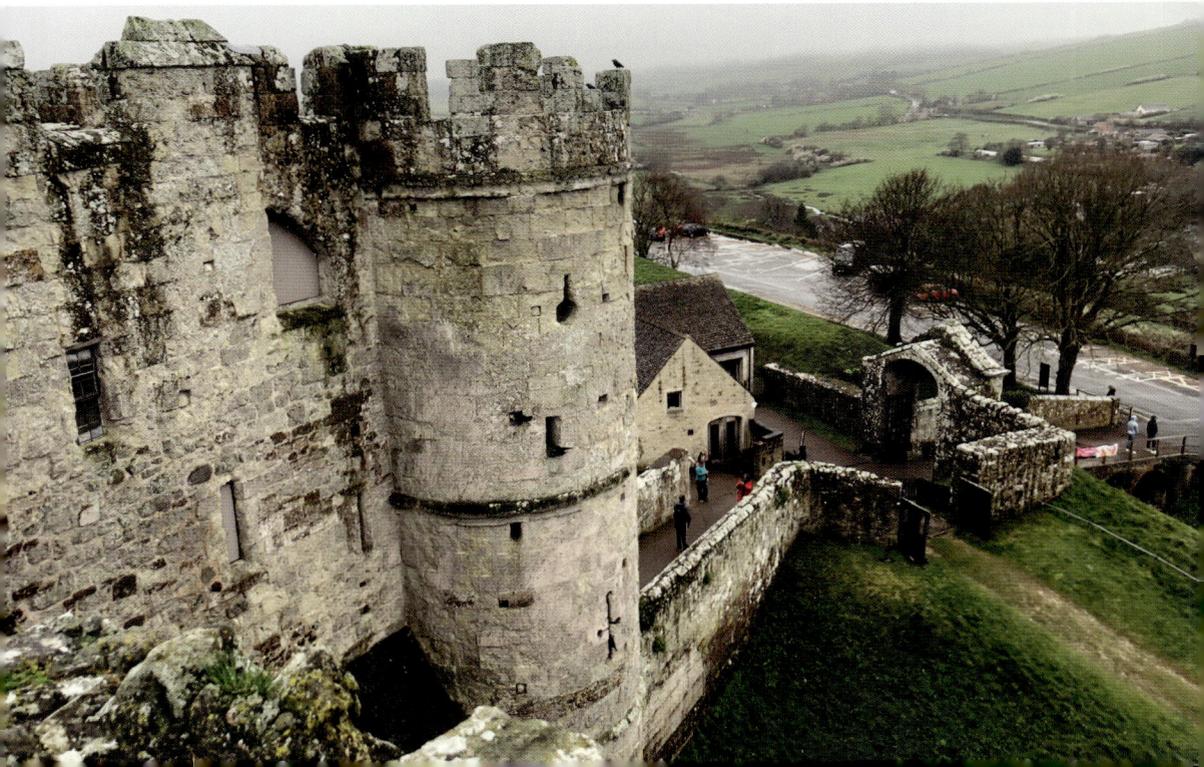

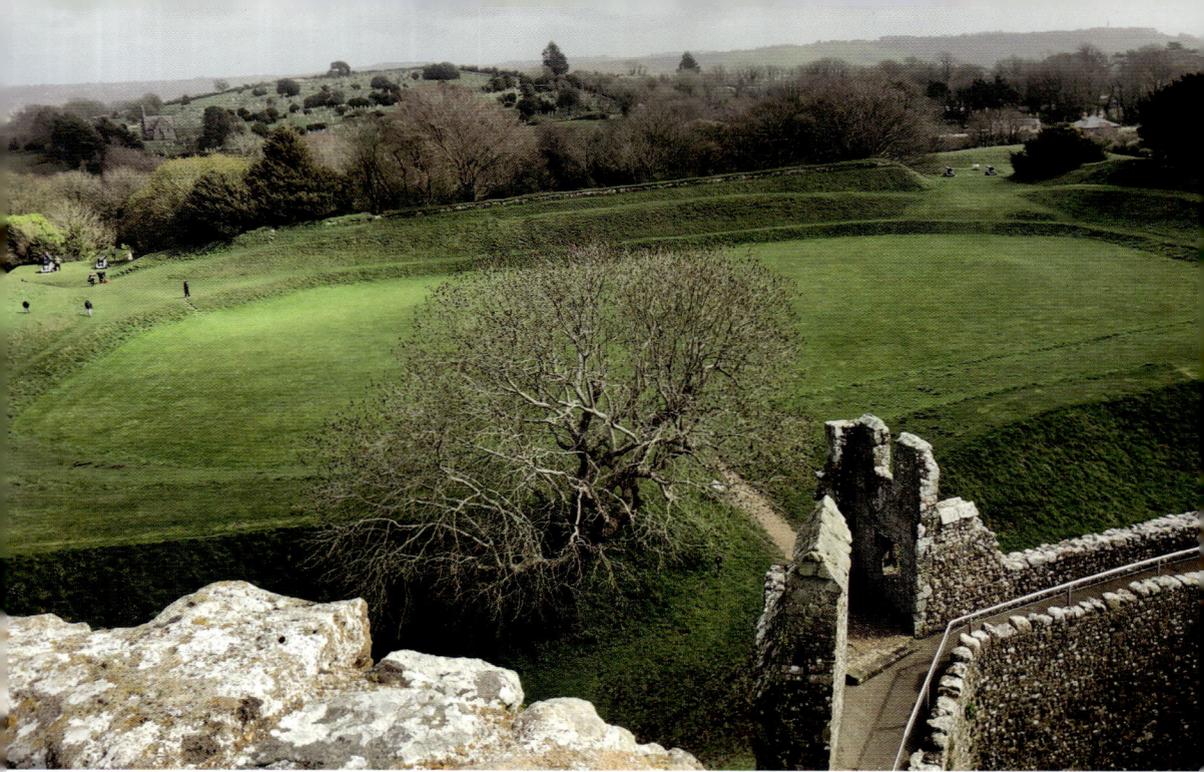

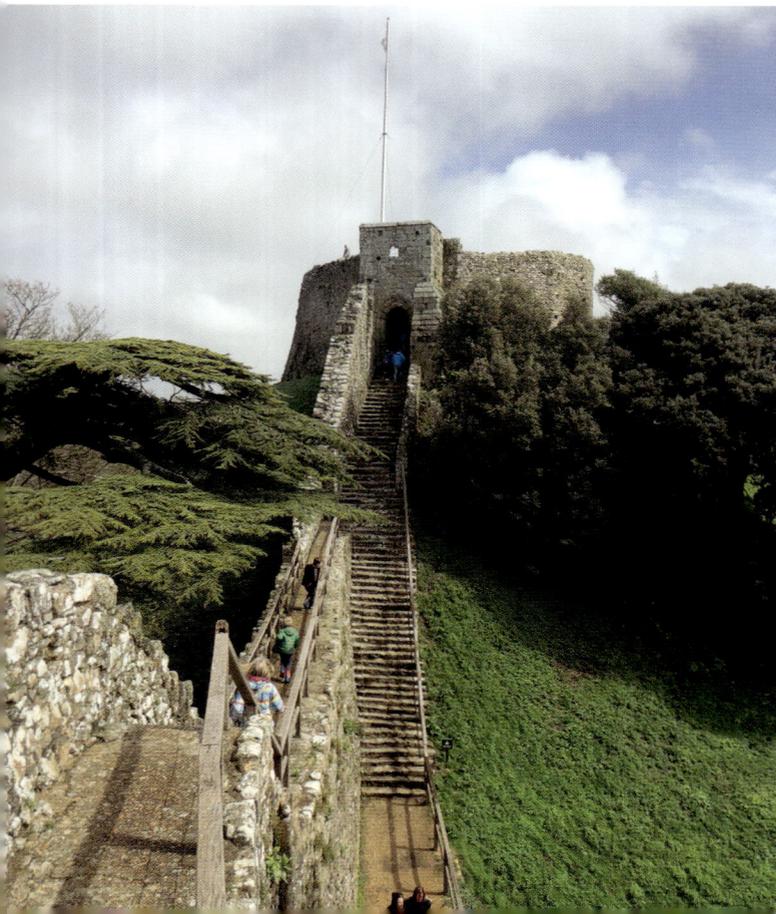

Above: The bowling green was created especially for Charles I, who was imprisoned here in the seventeenth century. (Author's collection with permission from English Heritage)

Left: The numerous steps up the side of the motte to the twelfth-century keep. (Author's collection with permission from English Heritage)

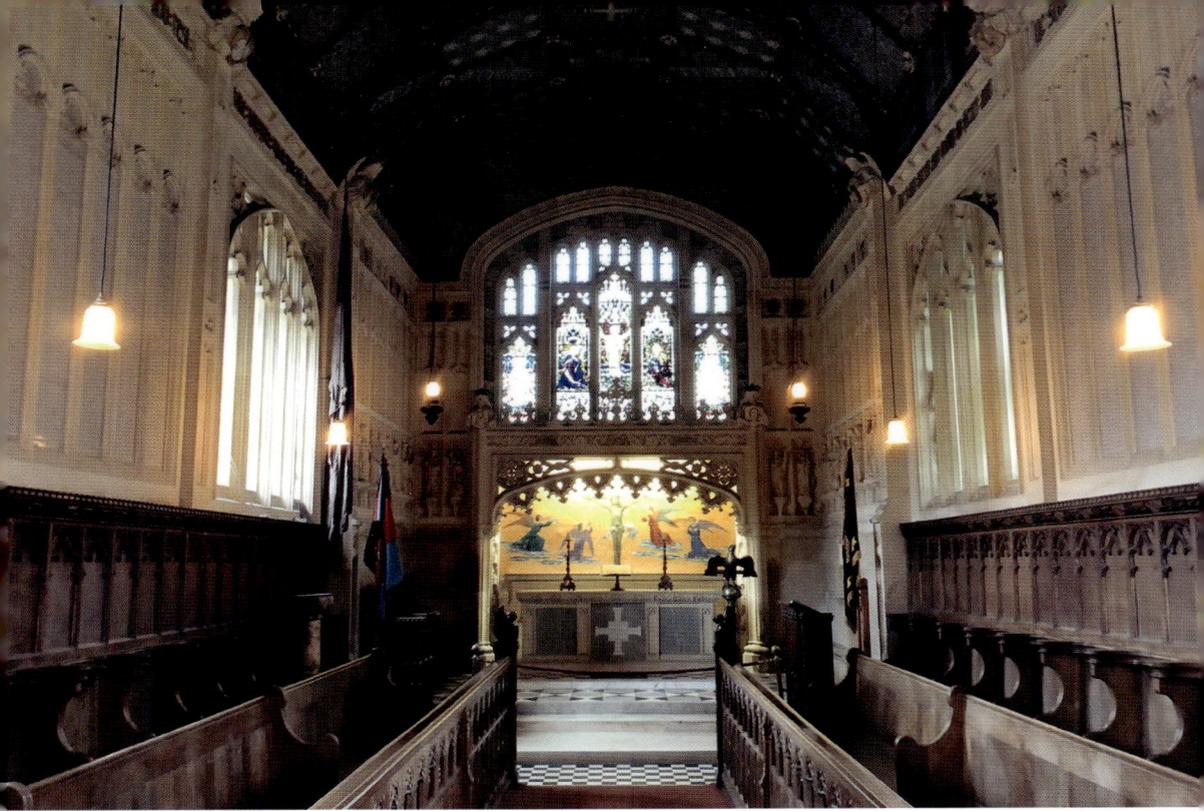

some interesting artefacts associated with the island. The Constable's Chamber is an interesting visit, as it was the bedroom of King Charles I when he was imprisoned in the castle and contains his bed and items of clothing from the time. There are large earthworks surrounding the castle, as well as the keep perched high on top of the motte, but a particular favourite is the wall walk. It is possible to take a complete circuit of the castle along the top of the walls, and in doing so, you are given some spectacular vantage points overlooking the castle and the surrounding countryside.

10. Colwell Bay

It's not exactly surprising that the Isle of Wight has a number of beaches, bays and coves, and Colwell Bay is one that is definitely worth a visit. Located in the west of the island it offers a few miles of sand and shingle beach that make it very popular for locals and tourists alike – especially as it has cafés and shops at certain points. As well as the beaches, there are three chines: Colwell Chine, Brambles Chine and Linstone Chine. These steep gorges offer some unique scenery and are important

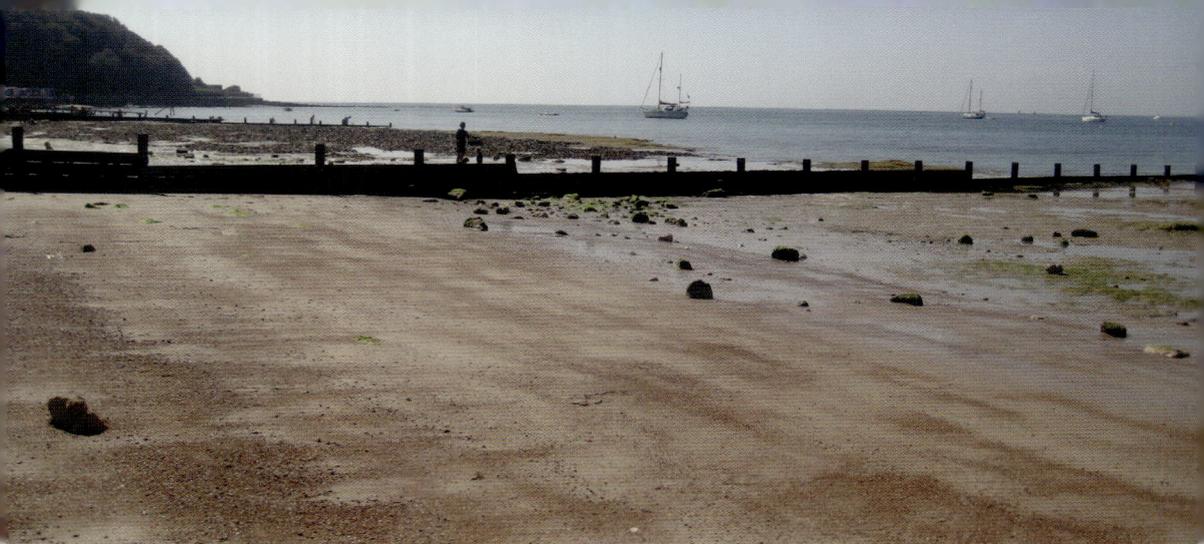

for their rare flora and fauna, fossil records and archaeology – and there are over 13 hectares listed as a geological Site of Special Scientific Interest.

Cliff's End is the bay's most northerly point and here you will find Fort Albert. Constructed in the nineteenth century when there was the threat of French invasion, it was built to help defend the Needles Passage and approach to Southampton and Portsmouth. It was to work alongside Hurst Castle – which is a mere 1,500 metres away on the British mainland. Today it is private apartments.

11. Compton Bay and Downs

Not that far away from Colwell Bay, Compton Bay is found on the south-east of the island facing out towards the English Channel. The vast expanse of sand here makes it very popular for families and kite surfers, but that is not all that this area has to offer. On its north-western edge is the distinctive bright-white chalk cliff that sweeps around to the Needles, and the coloured cliffs in the opposite direction offer the tantalising prospect of dinosaurs!

Numerous dinosaur skeletons have been discovered on the Isle of Wight over the years and Compton Bay is a particular hotspot for this! When the tide is very low, it is possible to see dinosaur footprints in the rock, and as this is one of the best areas to find smaller fossils, fossil hunters of all ages are often seen scouring and searching across the beach and cliffs.

On the cliffs above there are a network of public footpaths offering some incredible views. They meander their way across some wildlife-rich grassland that has thrived as part of the chalk ecosystem, with important species of plants and animals calling this home, such as the island's county flower, the pyramidal orchid. With a rocky reef, as well as a sandbar, Compton Bay is also a popular destination for surfers, meaning that there is something for everyone here!

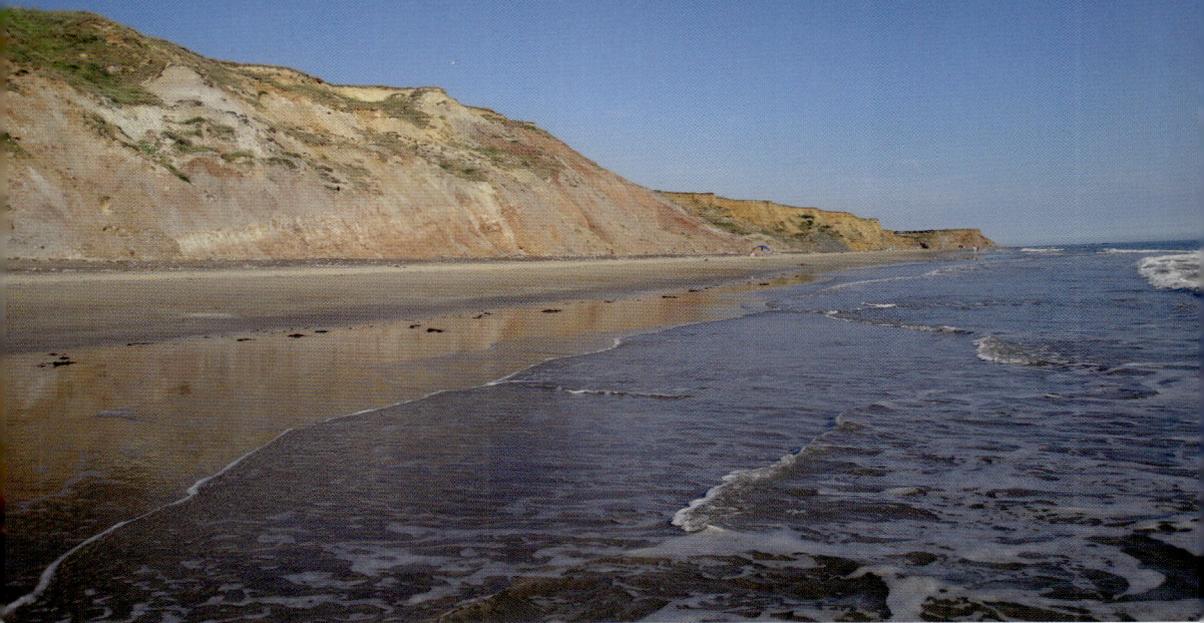

12. Cowes

Just under 15,000 people call the historic town of Cowes home. Located at the very top of the Isle of Wight, Cowes is on the west bank of the River Medina with East Cowes on the opposite bank. They are linked by the Cowes Floating Bridge, a small chain ferry that means you can get from one side to the other without having to take a 10-mile detour via Newport.

Being adjacent to the docks of Southampton and Portsmouth, it is not surprising that both Cowes and East Cowes became heavily associated with boat making and all other aspects of marine craft, including sail making – it was here that the first hovercraft was tested. There is a Maritime Museum in the town, with further details being found at gem 22 in the book!

Because of this history of boat building, and with the town's links to the docks of Southampton and Portsmouth, on 1 June 1815 the Yacht Club was formed, with the Prince Regent being inducted as a member in 1817. When he became King George IV in 1820, it was renamed the Royal Yacht Club, and this led to the world's oldest regular regatta, Cowes Week, being established in 1826. In 1833, King William IV renamed the club The Royal Yacht Squadron – due to its association with the Royal Navy, with Nelson's captain at Trafalgar, Admiral Sir Thomas Hardy, being amongst the members. In 1854, The Royal Yacht Squadron leased, and in 1917 bought, Cowes Castle to use as its clubhouse. Originally constructed in 1539 to

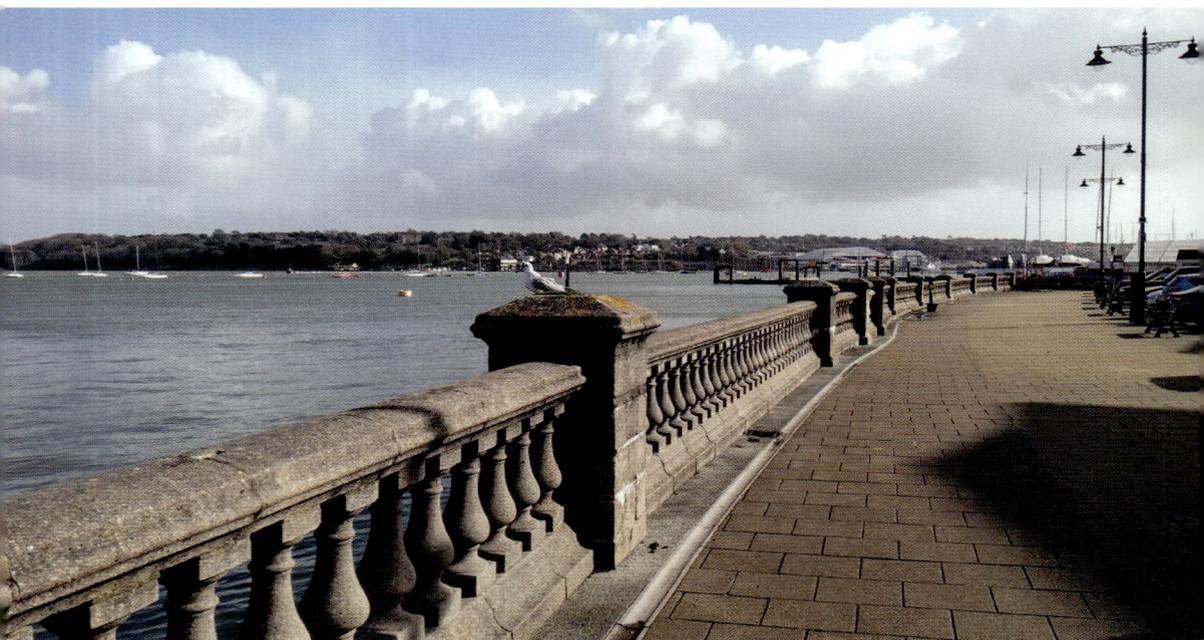

Above: Cowes promenade. (Courtesy of Ronald Saunders, CC BY 2.0)

Below: There are still plenty of shipyards and boatbuilders in Cowes. (Courtesy of Ronald Saunders, CC BY 2.0)

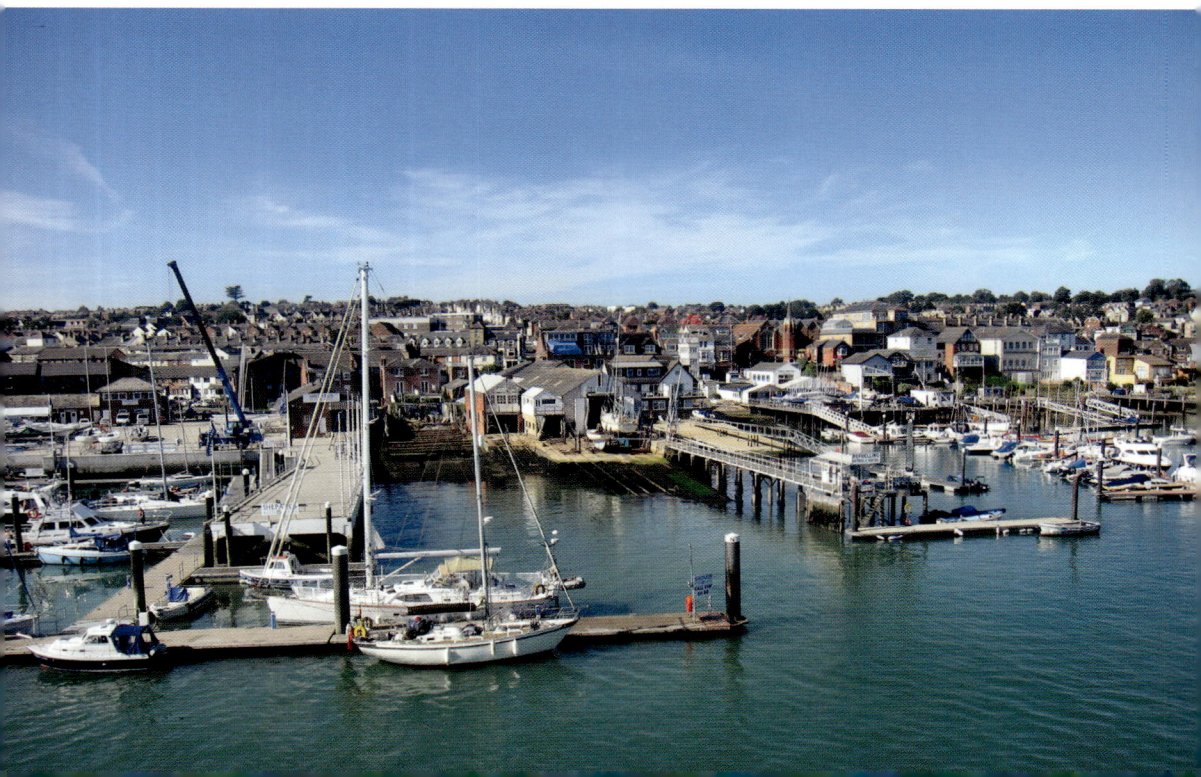

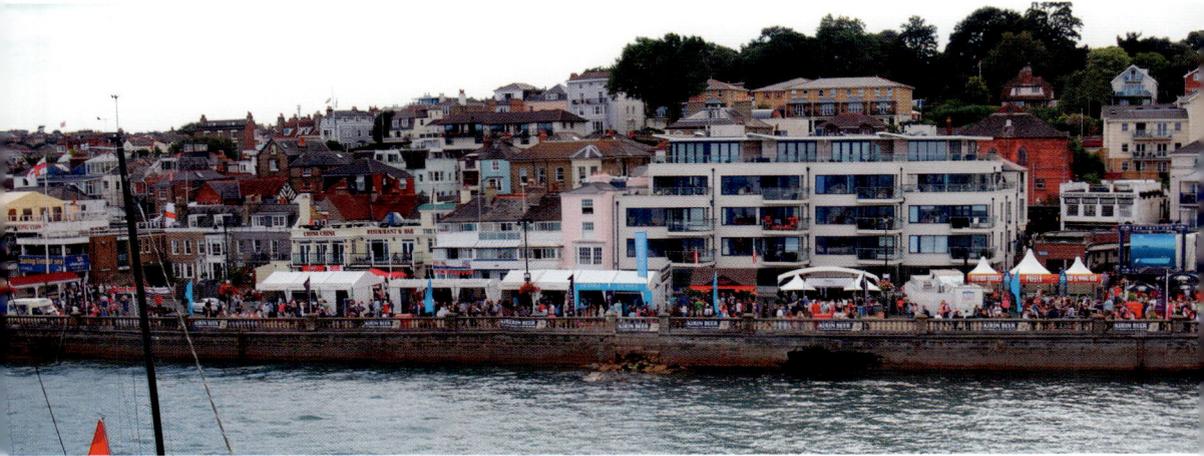

help protect the country from the threat of invasion from France and the Holy Roman Empire, it was garrisoned throughout the English Civil War (changing from Royalist to Parliamentarian hands in 1642) and remained in use in 1825 during the Napoleonic Wars. It was used by the British Admiralty during the Second World War, and remains in the hands of The Royal Yacht Squadron.

Cowes Week takes place in the first week of August every year and has done for nearly 200 years, which is why Cowes is viewed by many as the natural home for international yacht racing. It has come a long way from those first years where yachting was seen as an event for just the wealthy. Today, there are around forty races taking place each day, with well over 2,500 competitors and at least 500 boats – filling the already busy Solent with every sort of class of boat. However, Cowes Week isn't just limited to the water, as an estimated 100,000 visitors come to the town to watch the action, as well as participate in numerous onshore events that can be found along the quayside and beyond.

13. Dinosaur Isle

There is just something about dinosaurs that captivate the imagination – no matter what age you are! The fact they lived so long ago; the fact that some of them were so big and the fact that many were so ferocious. It is somewhat fortunate then that the Isle of Wight is one of the best areas in the whole of Europe for discovering them – with over twenty species of dinosaur having been found here! With such a rich heritage, it isn't surprising that there is a dedicated museum to the creatures – Dinosaur Isle.

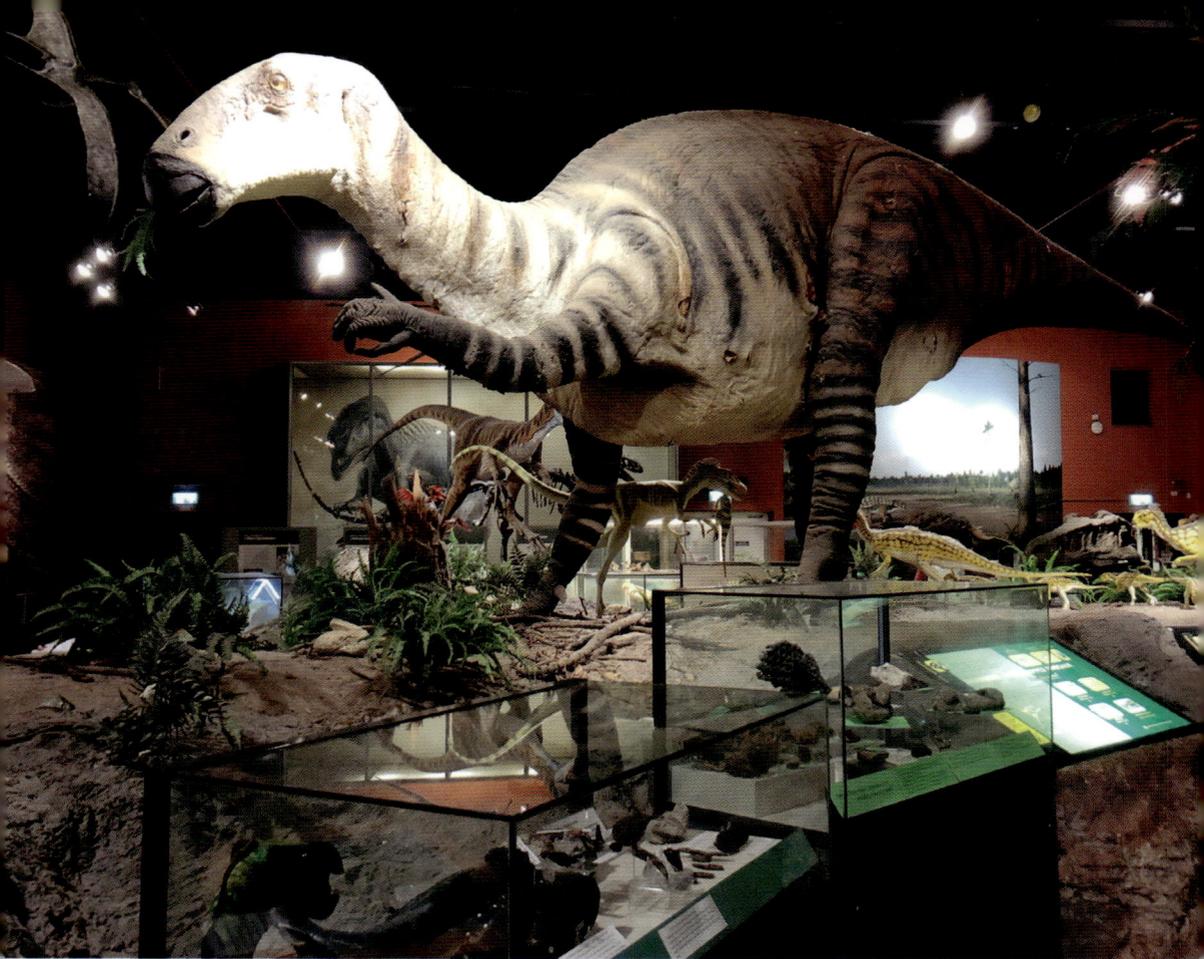

There are plenty of life-sized models at Dinosaur Isle. (Author's collection)

Located on the east of the island at Sandown, just a stone's throw from the very beach where some of the exhibits might have once roamed over 100 million years ago, Dinosaur Isle is regarded as the country's first purpose-built dinosaur attraction. On display are numerous fossils, the tusks of Ice Age elephants, teeth and bones of alligators, and a whole range of shells and, of course, ammonites.

As you leave the traditional museum set-up and enter the main hall, a spectacular sight awaits you. Spreading out in all directions is a large, recreated landscape with life-sized models of the dinosaurs that once walked on the Isle of Wight, with pterodactyls flying high above you too. You can't fail to stop in your tracks and take it all in for a second, and as you explore, it's impossible not to get mesmerised by the dinosaur skeletons. The museum often has qualified palaeontologists and volunteers working in the on-site glass-fronted laboratory – you can only assume that they are used to visitors gawping at the work they are doing each day! If all this wasn't enough, for the children there are a number of hands-on interactive displays and activities in the museum, with a sandpit and robotic dinosaur amongst the favourites. Dinosaur Isle is a fantastic place to learn more about these fascinating creatures, whilst having an enjoyable day out at the same time.

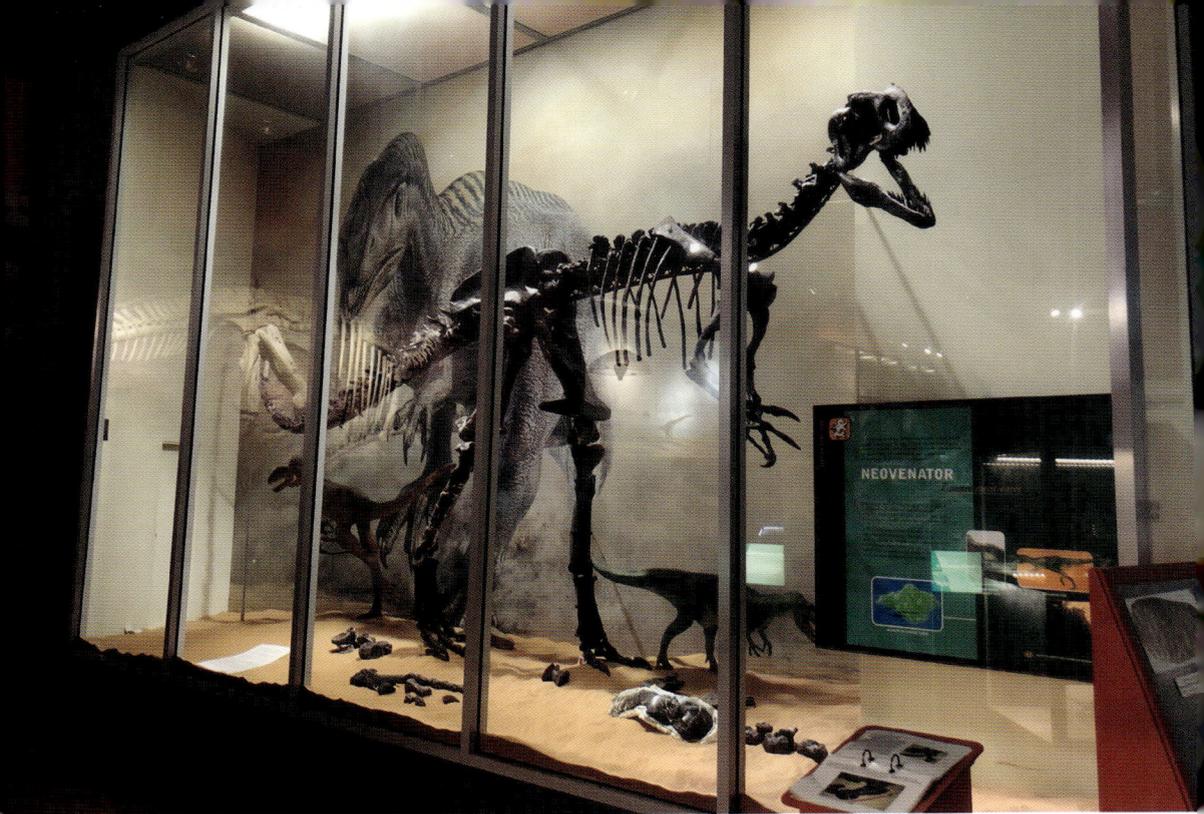

Above: Just one of many skeletons on show. (Author's collection)

Below: Plenty of displays showcase what has been discovered on the island. (Author's collection)

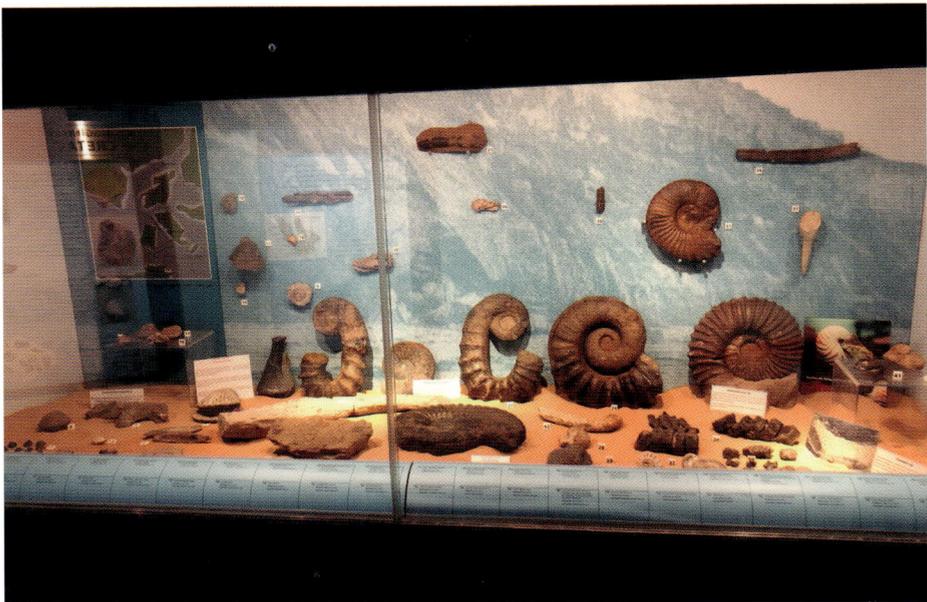

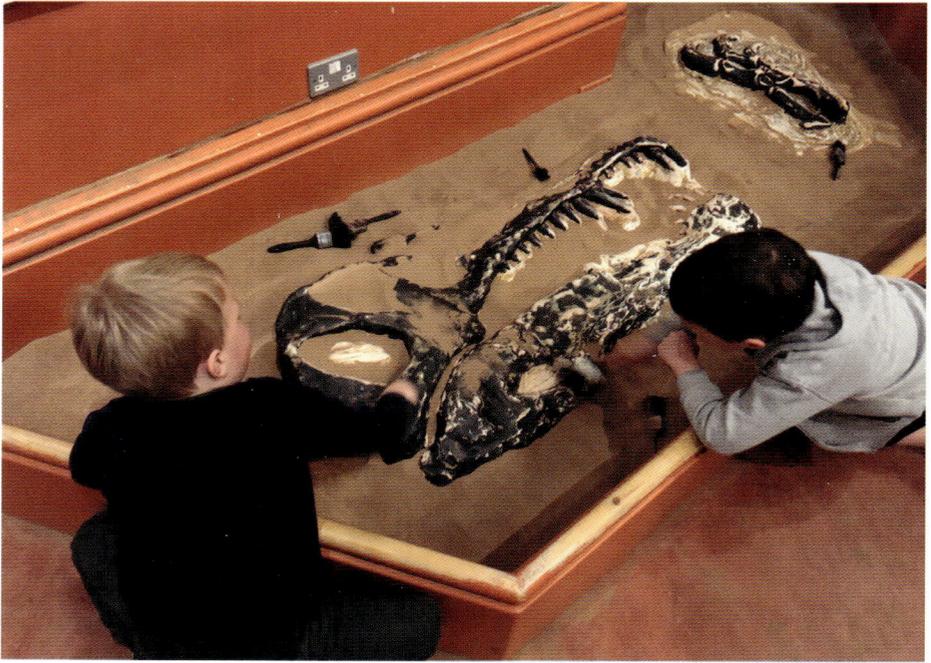

Children can get hands-on with the interactive displays. (Author's collection)

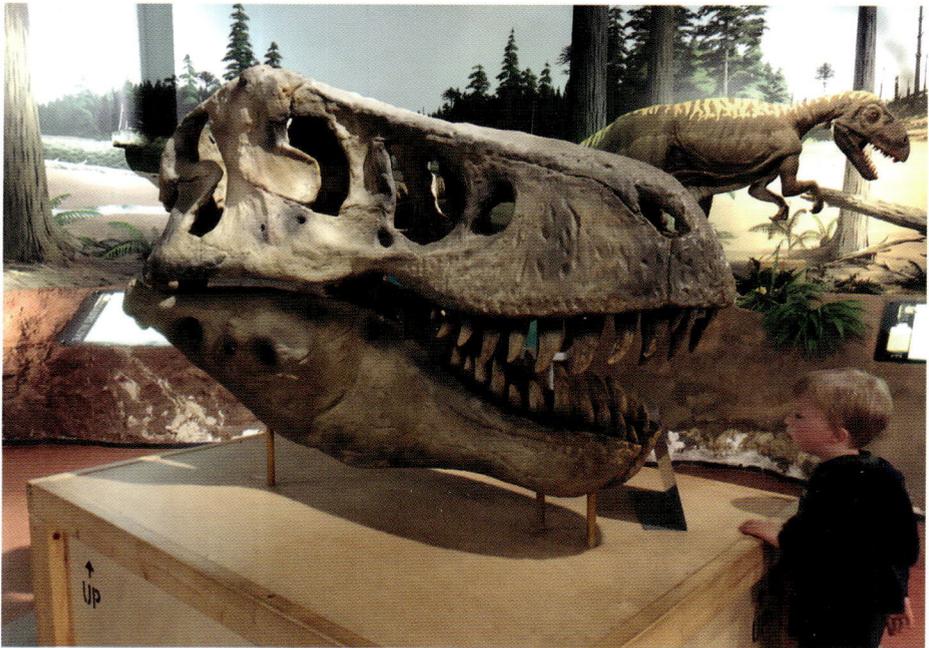

Face-to-face with a monster. (Author's collection)

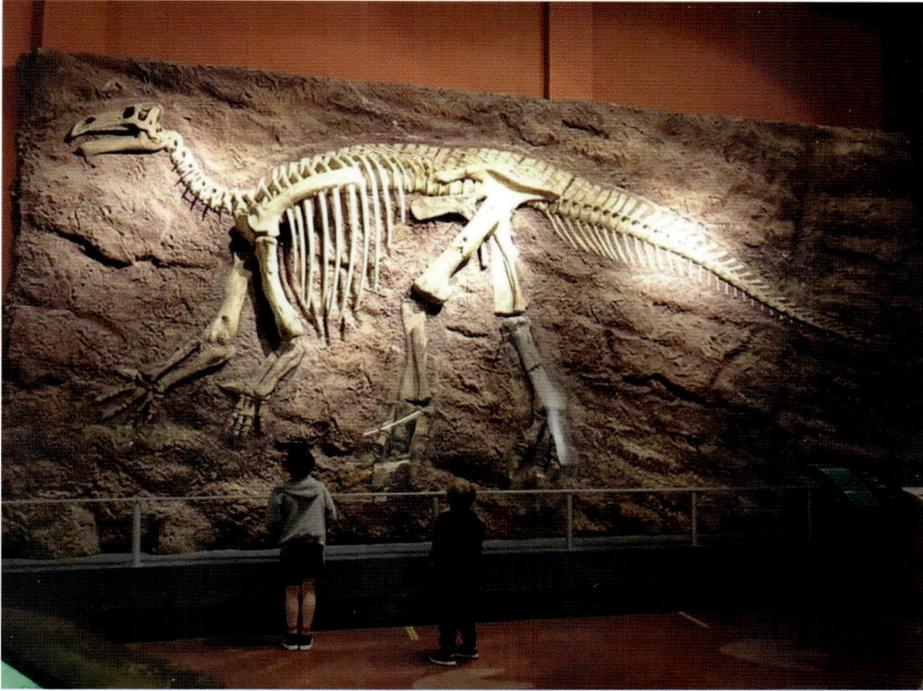

There's nothing quite like standing next to a skeleton to truly understand the size of some of these creatures. (Author's collection)

14. Farringford House

Located to the west of the Isle of Wight in the village of Freshwater, Farringford House was the home of the renowned poet Alfred, Lord Tennyson, for nearly forty years. The house was originally built in the early part of the nineteenth century and has undergone a number of renovations over the years. In 1853, Tennyson initially rented Farringford before buying it outright a few years later in 1856. Alfred and his wife Emily added a second library and redesigned the gardens and grounds to their liking. They spent their time between here and their other house on mainland England called Aldworth, right up until his death in 1892. The house remained in the Tennyson family for the next fifty years, before it was sold in the 1940s, and in the years that followed, it became a Pontin's Hotel! In 2009 it closed, before reopening in 2017 as an historic house attraction after various renovations. The estate now has self-catering accommodation within it, and as well as being able to visit the Grade I listed house as part of a guided tour, there are also large grounds, including a walled

garden, to explore. These have all been restored to what they would have looked like during Tennyson's time in the nineteenth century, and provide us with a glimpse of the environment in which he wrote some of his poetry.

15. Fort Victoria Country Park

The Isle of Wight's location in the English Channel has seen many coastal defences being built here over the centuries. Although this one bears the name of Fort Victoria, an earlier fort was constructed here by King Henry VIII in the mid-sixteenth century. Located at Sconce Point on the west of the island, it overlooks the Needles Passage and the Solent towards the vitally important docks of Southampton and Portsmouth. This original fort was in a ruined state by the nineteenth century, but in the 1850s, a new brick and concrete triangular fort was built in order to bolster the defences of the area. Named and partially designed by Prince Albert, it covered quite a large area and even had its own pier built to ensure that men and supplies could be unloaded here as quickly as needed, and was the first of the Palmerston Forts to be constructed on the island. The 1880s saw a period of rearmament due to the technological developments of the time and in the First World War, it was used as a large storage facility, as well as offering protection to the Solent. It again provided protection during the Second World War but was also utilised as a training establishment for coastal gunners. It remained

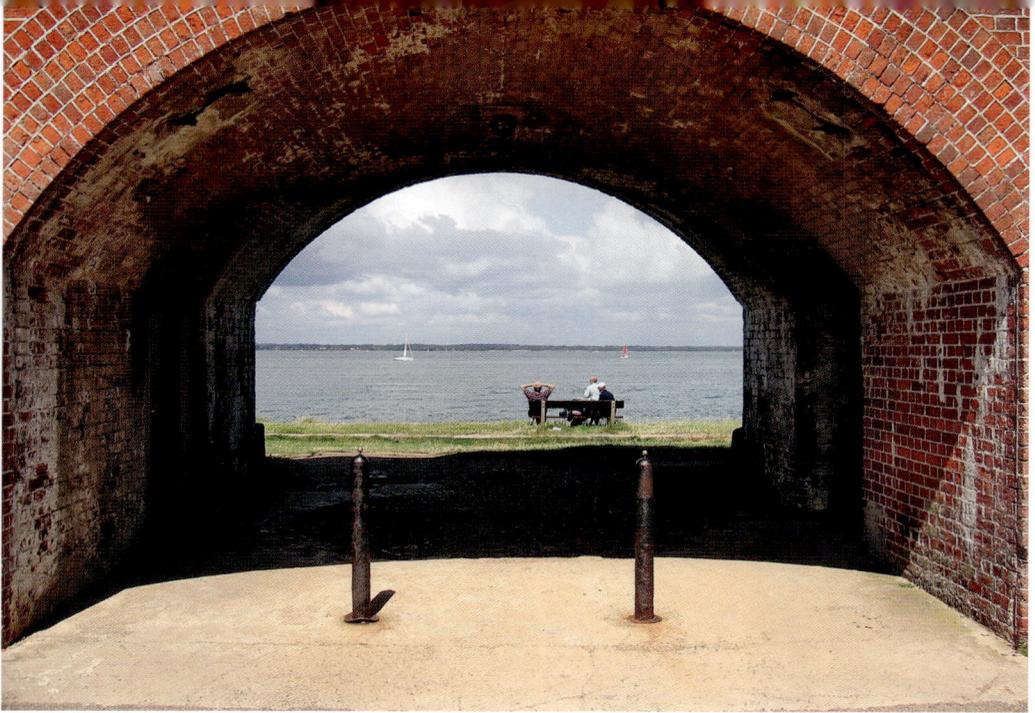

Above: Looking out across the Solent from Fort Victoria. (Courtesy of Ronald Saunders, CC BY-SA 2.0)

Below: Fort Victoria offers some beautiful sunsets. The silhouette of Hurst Castle is visible on the right. (Courtesy of Linda Hartley, CC BY 2.0)

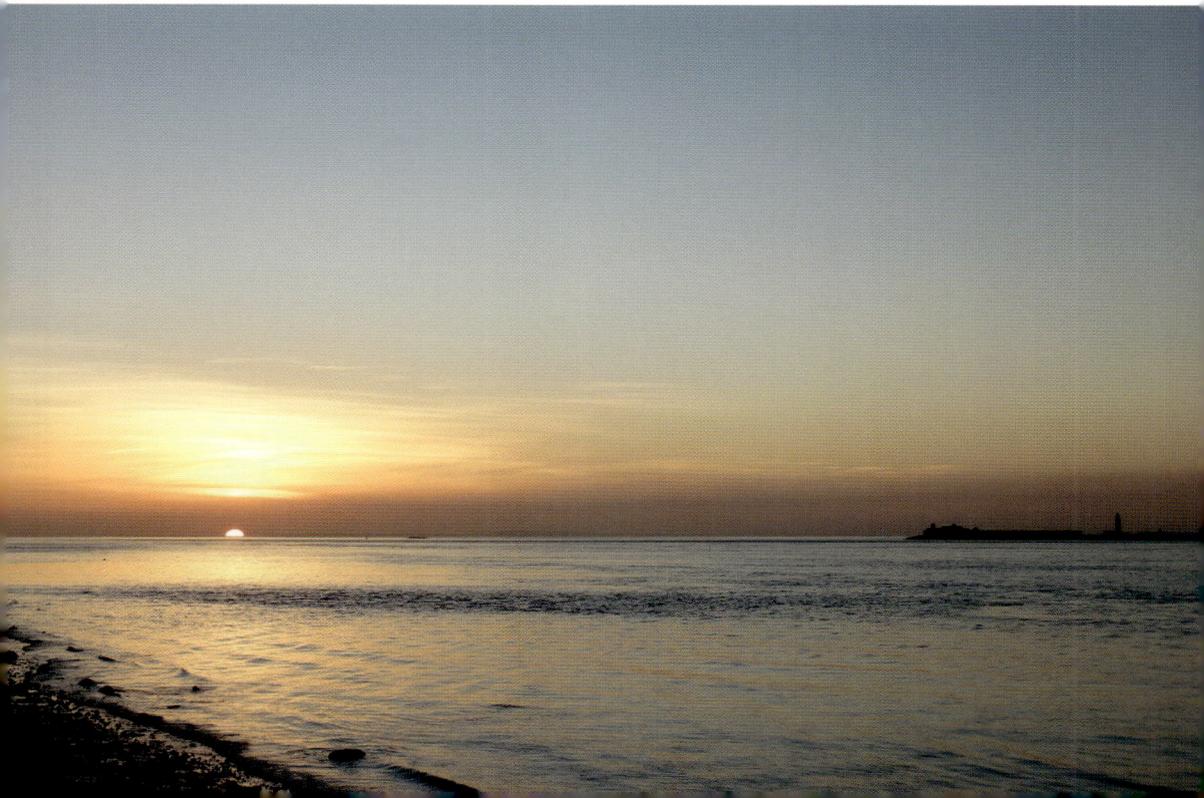

a training centre for those undertaking their National Service in the post-war era, right up until it closed in 1962. Some of the barrack blocks were subsequently demolished to help provide material for local sea defence projects but the remainder of the fort became Grade II listed and sits on the edge of the 20-hectare Fort Victoria Country Park. The woodlands here offer a number of scenic walks whilst the brick casemates of the fort are now home to a variety of attractions, including: The Imaginarium – a creative hub and art gallery; the Isle of Wight Reptilarium – housing various species of snakes, lizards and insects; and the Fort Victoria Museum, which details the history of the fort and some of the events that took place here.

16. Freshwater Bay

Freshwater Bay offers some of the most picturesque scenery that the Isle of Wight has to offer. Lying on the south-west of the island, the massive white chalk cliffs that surround the beach are easily one of the most photographed areas and it is certainly worth seeing them, not only from the beach, but also from walking along the numerous cliff paths. The beach here is essentially the same as that at Compton Bay a bit further to the east – with flint and pebbles at the top of the beach and sand below the low water mark. Smugglers are known to have used the area in the past, and at low tide, caves that they once used are exposed for a brief period of time – well worth exploring if you can. Various water sports, including kayaking, take place here, and boats will often moor offshore in the area.

The stunning chalk cliffs of Freshwater Bay. (Courtesy of John Morton, CC BY-SA 2.0)

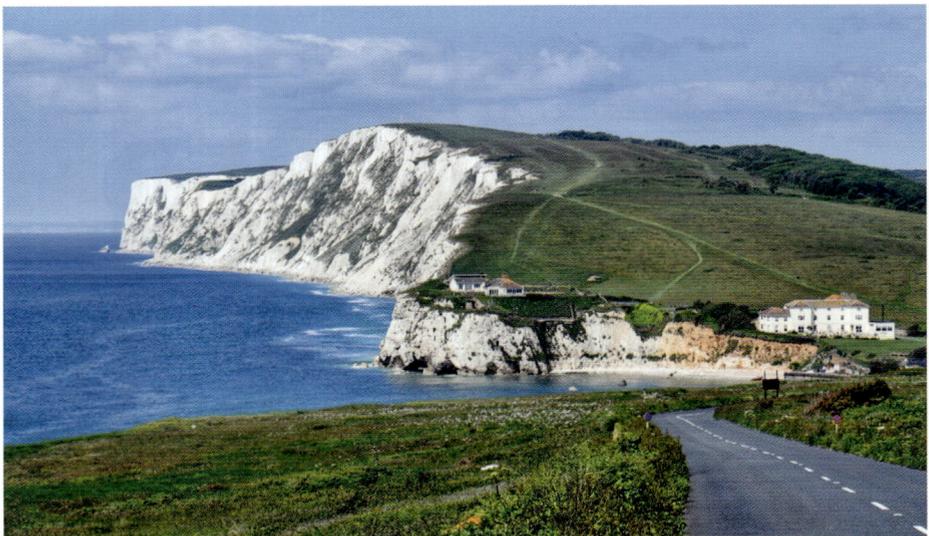

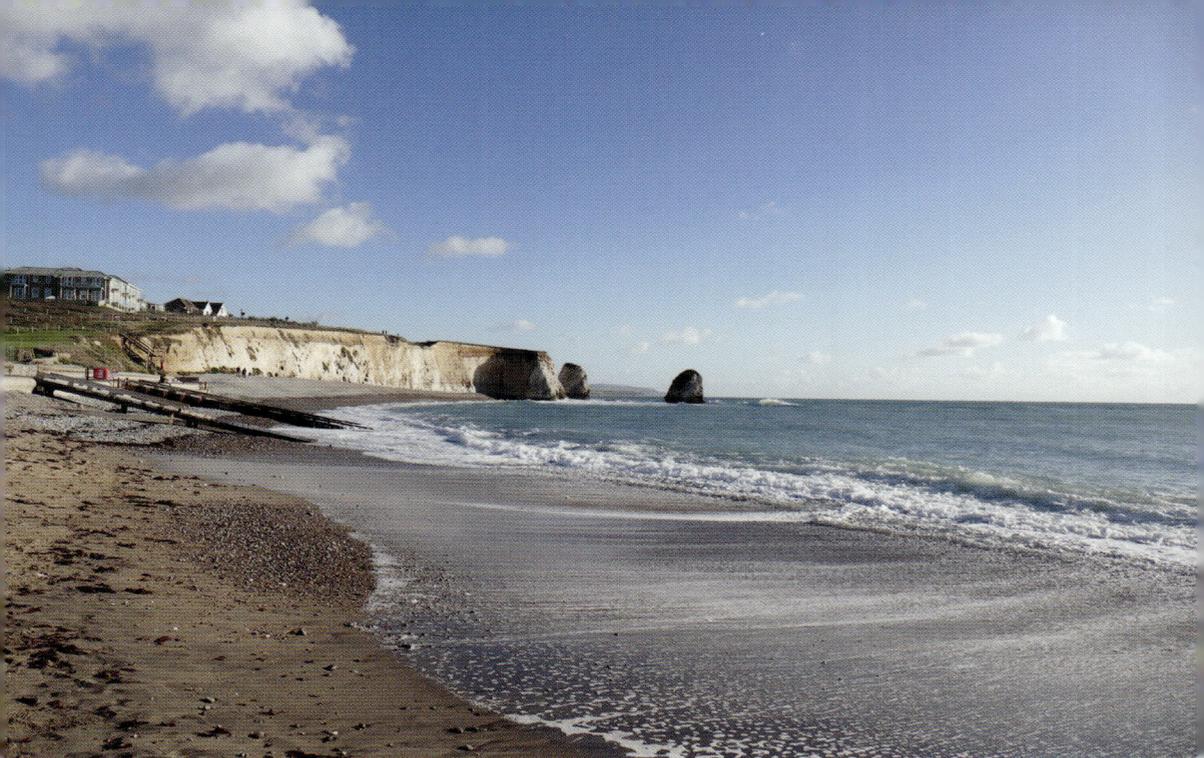

The beach at Freshwater Bay is a mixture of grey flint, chalk pebbles and sandy areas too. (Courtesy of Les Chatfield, CC BY 2.0)

17. Godshill Model Village

It is almost impossible to spend any length of time on the island and not visit the beautiful village of Godshill and its model village. Set in the middle of the Isle of Wight with its thatched buildings, small narrow streets, old pubs and church, it is hard not to be drawn in by its charm. There are a range of walking routes around the local countryside and plenty of little shops that offer all sorts of things on sale. Of course, if you do stop here, then exploring the miniature world of the Godshill Model Village is a must.

Set in almost 2 acres of land in the grounds of what was the old vicarage, the model village has been a family-run business since the 1960s and you can certainly feel the pride and love that goes into it. It is a Royal Horticultural Society Partner Garden, with over 3,000 plants, trees and shrubs – some of them have been shaped in order to keep perspective with the models. But the main draw is the one-tenth scale buildings and little people on display; you can't fail to be impressed by the attention to detail in the model village – it is staggering. There are recreations of the villages of Shanklin and Godshill as they were in the 1920s, with shops, cars, airplanes and boats all adding extra to the scenes. But it is the little people, cast in resin, and what they're up to that add the finishing touch – from playing a football match to attending a dinosaur dig, this is one of those attractions that the more you look the more you see.

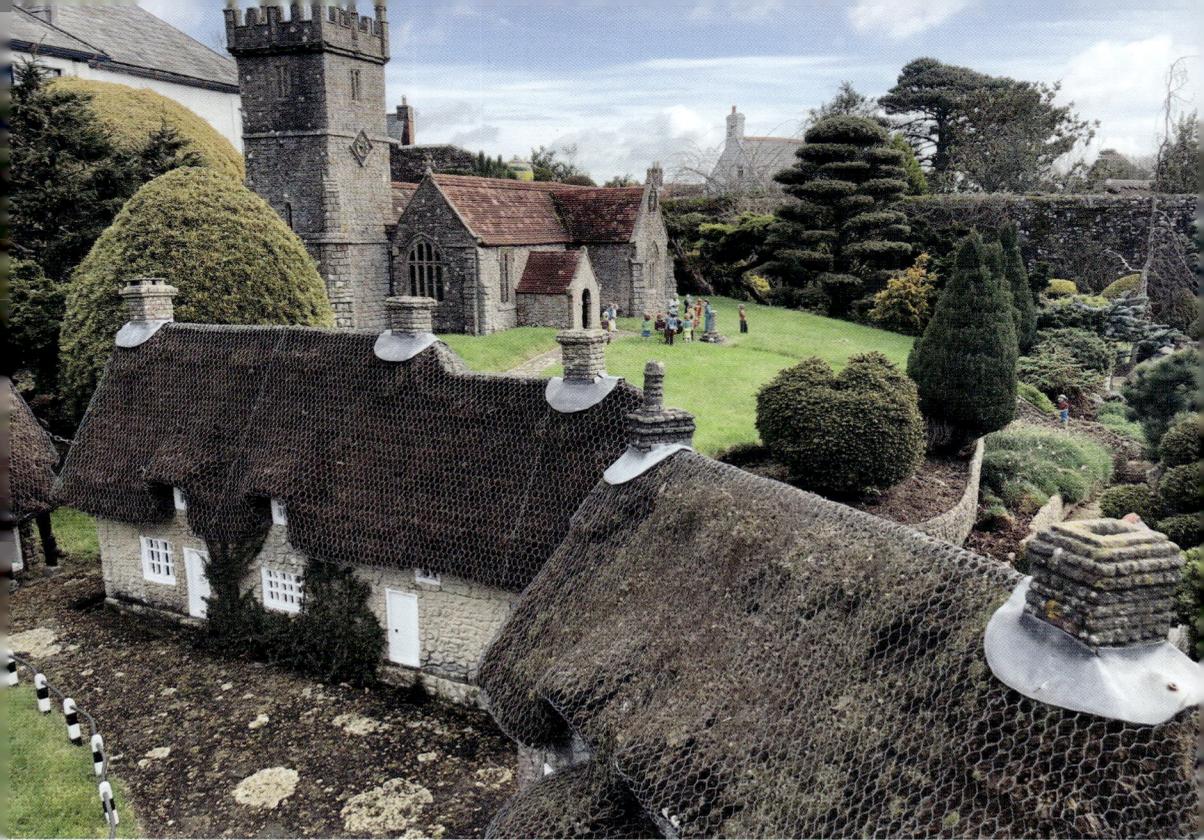

Above: The village of Godshill – in model form! (Author's collection)

Below: A picture-perfect model. (Author's collection)

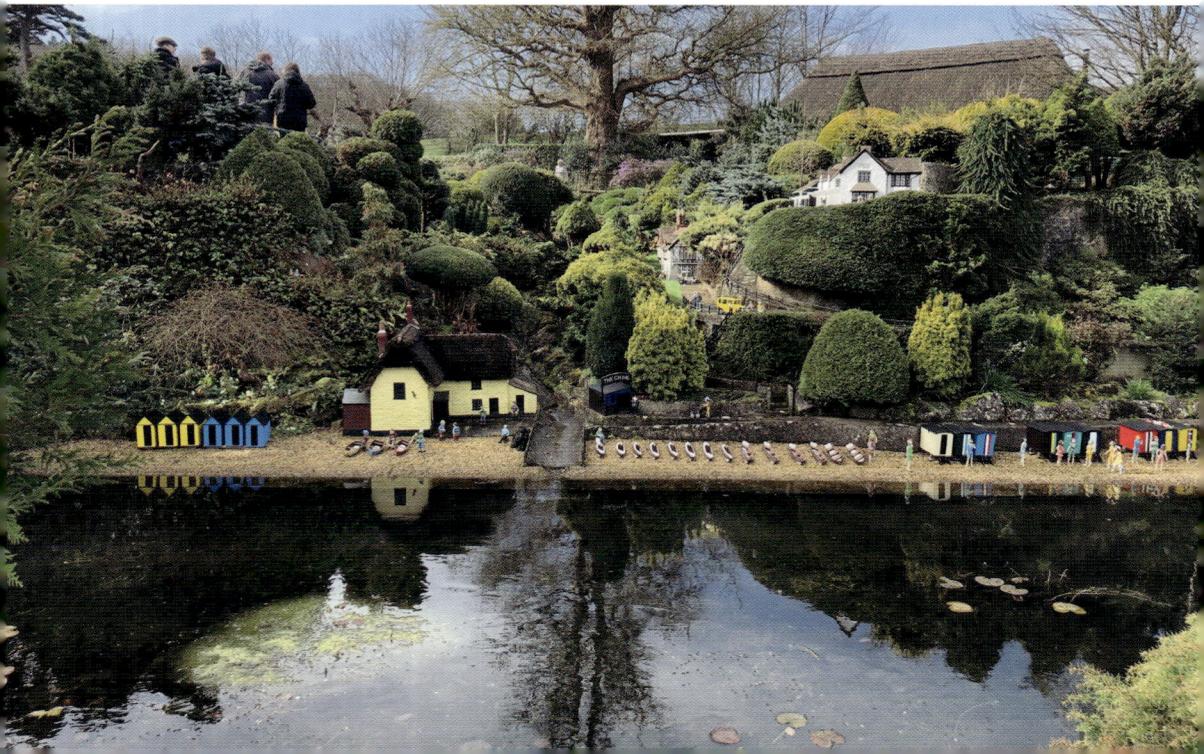

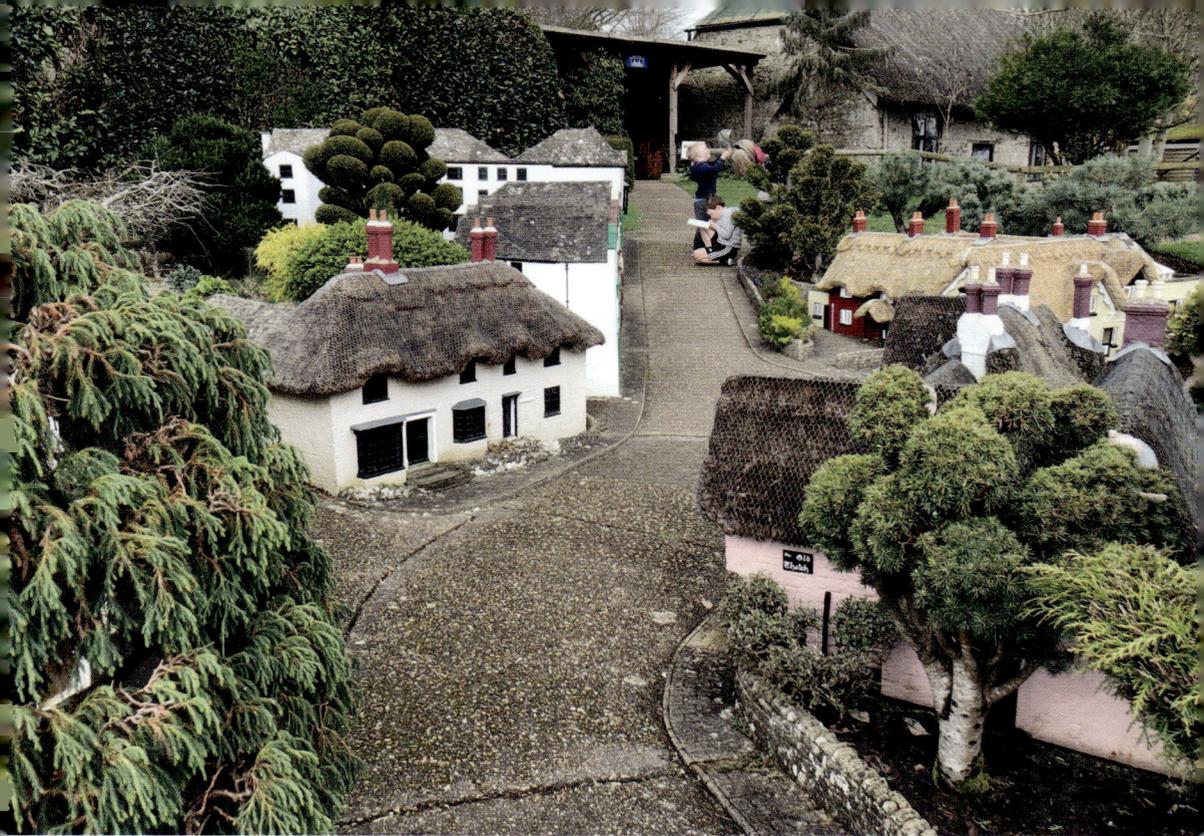

Above: Such attention to detail in all of the models. (Author's collection)

Below: A bird's-eye view of a dinosaur dig. (Author's collection)

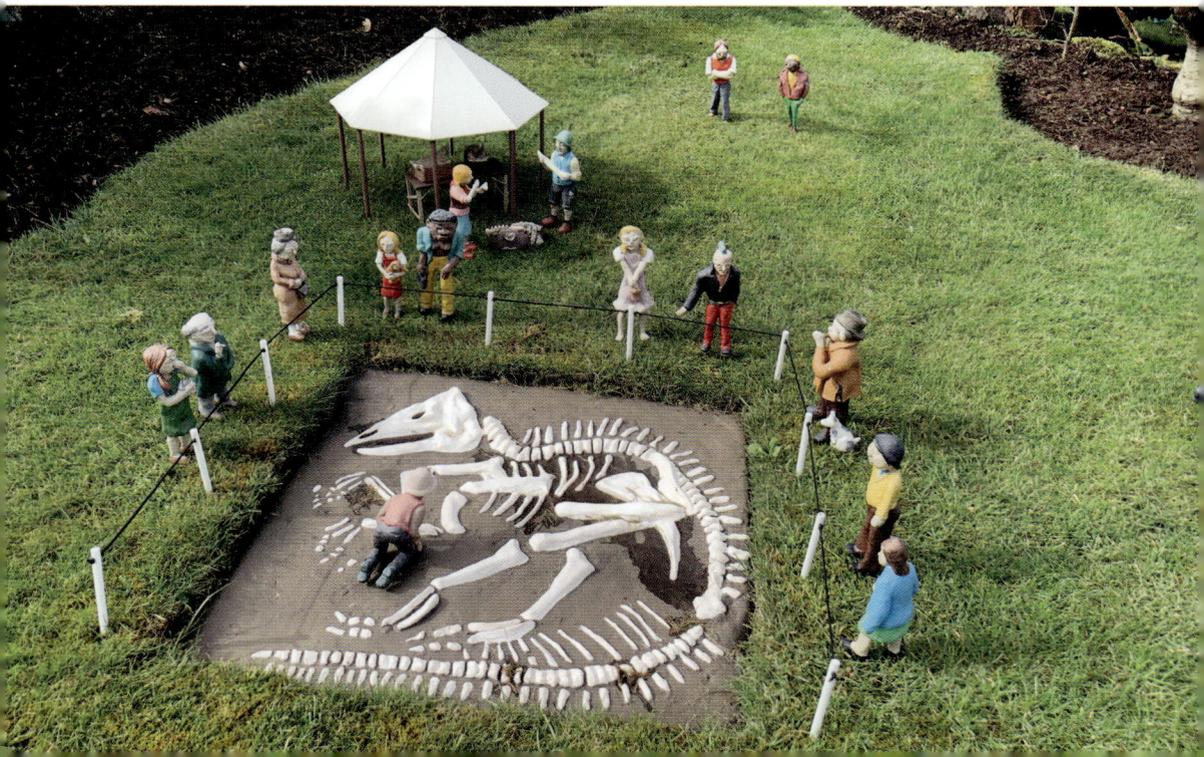

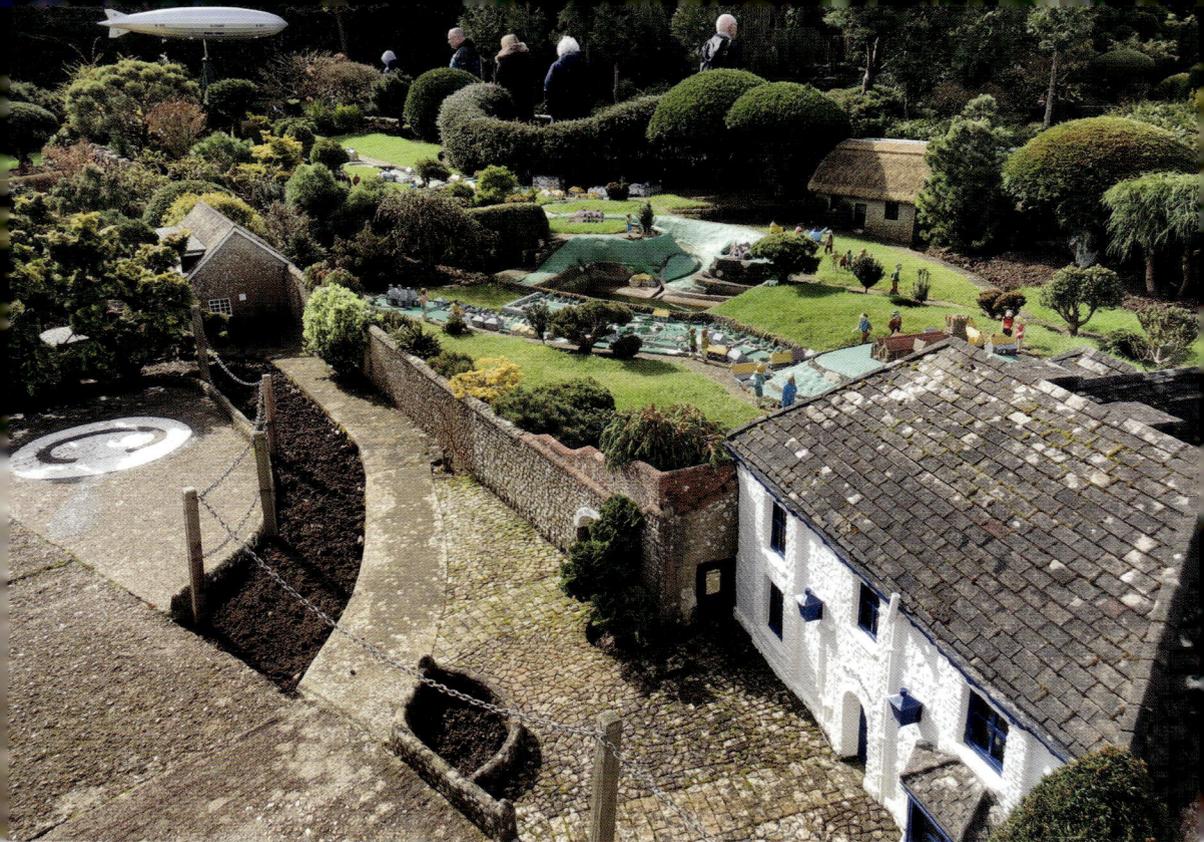

Above: There's even a model of the model village. (Author's collection)

Below: A view of the actual village of Godshill. (Author's collection)

18. Isle of Wight Festival

The Isle of Wight music festival was the brainchild of the Foulk brothers, who organised the first festival for around 10,000 people near Godshill in 1968, featuring T. Rex and Jefferson Airplane. The following year, a staggering 150,000 turned up to the village of Wootton to watch Bob Dylan and The Who, amongst others. This success led to the organisers expanding the event for the next year; however, nothing could prepare the organisers, or indeed the local population, for the 1970 event! An estimated 600,000–700,000 turned up for the five-day event at Afton Down thanks to the success of the previous year and to the start studded line up of Jimi Hendrix, The Who, The Doors, Jethro Tull, Ralf McTell, Supertramp – in fact, the list just goes on and on! Due to the somewhat unexpended high attendance, in 1971 the Isle of Wight County Council Act added a clause preventing overnight open-air gatherings of more than 5,000 people without a special licence, and so the event stopped.

In 2002 it was revived and takes place annually every June on the outskirts of Newport. It has become an important cultural event on the island, with a whole range of artists performing here, with The Rolling Stones, Red Hot Chili Peppers, The Who, Noel Gallagher's High Flying Birds, Rod Stewart and David Bowie on the list. The festival provides seasonal jobs and an influx of visitors to the island, making it a valuable economic event for the island too.

The Isle of Wight Festival. (Courtesy of David Jones, CC BY 2.0)

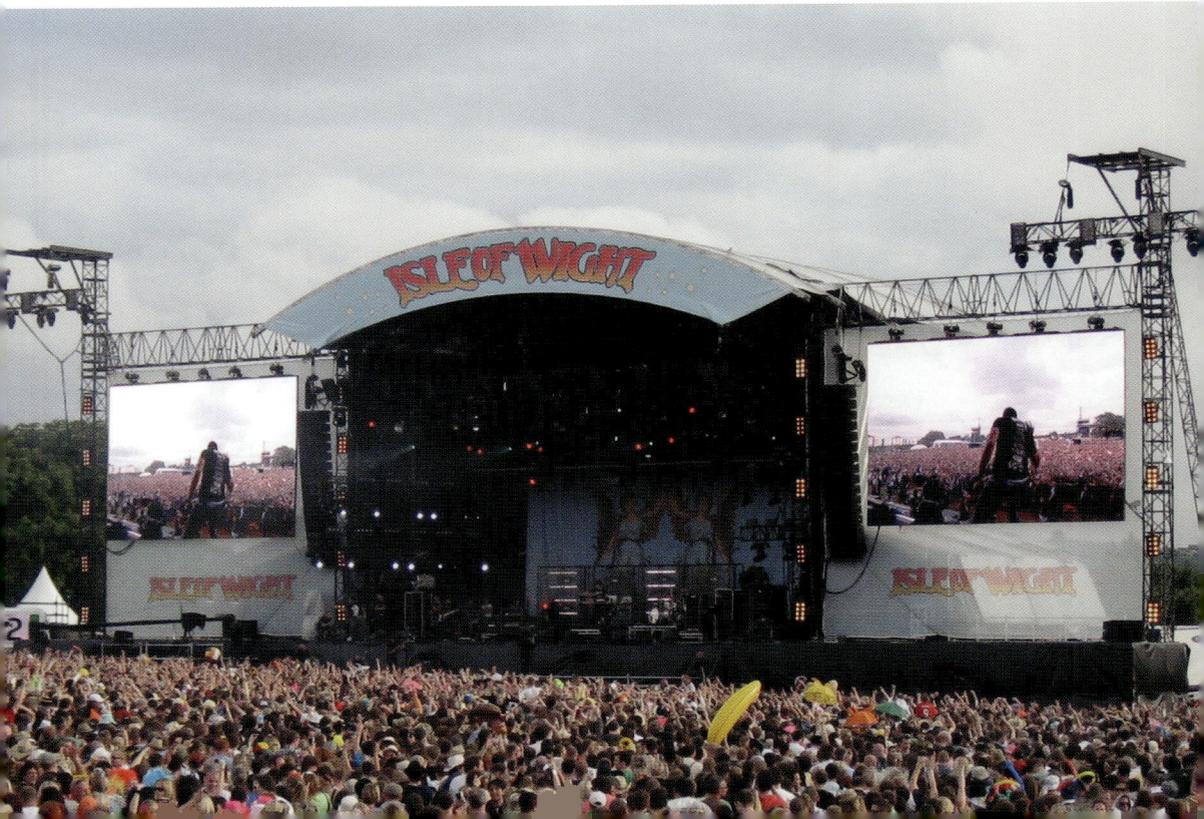

19. Isle of Wight Steam Railway

The Isle of Wight Steam Railway is a living heritage museum that stretches for little over 5 miles from Wootton to Smallbrook Junction in the east of the island. It was once part of the Newport to Ryde line, which formed part of the 55-mile railway network built up on the island in the mid to late nineteenth century. The railway boom enabled locals and livestock to move around the island easier, as well as making the Isle of Wight a destination within reach of the Victorian and Edwardian tourist. However, by the 1950s, many rural branch lines began closing and by 1966 the last steam train had run on the island.

Thankfully, the Wight Locomotive Society had been set up in an effort to preserve some of the island's rich railway heritage, and in 1971 they established the Isle of Wight Railway Company Limited and purchased nearly 2 miles of track between Wootton and Havenstreet station. Since then, further track was purchased to extend its length from Havenstreet to Smallbrook Junction, just outside Ryde.

The Havenstreet station acts as the main focal point for visitors to the Isle of Wight Steam Railway and allows you to take a real step back in time. The staff here are dressed in the traditional uniform of Southern Railways, and as soon as you enter, it

There is plenty of rolling stock at the Isle of Wight Steam Railway – including *Calbourne*, built in 1891. (Courtesy of IWSR/John Faulkner)

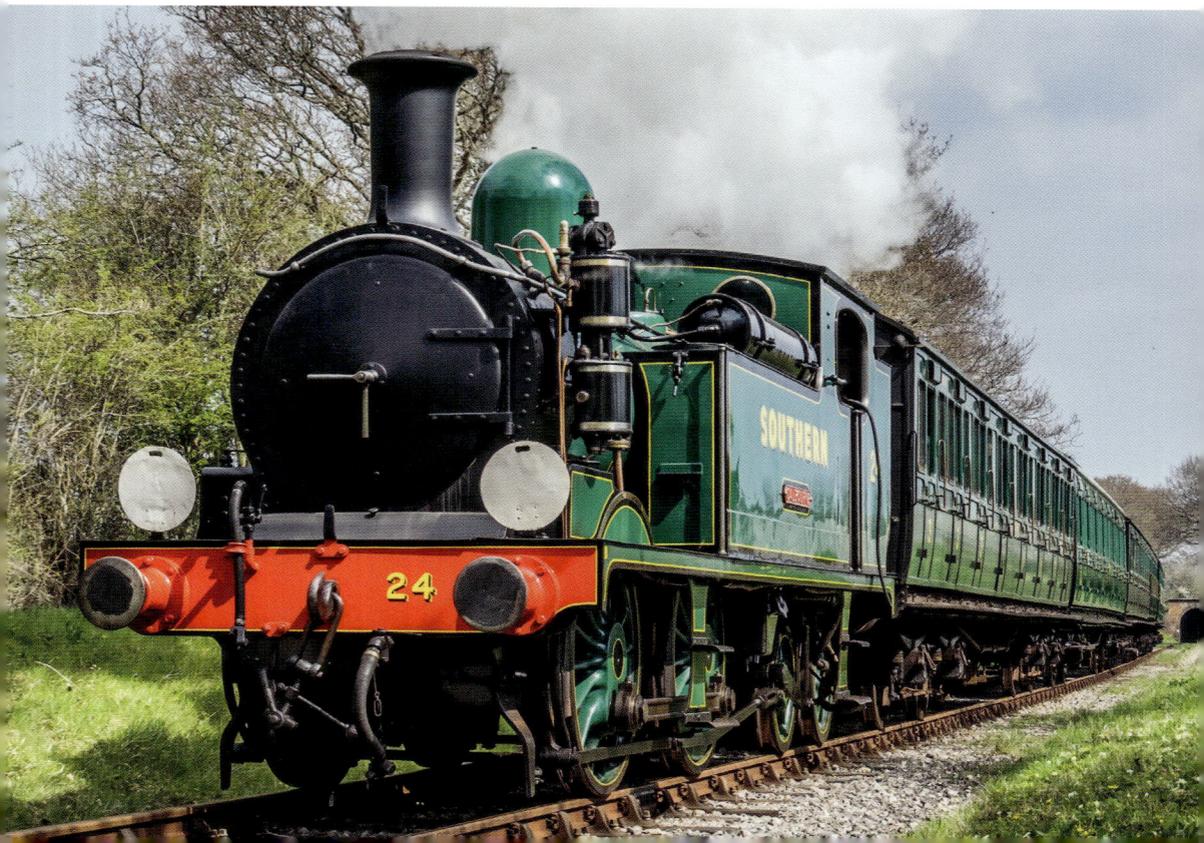

feels like you are leaving the hectic modern world behind. There is nothing quite like the sound and the smell of steam trains approaching and stopping at the station, and once on board, the gentle rhythm of the carriage allows you to take in the gorgeous Isle of Wight countryside as if it were over a hundred years ago. It is possible to alight at all three stations on the route, giving you chance to explore the surrounding landscape. All the rolling stock have been painstakingly preserved and restored to their original condition, with the oldest locomotive on show built in 1876, and the oldest carriage in the collection dating to 1864! With the Discovery Centre and Indoor Museum charting the history of the islands' railways, and the fight taken to preserve them, it is easily possible to spend the best part of a day exploring the past.

20. Lilliput Antique Doll & Toy Museum

Located in Brading in the east of the island, the Lilliput Antique Doll & Toy Museum has an incredible collection of over 2,000 artefacts. This family-run museum first opened its doors in 1974, after Margaret Munday had been sent a nesting doll by the 7th Premier of Russia, Nikita Khrushchev, in the 1960s. The subsequent collecting of

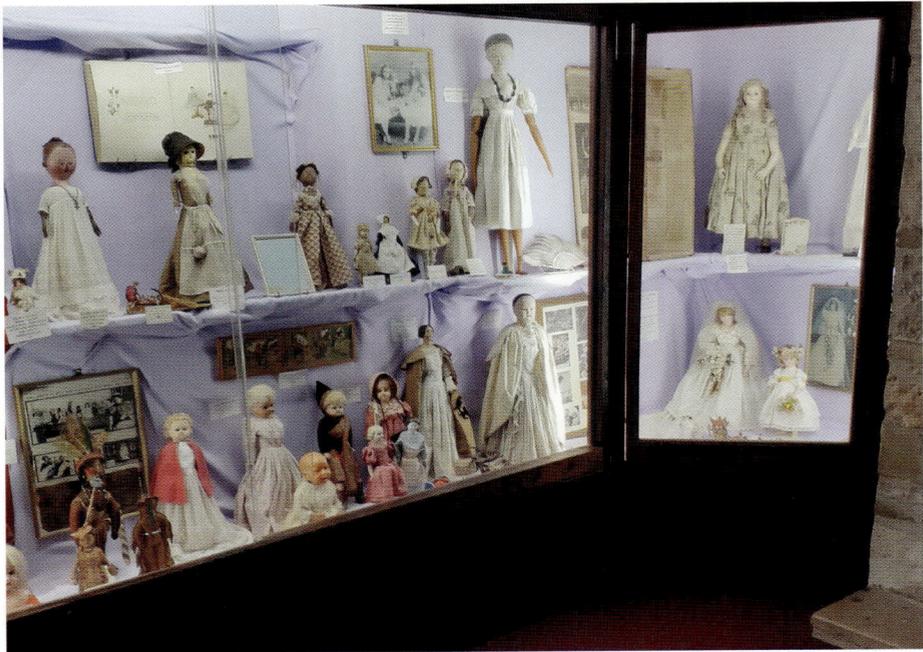

There are over 2,000 items in the museum. (Courtesy of Jacqueline Munday, Lilliput Doll & Toy Museum)

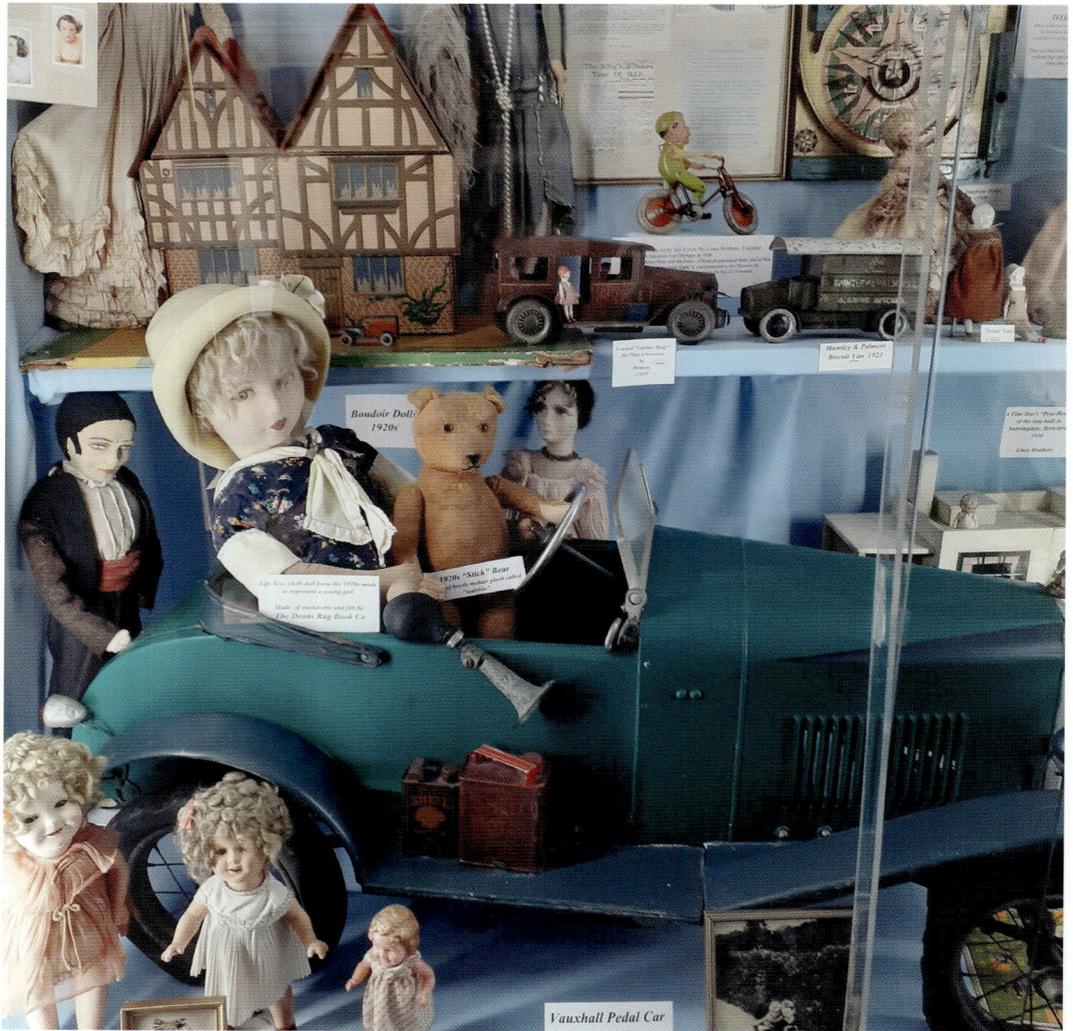

There are many unique and rare toys to be found on display. (Courtesy of Jacqueline Munday, Lilliput Doll & Toy Museum)

dolls and toys that this inspired reached a point where they needed to be displayed and looked after properly, and so the museum was born.

Described as one of the finest private collections of its kind in the country, there is much more to see than just antique dolls. Teddy bears, model trains and vehicles, puzzles and games can all be found – with the oldest item dating to 2000 BC! There are some familiar faces amongst the items, with Popeye, Muffin the Mule and, of course, Hornby trains, all featuring as very popular toys in their day. A number of the items have their own story to tell – like Rags the dog, who became an unofficial mascot for an airman and his crew during the Second World War.

21. Marconi Monument

In today's world we all take instant communication for granted, and the experimental work of Guglielmo Marconi played an important role in mankind's technological advancements. It is somewhat odd then to think that some of this work took place on the Isle of Wight, within view of the Needles. But it did! In December 1897, Marconi established a massive 168-foot mast right outside the then Royal Needles Hotel, and sent one of the very first wireless transmissions to a ship out at sea. The following year, he continued his pioneering work as messages were sent and received to Osborne House. Sadly, neither the hotel nor the mast remain, but within the Needles park overlooking Alum Bay is a small monument to him and his investigational work, at the exact location of that mast.

The Marconi memorial. (Courtesy of Matt Brown, CC BY 2.0)

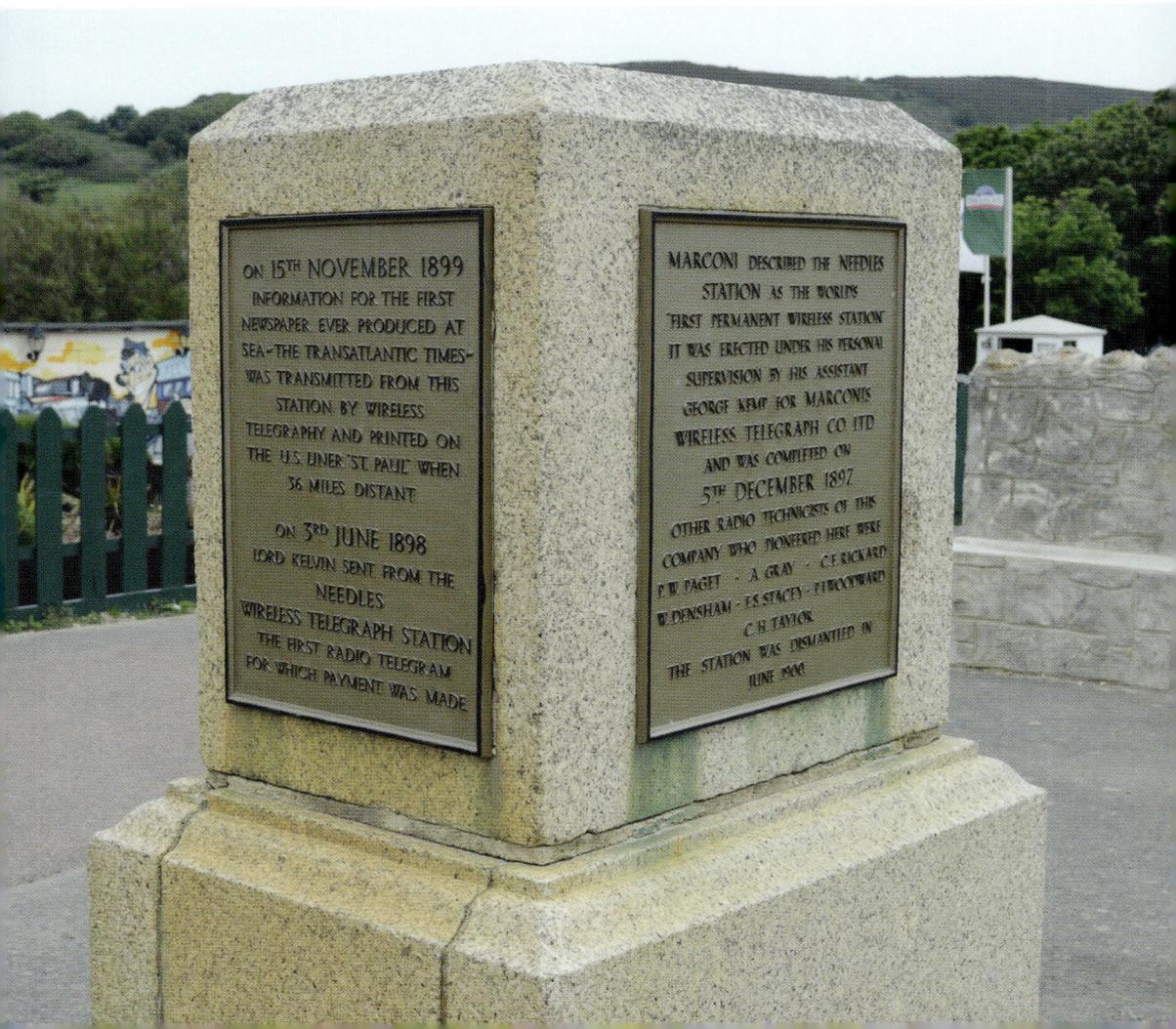

22. Maritime Museum

With the town of Cowes having such a grand shipbuilding and maritime heritage, it is not surprising in the slightest that it also has a Maritime Museum. It is located in the same building as the library, as the museum collection began its life as a small exhibition started by the library staff in the 1970s. Free to enter, the museum has photographs, plans and many models on all aspects of the maritime history of Cowes. The objects on display tell the story of local shipbuilding and yachting over the centuries. Within the same building is the Library Services' Maritime Collection, which has an innumerable amount of books, press cuttings and documents that are linked to Cowes' maritime heritage.

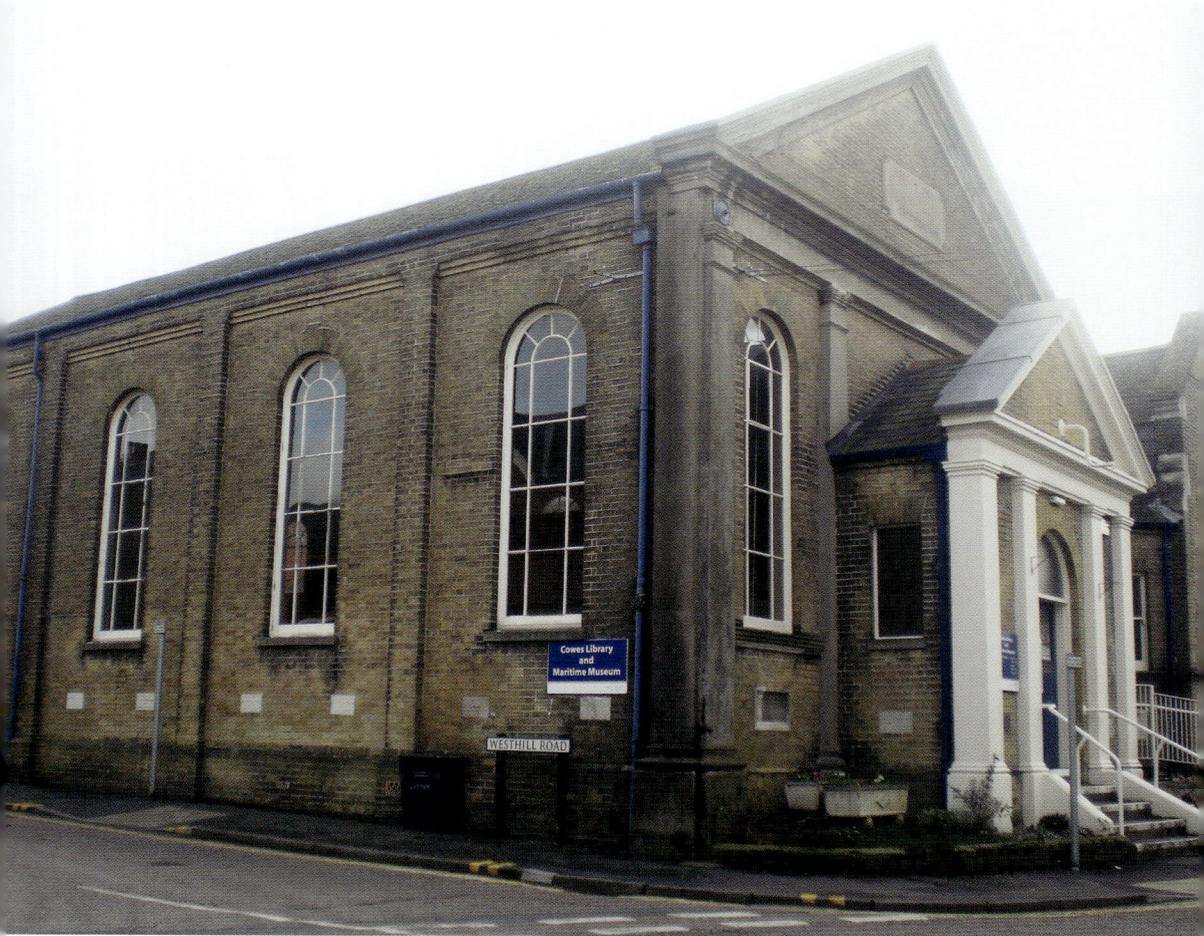

The Cowes Maritime Museum, and library, building. (Public domain)

23. Monkey Haven

If you're looking for a fun day out for the whole family, whilst also contributing to the conservation and protection of animals in the process, then Monkey Haven is the place to go! In 1999, Don Walser purchased a field to the east of Newport with the intention of creating a sanctuary for rescued monkeys and birds of prey. Little did he know then that this idea would snowball and turn into Monkey Haven!

Operating as a charity, all proceeds from visitors are ploughed back into the reserve, helping to pay for the food, vets bills and accommodation of the animals. Specialising in primate care, there are over nineteen different species here – most of which were rescued from illegal animal traffickers or from serious neglect. From marmosets, siamang gibbons and colobus monkeys to the endangered cotton-top tamarins, the majority of the creatures here have a tragic story that, thankfully, has a happy ending – and it is so heart-warming to see them thriving and being cared for after all they have been through.

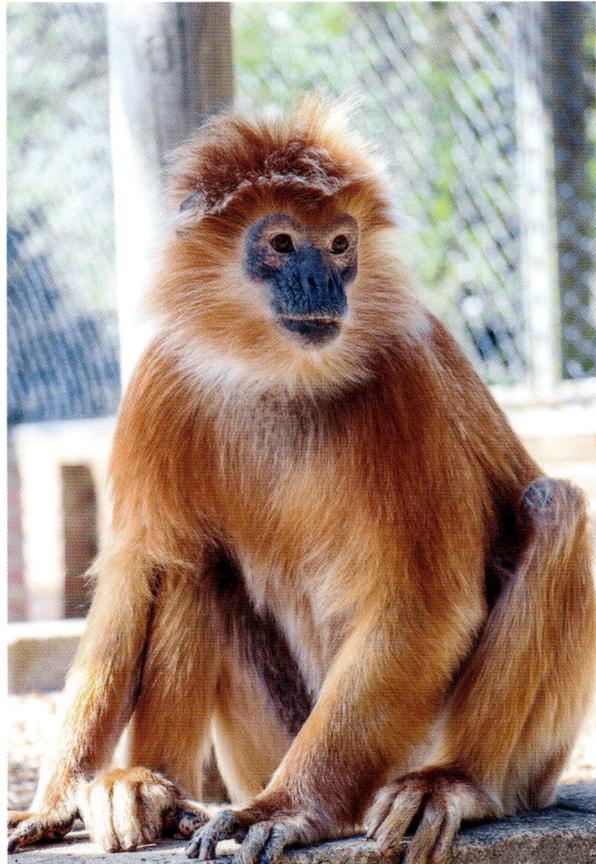

Monkey Haven have rescued hundreds of primates, birds and reptiles. (Courtesy of Monkey Haven)

However, it's not just primates at Monkey Haven. As the sanctuary's reputation has grown, so has their desire to accommodate other species. There are plenty of reptiles and insects, including snakes and tarantulas, in the warm environment of the reptile lodge; rescued birds of prey and all types of owl, including snowy owls and Bengal eagle owls; and of course the meerkat mob are always entertaining!

Everyday there are informative and entertaining keeper talks. These allow you to better understand your favourite creatures, as well as watching them eat lunch, and in some cases, there is even the opportunity to hold them. Monkey Haven are also proactive at involving schools and groups with their work – which helps to ensure that the message of understanding conservation is passed on to the next generation.

All of this, together with a tearoom and children's play areas, make this a thoroughly enjoyable and worthwhile day out.

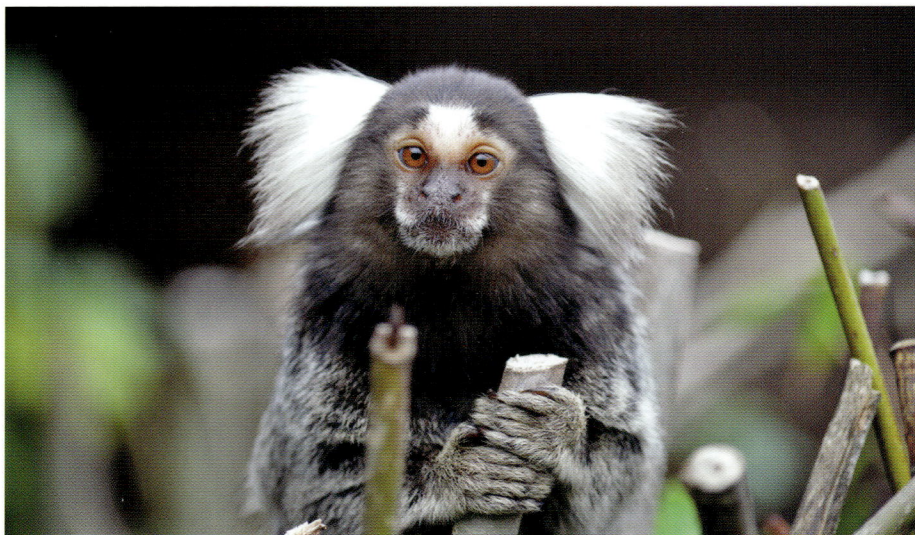

Above: Plenty of species of monkey here – like this marmoset. (Courtesy of Monkey Haven)

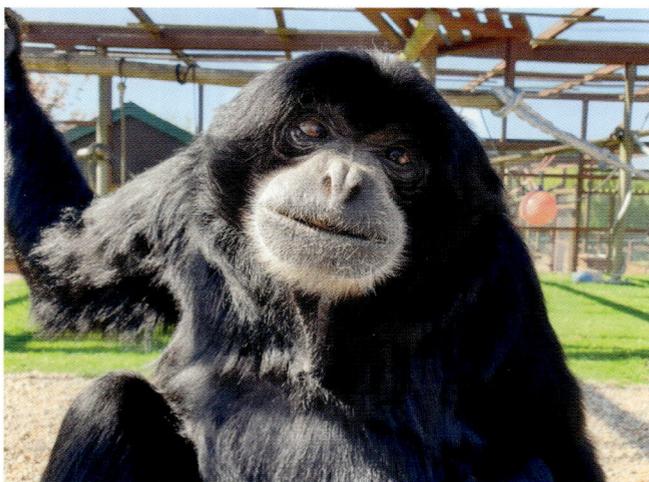

Left: Some of these creatures are real characters, like Xhabu, the siamang gibbon. (Courtesy of Monkey Haven)

Above: Of course, it's not just primates here. These are boobook owls. (Courtesy of Monkey Haven)

Below: There's nothing better than getting face-to-face with the animals. (Author's collection)

24. Museum of Island History

The Museum of Island History can be found in the rather grand Guildhall in Newport. The building, designed and built by John Nash in 1816, was originally constructed to home the market hall, town hall and council chambers, with the imposing clock tower being added in 1888. The 1960s saw its role change, with the inside being converted for use as the island's courts. In the mid-1990s, the courts moved to a new location and this Grade II listed building was then converted into the museum we have today. The museum provides information on all aspects of the islands' history, from the dinosaurs and the Neolithic to the present day. There are a number of touch-screen information points inside, as well as some hands-on activities, and the items on display in the temporary exhibition gallery is changed throughout the year.

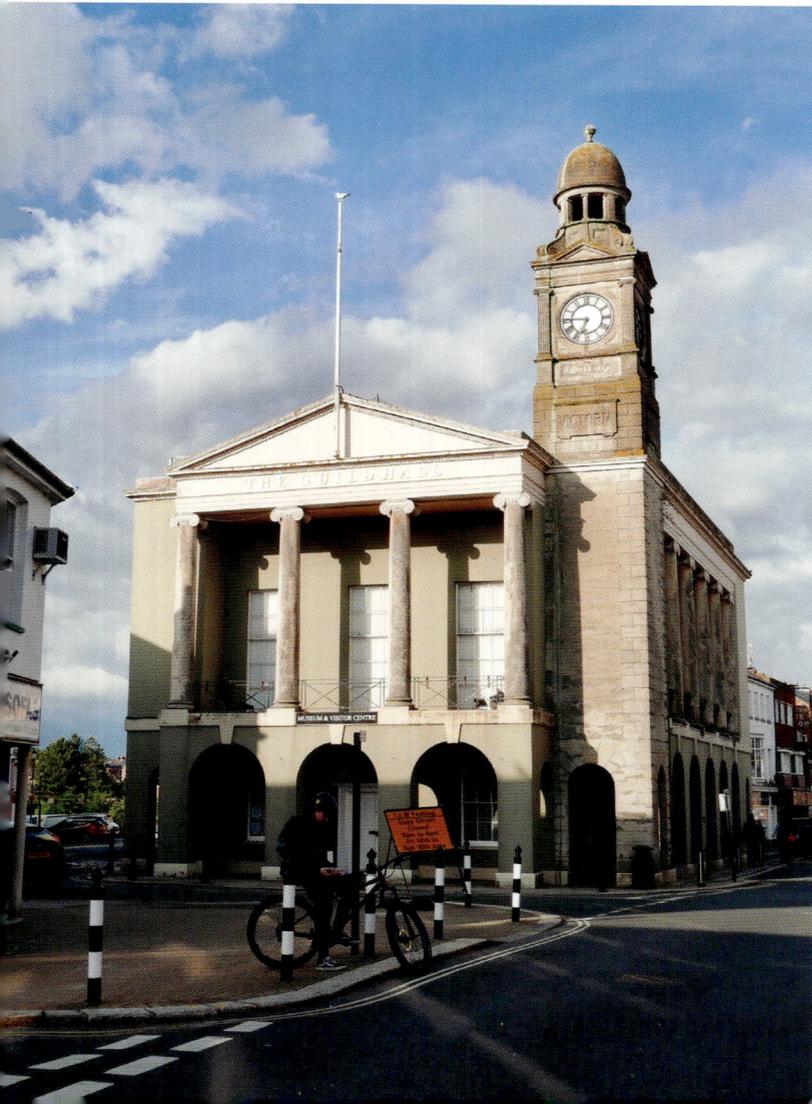

The Museum of Island History is housed within Newport's impressive Guildhall. (Courtesy of John Lord, CC BY 2.0)

25. Newport

Located towards the centre of the island at the head of the River Medina, 25,000 people call Newport home. The discovery of Roman villas within the area clearly suggest that there has been a settlement of some sorts here for at least a few thousand years. The nearby village of Carisbrooke, with its impressive fortress, led to a 1377 attack on the area by the French and although they didn't take the castle, they did

St Thomas' Church in Newport. (Courtesy of Simon Haytack, CC BY-SA 2.0)

attack and burn down much of Newport. The town has an impressive Guildhall, which now houses the Museum of Island History, and Seaclose Park on the east of the town has been the venue for the Isle of Wight Music Festival since 2002. However, this isn't the only event taking place in the town, with Newport Carnival and The Royal Isle of Wight County Show taking place in the summer months. It is worth wandering around the town centre's narrow streets as there are plenty of shops and eateries to explore, notably on High Street, Holyrood Street and Nodehill, whilst St Thomas' Church is the final resting place of Princess Elizabeth, second daughter of King Charles I. The old quay area has had its warehouses redeveloped into a number of new flats and the Quay Arts Centre always has something on.

26. Newport Roman Villa

In March 1926 a local homeowner got more than they bargained for when laying the foundations for a new garage – with the discovery of some intriguing Roman floor tiles. A full excavation of the site was carried out and the ground floor plan for a large Roman villa, believed to be a farmhouse, was uncovered!

Newport Roman Villa. (Public domain)

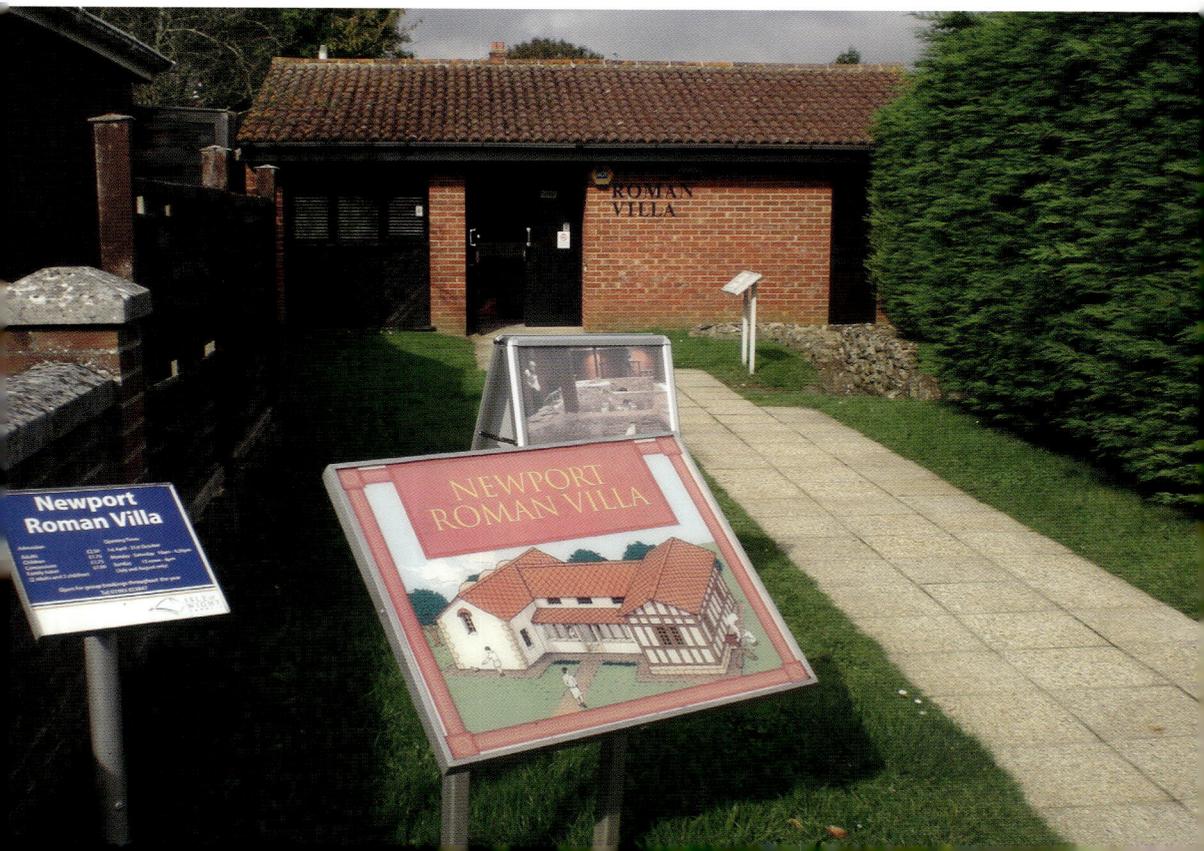

Much of the villa was in very good condition having been buried under the ground for around 1,700 years, with the remnants of some beautiful mosaic flooring and a well-preserved bathing wing complete with the hypocaust (underfloor heating) of the caldarium (a hot plunge bath – often found in large bath complexes) in particularly good shape. Having uncovered such a good condition villa, there was much debate about what to do next in order to preserve it – build a structure over it to help protect the site from the elements whilst allowing visitor access or simply rebury it. Newport Town Council declined to take over the site, but thankfully Alderman Millgate (former Mayor of Newport) purchased the site himself and erected a cover building. After his death, his family offered the structure to local authorities, with the Isle of Wight County Council taking responsibility for the villa in 1961.

Archaeologists date the villa to approximately AD 280 and believe that it was very likely the focal point of a large and wealthy estate – thanks in no small part to the mosaics uncovered and the hypocaust underfloor heating that has been found. The remains of some painted plaster walls suggest that some of the rooms were brightly decorated and fragments of glass discovered on the site indicate that there were at least some glazed windows. The excavations in the 1920s understandably focused on the villa remains, without fully excavating the surrounding area, which would have probably had various barns, storehouses and granaries – maybe even stables. Any full evidence for these lies under the residential housing development. Why the villa became vacant is open for debate.

The hypocaust of the caldarium. (Courtesy of Jamie Heath, CC BY-SA 2.0)

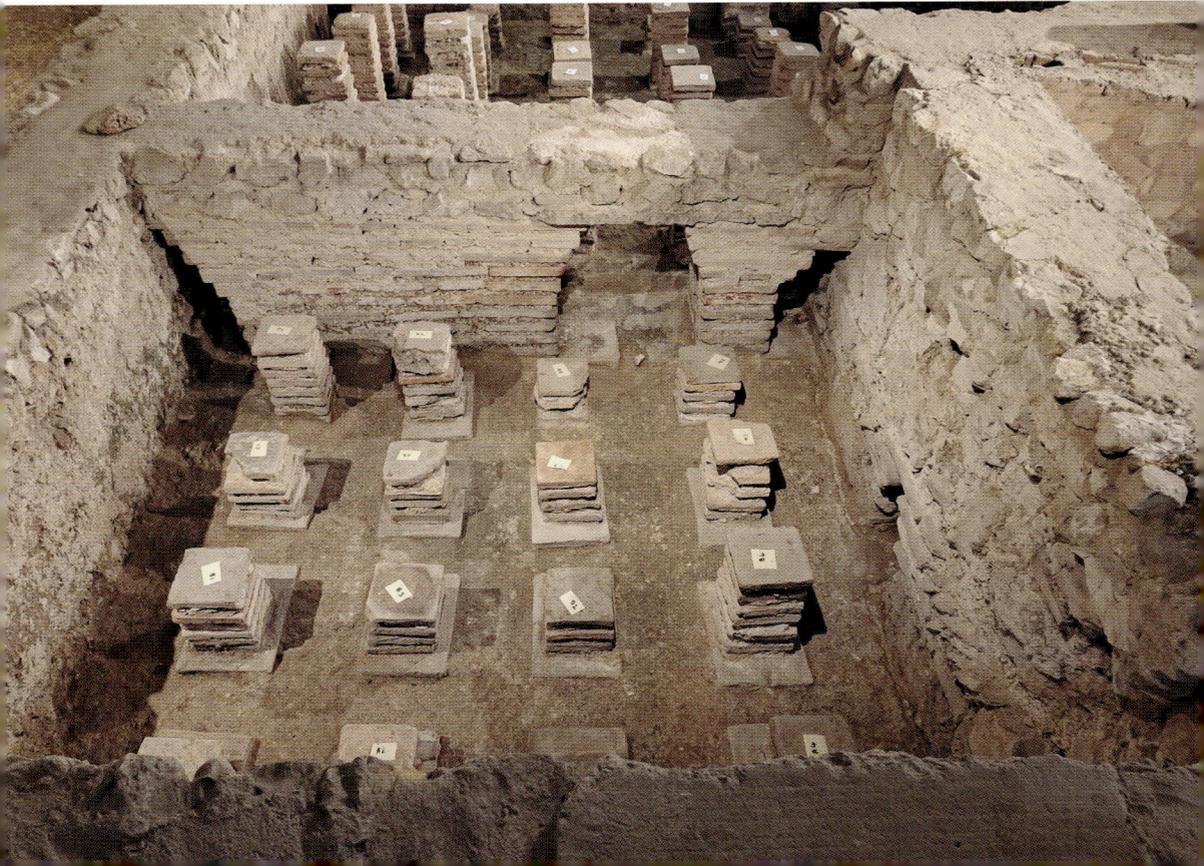

A skull of a woman was found in one of the rooms, leading some to hypothesise it was because of Anglo-Saxon raiders, whilst others think economic difficulties led to the abandonment of the site.

Now a protected Scheduled Ancient Monument, parts of the villa today have been reconstructed in order to help show what it would have been like in its day, with preparations for a Roman feast on display in the kitchen and a Roman herb garden being the two main features. Finds from the site are on display, with nails, coins, marbles and bracelets amongst them, and there is photo-hunt challenge and other activities enabling children to be fully engaged with the site.

Whatever your age, there is something fascinating about the Romans, and the villa at Newport is a wonderful example of life 2,000 years ago.

27. Nunwell House & Gardens

The Grade II listed Nunwell House can trace its roots all the way back to before the Norman Conquest of 1066. Located just outside the village of Brading in the east of the island, it has been associated with the Oglander family since at least the beginning of the fourteenth century, and has been a family home since 1522. Set in

Nunwell House. (Courtesy of Jo Turner, CC BY-SA 2.0)

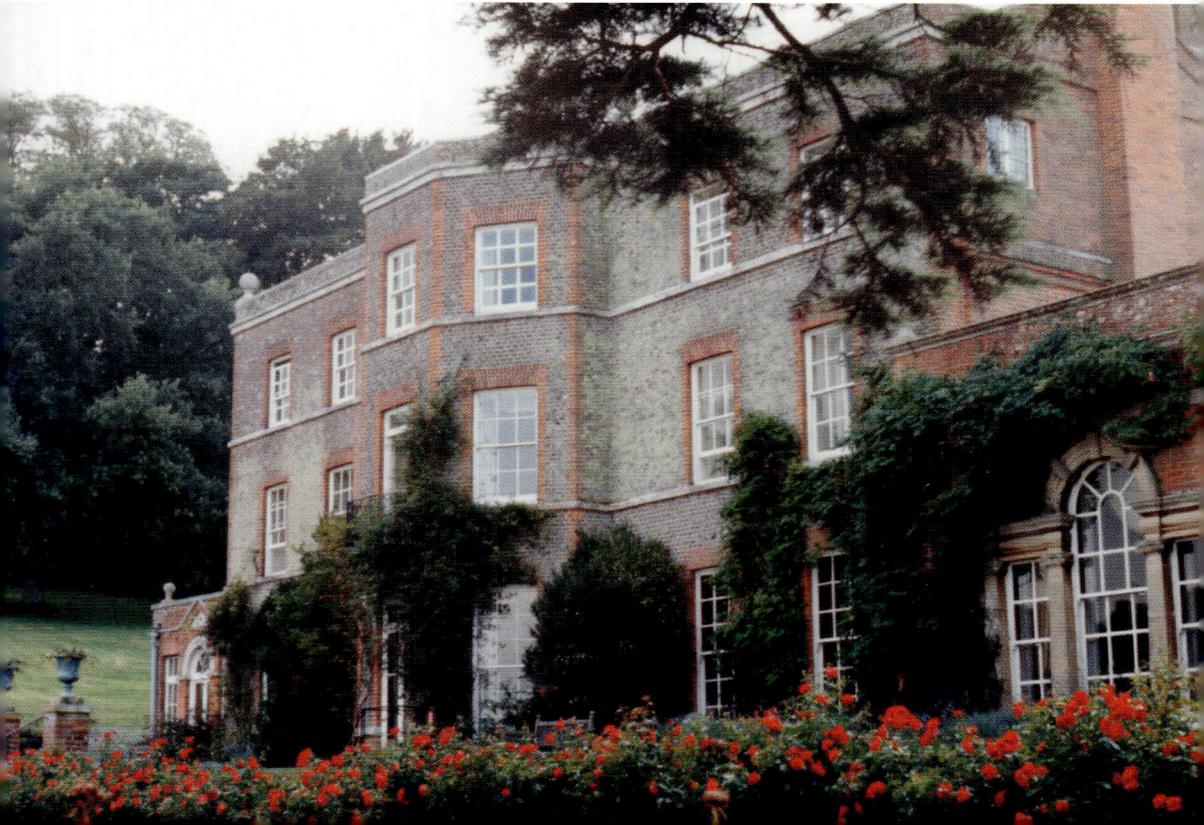

over 5 acres of gardens and woodland, it has some wonderful views stretching for miles, and even out to the Solent. It is the current owner's family home, although the gardens are open a few times a year, and it is possible to organise a group visit or even host a wedding or other function there.

28. Old Church of St Lawrence

Although rather small, the thirteenth-century Old Church of St Lawrence is incredibly picturesque. Situated on the south of the island, the original simple rectangular building had a chancel added in 1842 and inside there are features from various different periods of time – one of the oldest being a painted royal coat of arms on the west wall dating from 1663! A few hundred metres away is its successor church, constructed during the Victorian era, but it seems no one really wanted to remove this little old church. In fact, it was refurbished in the 1920s and it still has its nineteenth-century pews and hat pegs.

St Lawrence Old Church. (Courtesy of ITookSomePhotos, CC BY-SA 4.0)

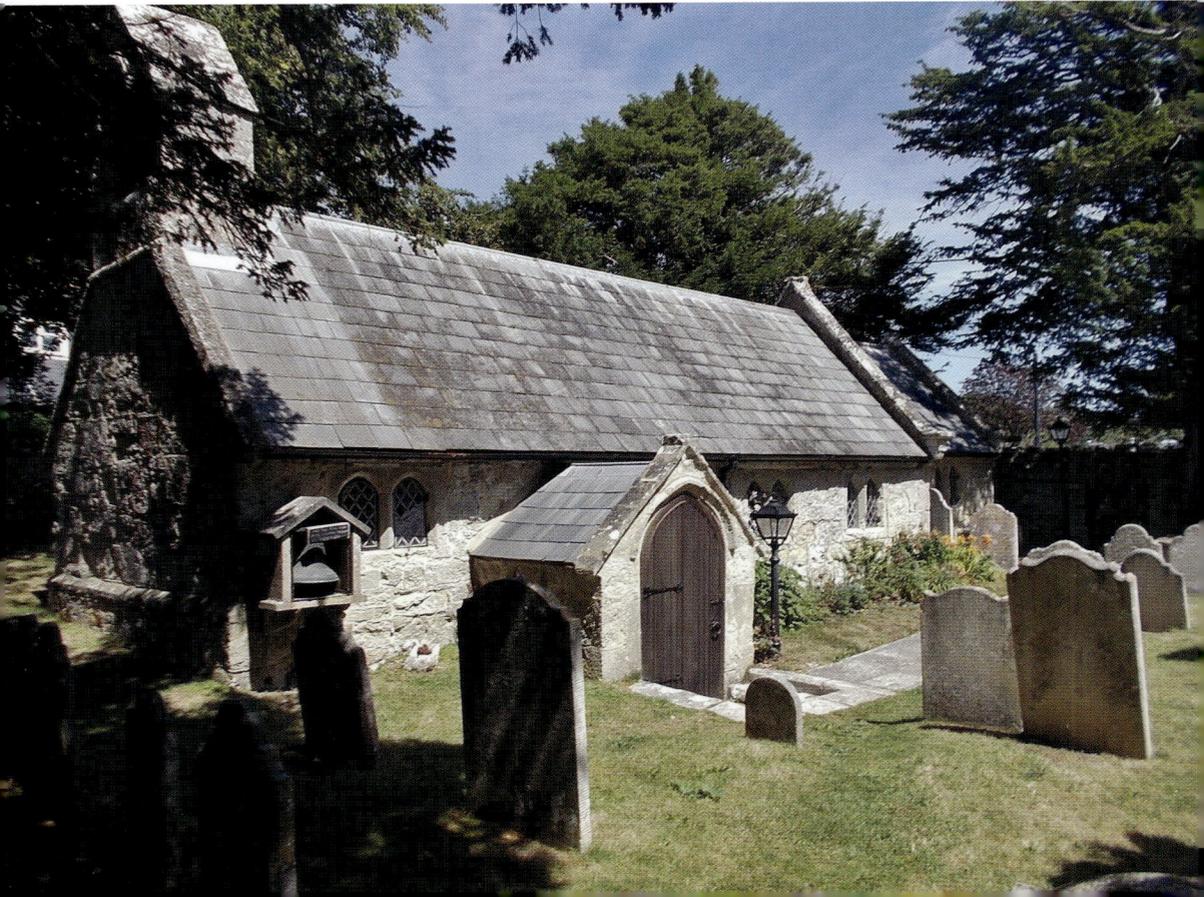

29. Osborne House

Regardless of how much time you are spending on the Isle of Wight, Osborne House, the summer residence of Queen Victoria, is a must-see destination.

In 1845, Queen Victoria and Prince Albert purchased the Osborne estate with the aim of creating somewhere they could escape to, away from the hustle and bustle of Buckingham Palace and Windsor Castle. The Osborne House they bought was a brick and stone three-storey dwelling, and Prince Albert was heavily involved in all aspects of designing and creating of their new estate, with London builder Thomas Cubitt supervising much of the work. What they created was a rather spectacular mix of royal residence and family home.

The Italianate design and construction of the main building gave it a Mediterranean feel – and this style was subsequently copied across the British Empire at the time, such as Government House in Melbourne, Australia. The internal rooms reflected the tastes of the royal couple and the influence of the Empire can be seen in the furnishings and artwork. As you walk around these rooms they have a strange feel of official and grandiose; and yet homely and intimate.

The steps into the house take you to the Household Wing and Main Wing. Linked by the Grand Corridor, which has copies of friezes from the Parthenon and numerous statues along its length, it leads you to the Council Room – the very place where Queen Victoria gave Prince Albert his title of Prince Consort in 1857. Here, Queen Victoria's privy council met a few times a year, and the room was also used for entertaining guests. The Grand Corridor makes its way to the Pavilion, where the Dining Room, Drawing Room and Billiard Room are located. These are all beautifully decorated, as you might expect for rooms that received dignitaries and friends alike, and your eyes are taken by the cut-glass chandeliers and, in particular, the yellow damask furniture and curtains. These features are striking, but as you look closer around the room you can spot more personal items on display.

Above these rooms are the private quarters. The first floor has Queen Victoria's dressing room, along with Prince Albert's dressing room and bathroom. The main room here is the sitting room, full of portraits of her family, and this has stunning views out over the terraced gardens and the Solent beyond. The focal point of the room is two adjoining desks, where Queen Victoria and the Prince Consort worked daily on the numerous dispatch boxes that would have arrived from London. When standing in this room, with the sun pouring in through the windows and with the blue of the Solent beyond, you can only the imagine the kind of decisions that were made here. Queen Victoria's bedroom is also on this floor and it is here that she died on 22 January 1901. After her death her son and successor, King Edward VII, had an iron gate installed at the entrance to the bedroom, with access restricted to members of the royal family, and it was only in 1955 that Queen Elizabeth II gave permission for this room and private apartments to be opened to the general public. On the second floor is the nursery bedroom and sitting room, which provide a glimpse of what life was like for Queen Victoria's nine children when they stayed here.

As well as the rooms of the main building, Prince Albert became occupied with almost every aspect of the large 1,500-acre estate. He made himself busy designing

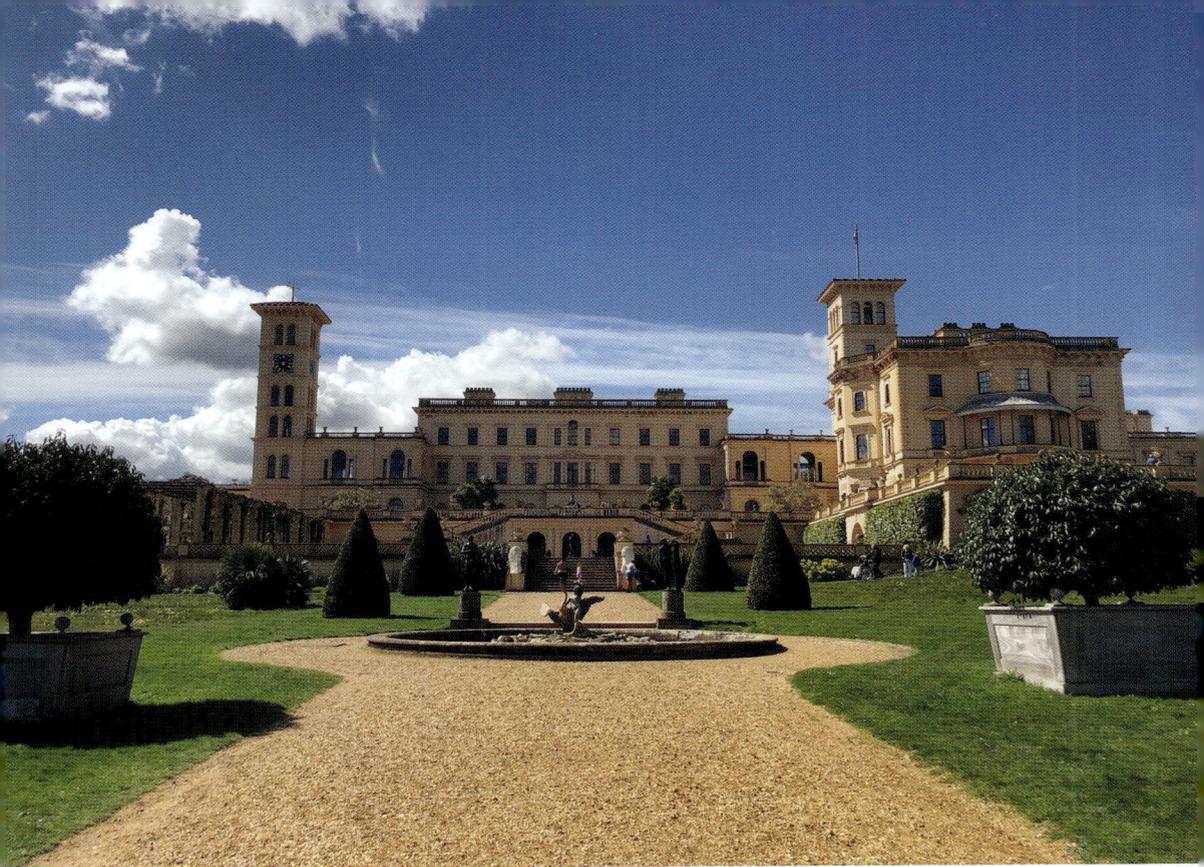

The spectacular Osborne House. (Author's collection with permission from the Royal Collection Trust and English Heritage)

the planting and woodland arrangements in the grounds, as well as the numerous driveways and paths that crossed them. He even installed a circular carriageway that ran along the edge of the perimeter, which the couple are known to have used regularly. It must have taken a lot of planning and an awful lot of hard work to establish the terraced gardens, with significant earthworks being needed to prepare the ground, but standing in them today, looking down towards the Solent, it is a sight to behold. Statues, walkways, bedding plants and the soft trickle of water fountains make this a wonderful place. Perfect for a bite to eat or to simply stop and rest, you can envisage the royal couple and their children making the most of the beautiful surroundings.

As the building developed, nearby Barton Manor was purchased, with its 500 acres to act as a home farm to help keep the royal estate supplied – particularly when the queen and her large entourage were staying.

And stay they did. Queen Victoria used Osborne House for over fifty years – both as an official residence to meet and entertain foreign dignitaries, and to spend time with her family. The queen and her family soon established a regular set of visits right across the year – enjoying the fresh air, walking and riding in the grounds, all at a casual pace that was simply unachievable when staying in Buckingham Palace or Windsor Castle. This relaxed atmosphere probably allowed Victoria and Albert to spend more time with their children, whilst still being able to undertake their royal duties.

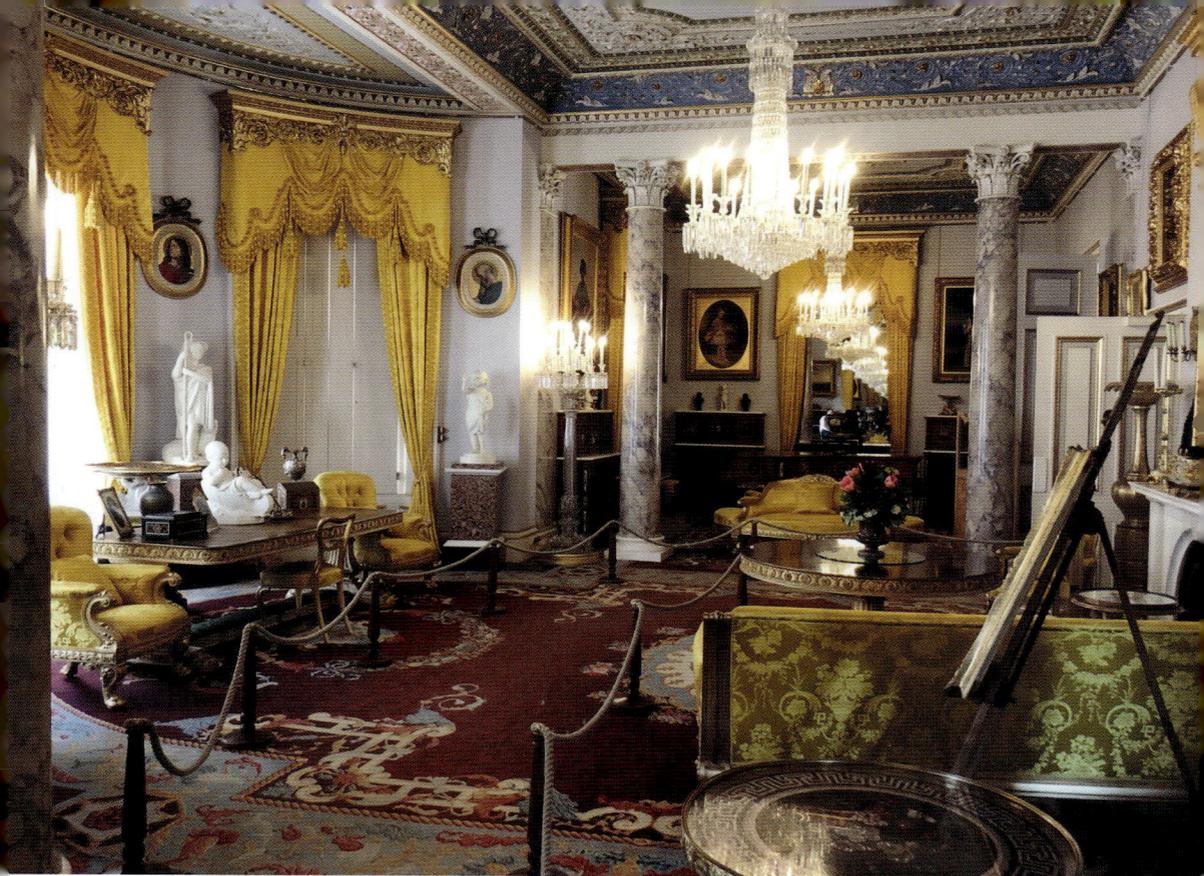

When Prince Albert died in 1961, Queen Victoria aimed to continue running Osborne House as he would have done. However, things didn't stand still, and the completion of the Indian-themed Durbar Room in the 1890s was in keeping with her title of 'Empress of India' and personal interest of the country. It is a large and spectacular room, with an ornate ceiling, countless gifts from the sub-continent, and a truly massive dining table!

Knowing that Queen Victoria spent so much time here simply adds to the intrigue and allure of visiting Osborne House. The fact you are walking the same rooms as corridors as Queen Victoria, when Britain's empire was at its height, is a thought-provoking experience. The mixture of official royal residence and family home is fascinating, and with countless walks across the grounds and down to the private beach available to discover, as well as the internal rooms, it is easily possible to spend an entire day here and still not see everything.

Osborne House is not only a gem of the Isle of Wight, but also of the country.

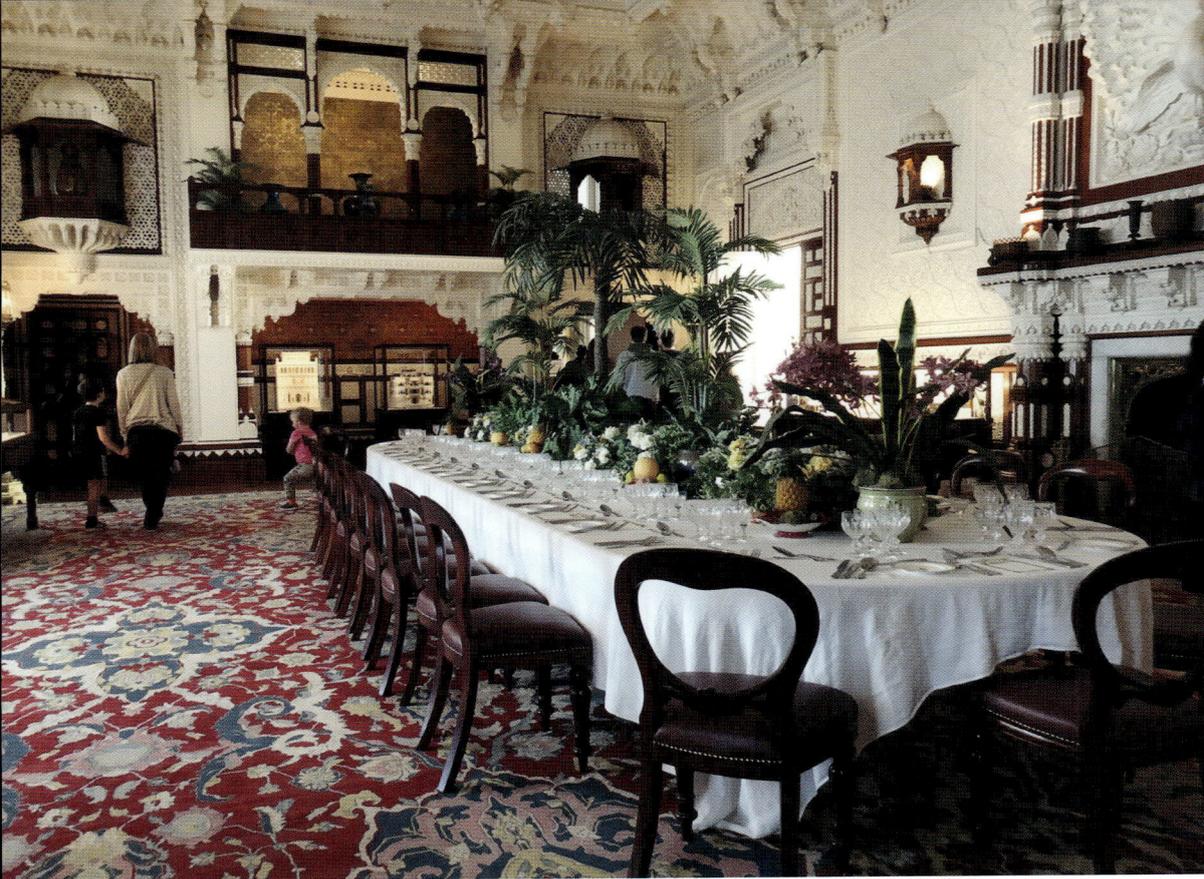

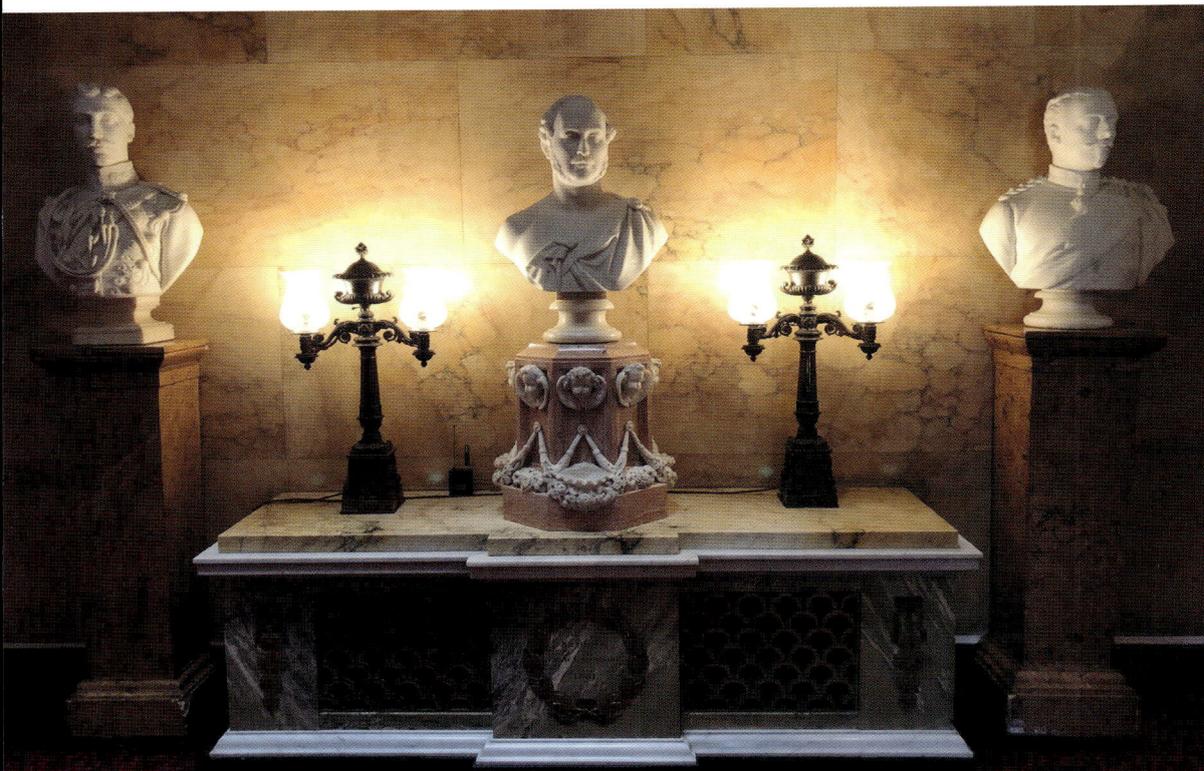

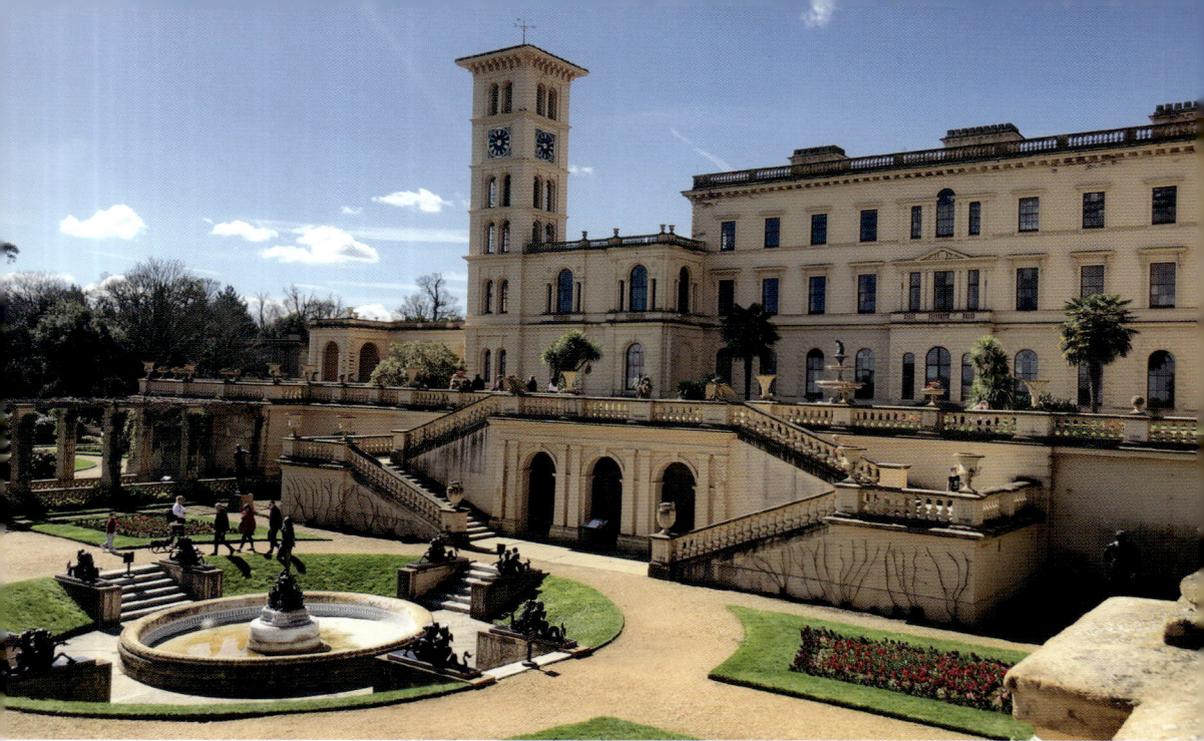

Above: The Andromeda fountain and terraces. (Author's collection with permission from the Royal Collection Trust and English Heritage)

Below: The Swiss Cottage Museum – located in the grounds. (Author's collection with permission from the Royal Collection Trust and English Heritage)

30. Quarr Abbey

The Grade I listed Quarr Abbey sits between Binstead and Fishbourne, with views right across the Solent, on the north-east of the island. The site can trace its history back to 1132, when St Mary's Abbey was built here as part of the Cistercian Order. In the 400 years that followed it became a rather prosperous estate, which led to a wall, seaward gate and portcullis being built to help protect it from attack.

Like all historic religious buildings, the Dissolution of the Monasteries had a huge impact. In 1536, the estate was sold off and the abbey building was torn down – its stone being used in local building projects right across the Isle of Wight, including Quarr Abbey House. It wasn't until over 300 years later that the site regained its religious connections.

A community from the Benedictine Solesmes Abbey in France sought refuge in England, with initially Appuldurcombe House and then Quarr Abbey House being used by them. The building of a new abbey church was completed in 1912 – and these are the buildings we see today. The Belgian brick pointed towers were completed in under two years and certainly stand out amongst the countryside. The Solesmes community left, leaving it to become an independent abbey in 1937, and today Quarr Abbey is home to a small group of Benedictine monks, who split their time between prayer, working on the farm and community life.

The majestic Quarr Abbey overlooking the Solent. (Courtesy of Meridian3.co.uk)

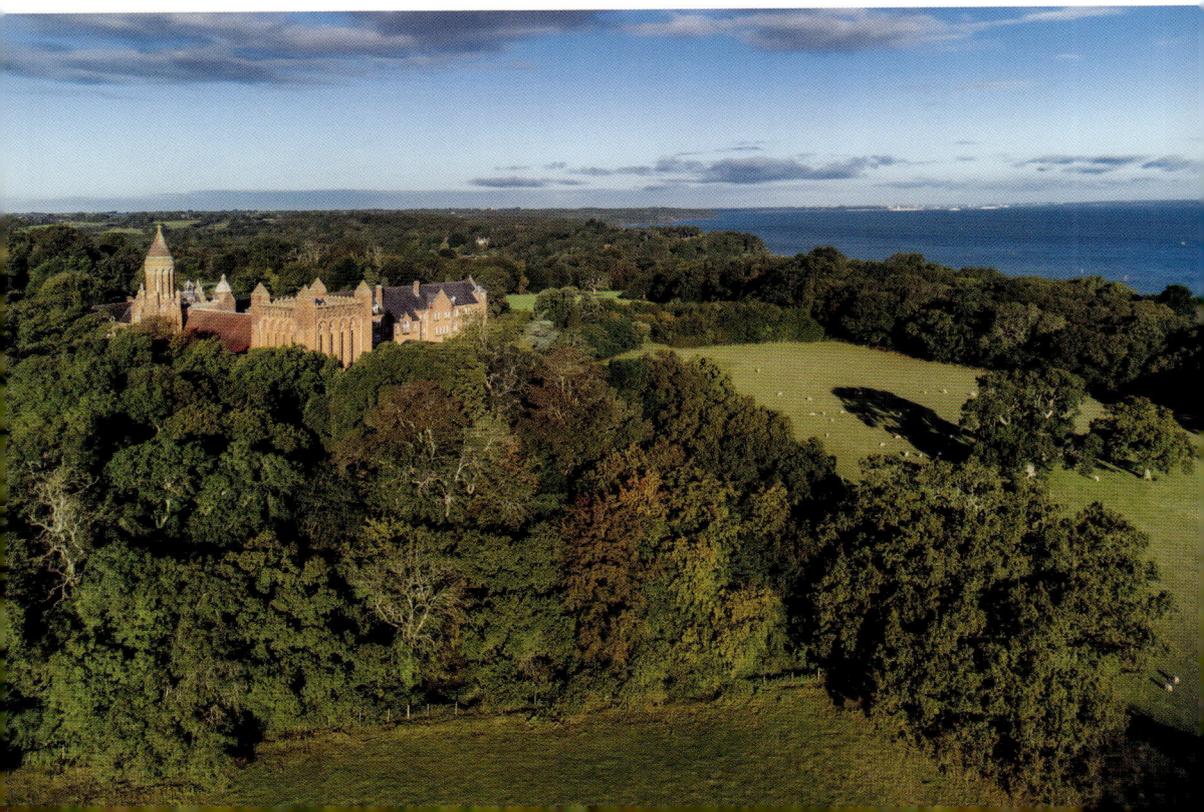

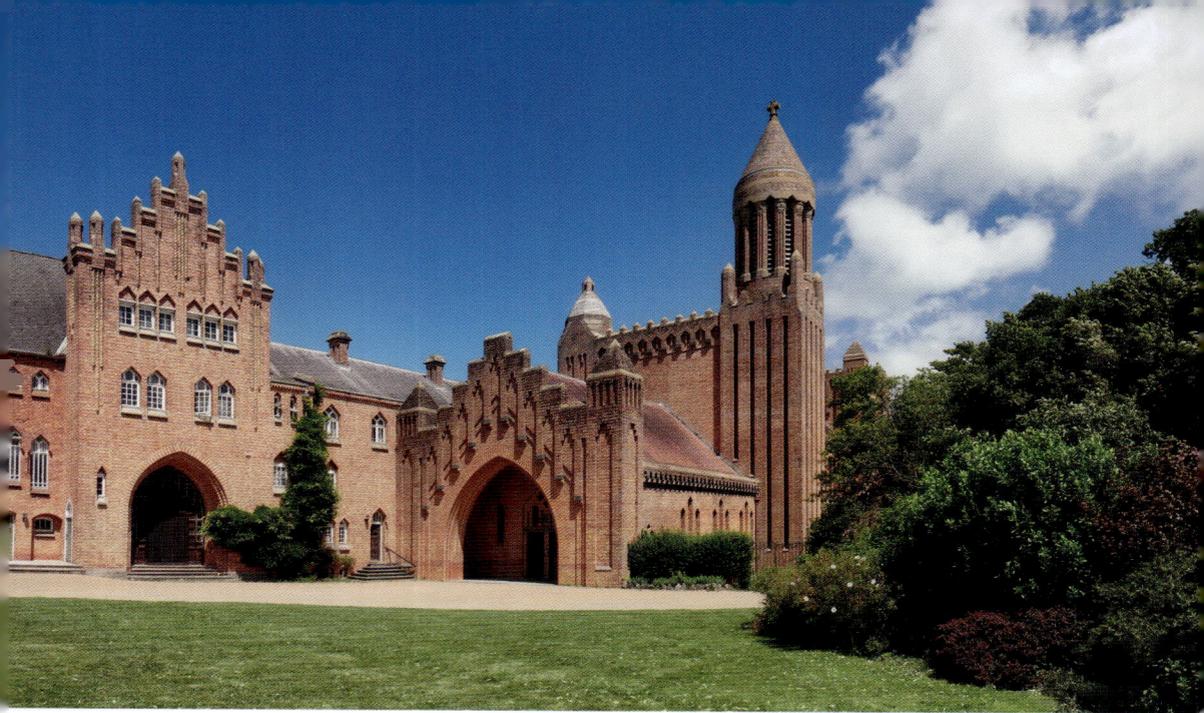

Above: The main façade, built in 1912. (Courtesy of Meridian3.co.uk)

Below: The immaculate interior. (Courtesy of Meridian3.co.uk)

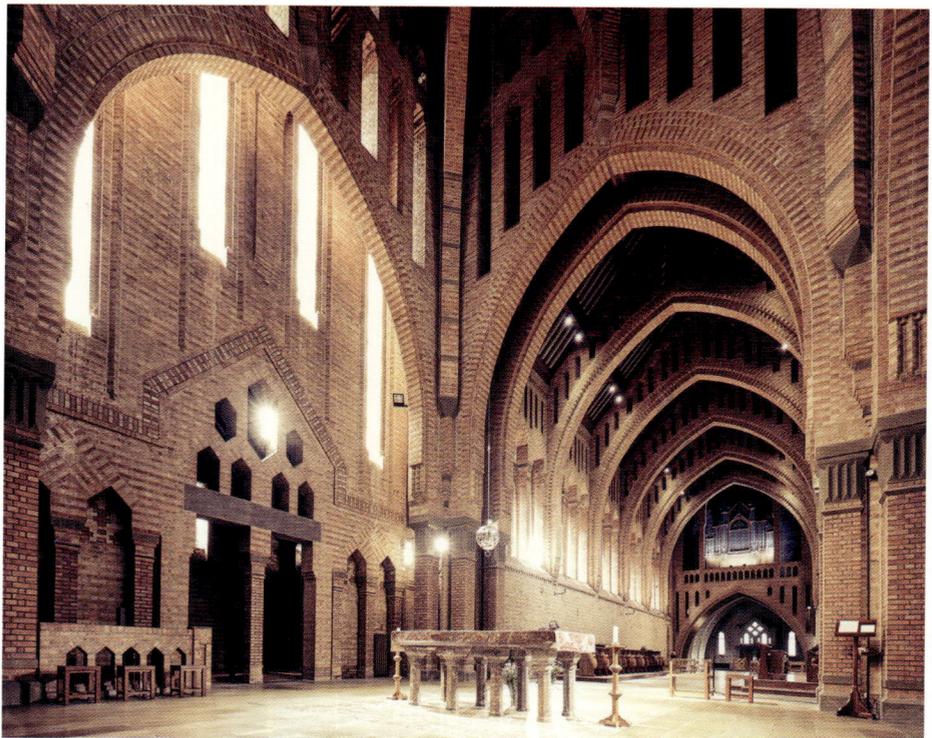

Entry to the grounds is free and as the abbey is in an Area of Outstanding Natural Beauty, there is plenty to explore. The peace and tranquillity felt here is quite powerful, but it is the incredible architecture of the buildings that cannot fail to impress, with the size of the refectory; the amazing arched ceilings and the imposing towers all making their presence felt. It is important to remember that this is still an active religious site, and visitors are welcome to attend worship in the Abbey Church. A tea shop offers refreshments and the visitor centre helps explain the history and the heritage of this beautiful building.

31. Robin Hill

Covering over 85 acres on the outskirts of Newport, Robin Hill Country Park was opened in 1971 and has everything you need for a fun day out for all the family. Open all year round, there are a few main attractions which are then complemented by a whole range of other activities.

There is a long quarter-mile downhill toboggan run that is worth the climb up the steps and a swinging galleon boat ride for those seeking an adrenaline rush. For those after something a little more leisurely, there is the 'Cow Express' train ride

There's plenty to keep the children entertained at Robin Hill Country Park. (Author's collection)

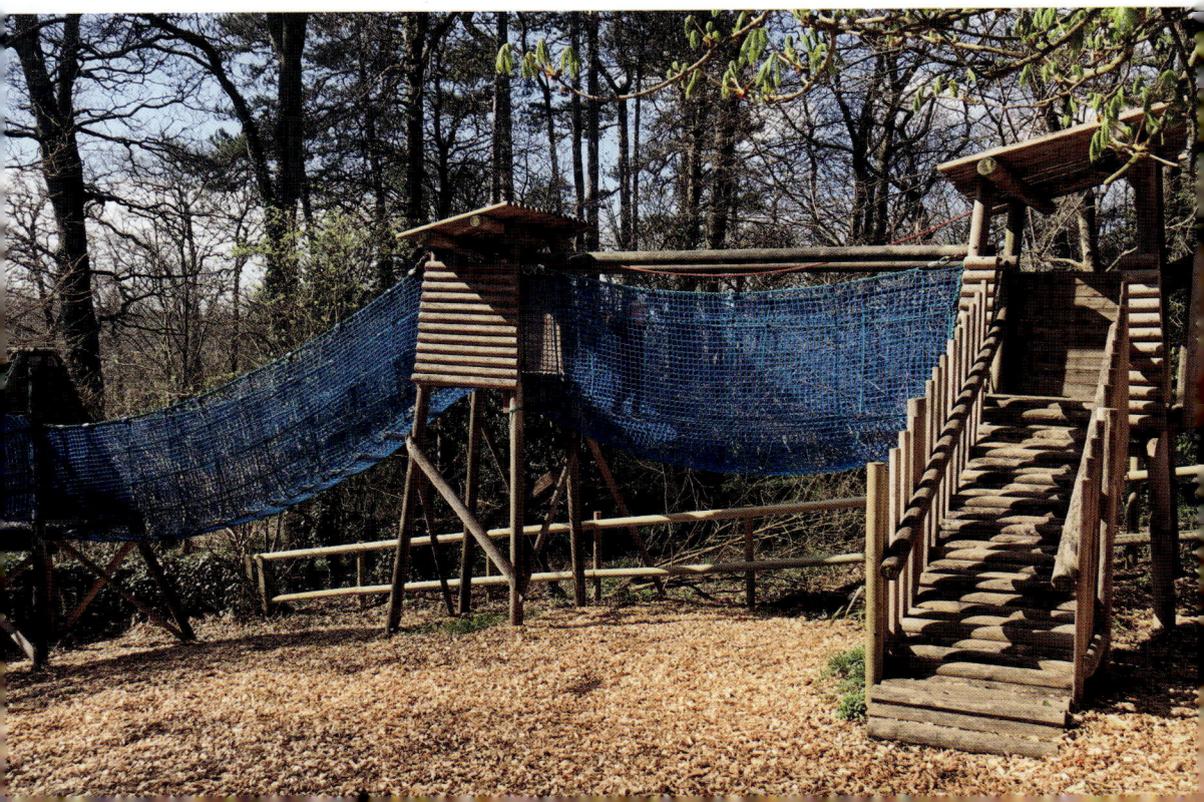

and a 4D Motion Cinema, which can get busy during inclement weather. A wooden maze is made all the more exciting with some water features that switch on and off – trying to get around without getting wet is great fun, especially when it goes wrong! A particular favourite of many is the canopy skywalk and tree-top trail that allows children (and adults!) to walk amongst the tree canopy courtesy of bridges and large nets some 10 metres above the ground – there is a great sense of anticipation as you ascend 'Squirrel Tower' to get to the skywalk. Like all good parks there are plenty of play grounds, with the 'African Adventure' offering an African village theme, and a 20-metre water pillow that is hilarious to walk on.

However, it's not only activities on offer here. Owing to the size of the grounds there are a number of nature walks available and throughout the different seasons, there are always different species of wildlife just waiting to be spotted – the red squirrel is a year round favourite. Robin Hill also offers a bit of history too, with the remains of Combley Roman Villa being on site, along with a small Roman exhibition that provides you with information. Carp Quay offers a moment of calm in the excitement and with plenty of picnic areas and eateries, a fun day out is assured. The park has also been known to host different events throughout the year.

Sadly, at the time of writing, the parent company who owns Robin Hill, as well as Blackgang Chine, has put the country park up for sale. We can only hope that this fantastic day out is preserved for the future.

Take a walk through the trees with the Canopy Skywalk. (Author's collection)

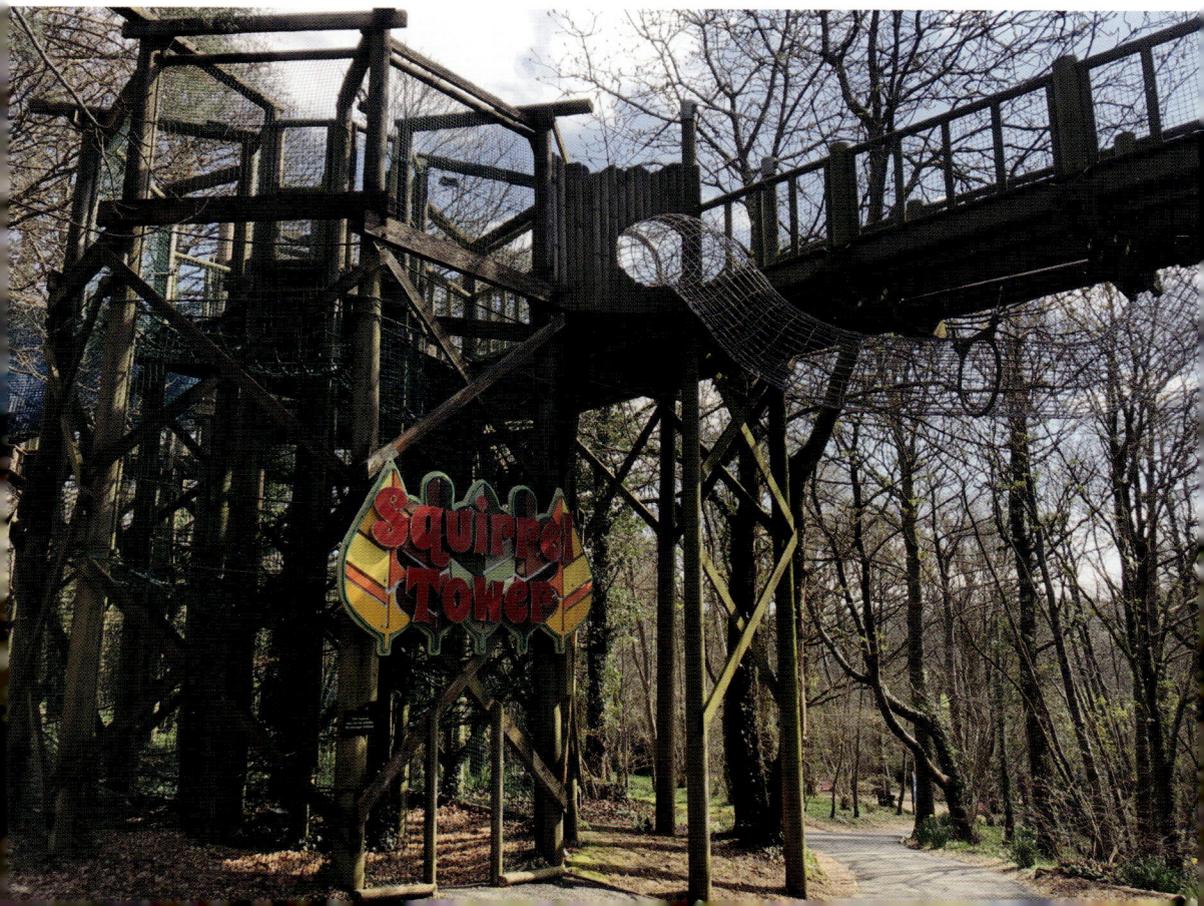

Above: The tranquil Carp Quay. (Author's collection)

Right: There are numerous walks to explore in the woods. (Author's collection)

32. Round Barrows

It's not surprising, due to its location and all the evidence of the dinosaurs having once roamed here, that the Isle of Wight has a lot of signs that Neolithic man once lived here. Numerous Bronze Age weaponry and artefacts have been found over the years, along with some animal and human bone fragments, with most being found in or near ancient round barrows. These were rather rudimentary in their design, with a mound of earth often being surrounded by a narrow ditch. Over 300 of these have been identified and recorded on the Isle of Wight, but sadly many are no longer visible, having been destroyed over the years by man or mother nature. However, there are a few barrows still within the rolling Brook Down landscape. They are not that easy to spot, owing to their age and the changing landscape over thousands of years, but they are there, as were our ancestors, all that time ago.

Over 300 round barrows have been discovered on the Isle of Wight. (Courtesy of Amanda Slater, CC BY-SA 2.0)

33. Ryde

On the north-east coast of the Isle of Wight, Ryde has the largest population of all the island's towns, with around 25,000 people living here. Modern-day Ryde is actually the result of two smaller villages, Upper Ryde and Lower Ryde, merging together as the area saw significant growth during the seaside tourism boom of the nineteenth century.

The town benefits from a large esplanade that stretches right along the vast beach. As train travel developed in the Victorian era, so did the number of people wishing to holiday, and thus Ryde grew and expanded. It's easy to see why they came – with miles of golden sand seemingly stretching on in all directions. The town capitalised on this, building an additional pier and extending the one it already had, as well as developing the seafront esplanade, which featured numerous entertainment activities and stalls. The Victorian Tramway Pier has sadly since gone, but Ryde Pier has the claim of being the oldest pleasure pier in the world! Stretching for over 650 metres, it was originally built in 1814, and has seen many alterations and improvements over the years. In 1895 a concert pavilion was built at the pier head, but this was later demolished. However, a road was put along the pier and a railway track, with a railway station at the pier head, in order to connect the town with a small ferry service to Portsmouth on the mainland – and these exist today, currently serviced by catamaran.

As well as those coming on a week-long holiday, the town saw a significant increase in the number of visitors arriving on day trips, especially in the post-Second

Opened in 1814, Ryde Pier is the oldest pleasure pier in the world. (Courtesy of John K Thorne PDM 1.0)

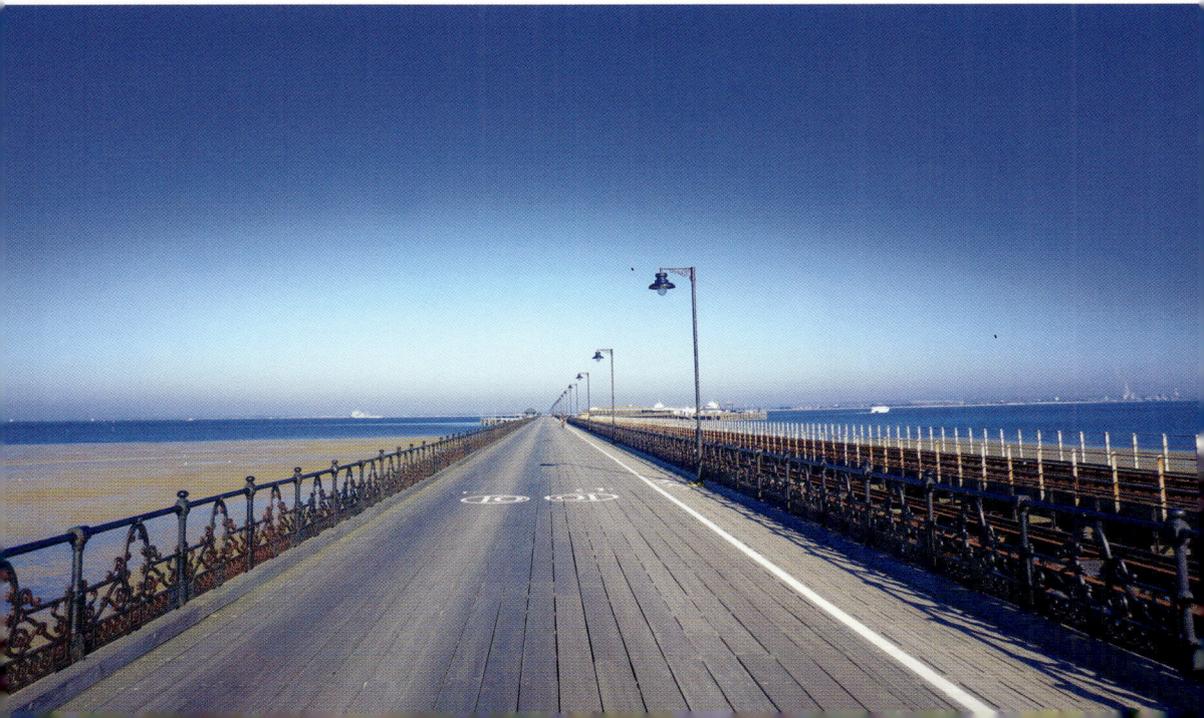

World War era. This has been actively encouraged, with the unusual hovercraft ferry service linking the town to Southsea in under ten minutes!

There are many Victorian-style buildings in the town and some interesting links to British rock royalty. The Rolling Stones once played at the town's Pavilion, and Sir Paul McCartney has said The Beatles hit song 'Ticket to Ride' was so called after a 'British Railways ticket to Ryde' in the early sixties! Ryde is also the host to the Isle of Wight Classic Car Show and Ryde Carnival, which is one of the oldest in the country.

The seafront is still the town's main draw, with the pier, beautiful beach, arcade and various eateries making Ryde worth visiting.

34. Sandham Gardens

Sandham Gardens is a theme park located right next to the beach at Sandown, on the south-east of the island. They stand on the site of what was the seventeenth-century Sandham Fort – built to help protect this stretch of land from a French or Spanish attack and had far-reaching views out to sea, but no trace of this earlier building remains. The gardens themselves are free to enter, but there are lots of additional

Sandham Gardens. (Public domain)

activities to keep the whole family entertained. In keeping with the dinosaur theme that runs across the whole island, there is a prehistoric golf adventure suitable for all – with life-size dinosaurs, volcanoes, bridges and waterfalls. The four Skynets around a central treehouse allow children and adults to bounce their way around towards three well-positioned slides. There is also an electric-powered 150-metre karting track that provides a high-octane thrill for those aged four and over. It is a well-located place, as just across the road from Sandham Gardens are the golden sands of Sandown beach, and the fantastic Dinosaur Isle museum.

35. Sandown

Yet another seaside resort town on the Isle of Wight that owes its growth and development to the holiday boom of the Victorian era. Located on the south-east of the island, 11,000 people live here, but if the nearby resort of Shanklin is included, this is nearer to 20,000 people. As the name suggests, there are some lovely sandy beaches here, but that isn't the only natural attraction. At its northern end there are some impressive chalk cliffs, and these form part of the scenic Isle of Wight Coastal Path.

There are around 5 miles of golden sands here, which makes Sandown one of the longest beaches in the country. The chalk cliffs, as well as being picturesque, offer a unique habitat to much flora, fauna and birds who nest there. Nearby is the Sandown Nature Reserve and Sandown Levels, both of which are very popular with birdwatchers.

The development of the railway, and of course Queen Victoria's love of the island, saw the natural splendours of Sandown attract many visitors – the safe bathing afforded by the bay even drawing foreign royalty in the form of the Crown Prince of Germany in the 1870s. The town built a pier in 1878, which was extended in 1895, and taking a stroll along the seafront today, you can just imagine the Punch and Judy shows and ice-cream stalls from its Victorian height. In fact, its popularity continued into the reign of Edward VII, and the architecture on display in Sandown today is a mixture of both these eras.

Sandown Pier is still there, with a large amusement arcade and fishing area providing entertainment alongside the bucket-and-spade-style attraction offered by the sweeping beaches – and it is here that the Sandown Bay Regatta takes place every summer. But there's more, as specific attractions are within easy reach of the town. Sandham Gardens, right along the seafront, is a theme park with karting and golf, whilst the impressive Dinosaur Isle is also overlooking the beach, and tells you everything you need to know about the incredible prehistoric creatures that once roamed across the sand! Then a few hundred metres further along the seafront towards Yaverland is the Wildheart Animal Sanctuary – another place well worth visiting.

Due to the vast expanse of sand here, a number of fortifications were built to protect the island from potential invasion, although sadly these have now mostly gone. Sandham Fort has been replaced by Sandham Gardens and Sandown Fort was where Wildheart Animal Sanctuary now is, leaving just Sandown Barrack Battery in

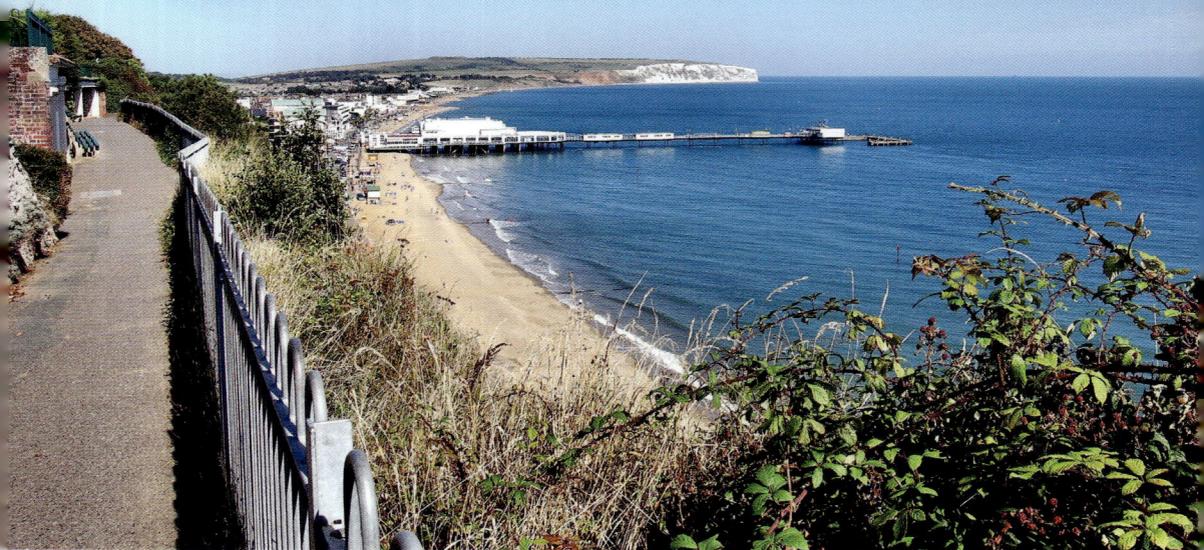

the west and Bembridge Fort in the north-east. Bembridge Fort is now a Scheduled Monument and is maintained by the National Trust, who operate limited tours around the fort at various times in the year, whilst most of the buildings associated with Sandown Barrack Battery have gone – with the site forming Battery Gardens Park. A few buildings do remain, with one of them housing the National Poo Museum – where you can find out everything there is to know about the subject, including coming face to face with a 38-million-year-old poo.

36. Seagrove Beach

The beach at Seagrove is one of the best on the Isle of Wight. Located on the north-east of the island, there are many impressive beach-front properties along this stretch of coast, from Seaview Beach to Priory Bay. Although pebbly near the shoreline, at low tide there is over half-a-mile of golden sand on offer that stretches for as far as the eye can see, and with the bay being quite well sheltered from the winds and waves, this is a popular destination for a day at the beach. As well as the sand, there are a myriad of watersports available too, with boats using the slipway. High tide completely covers the sand so it is well worth checking the tide times before heading here.

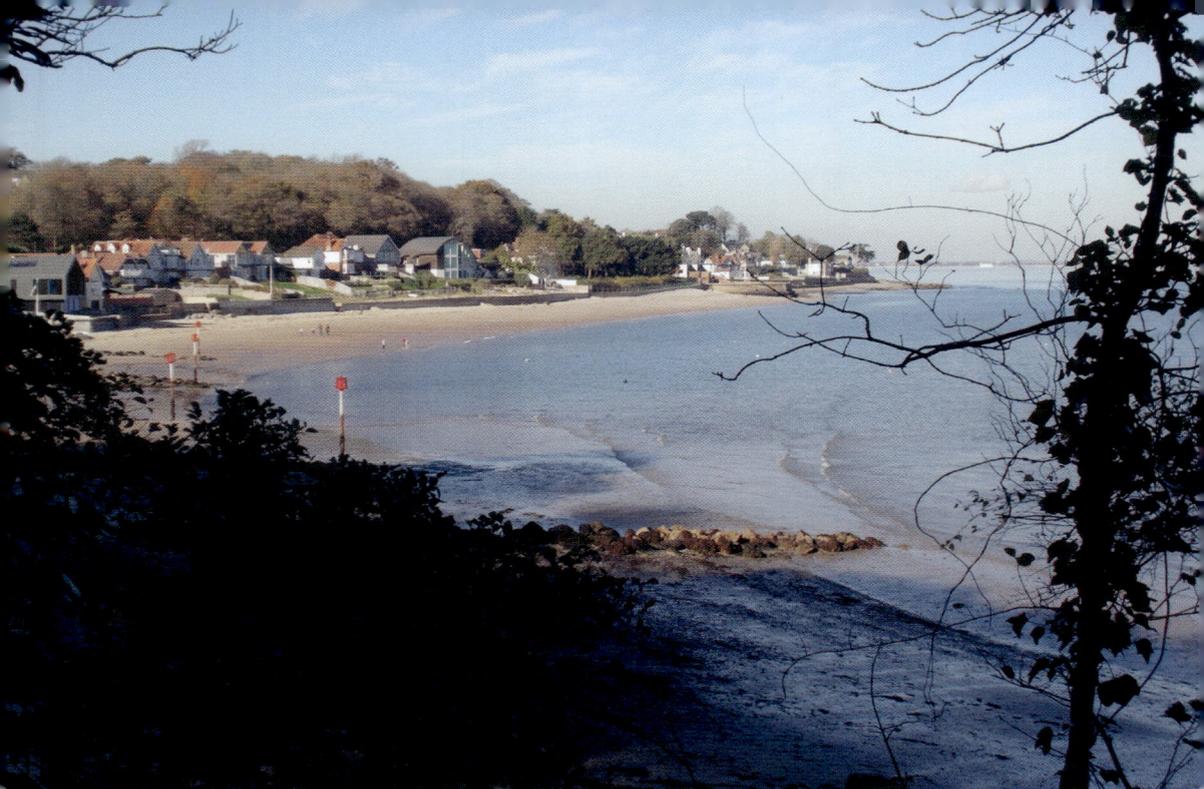

Seagrove Beach. (Courtesy of MyPix, CC BY-SA 4.0)

37. Shanklin

Situated within Sandown Bay, and just to the south-west of Sandown, Shanklin is another Victorian-era seaside resort. Smaller than Sandown, with around 7,000 people living here, Shanklin offers the same stretch of beautiful beach as the other towns within Sandown Bay. Its esplanade has a number of what you would call 'traditional' seaside activities, with play areas, crazy golf, amusement arcades and various stalls and 'knick-knack' shops. Add to that hotels, pubs and eateries and all you need is a pier for a seaside holiday. Shanklin used to have one, built in 1891, but the 1987 storm destroyed it, and sadly the cost of rebuilding has been too much. The Rock Shop offers a whole selection of traditional-style sweets and as the name would suggest, rock! Pirates Cove Fun Park is a more modern-day adventure park along the seafront that features mini go-karts, water zorbing and bouncy castles, amongst others.

Interestingly, there used to be a seaplane hangar along the esplanade, which led to portions of the town's seafront being bombed during the Second World War. But that is not the only wartime connection. 40 Royal Marine Commando used the nearby chine for training purposes and towards the end of the war the chine was again used, this time as the location for the PLUTO petrol pipeline.

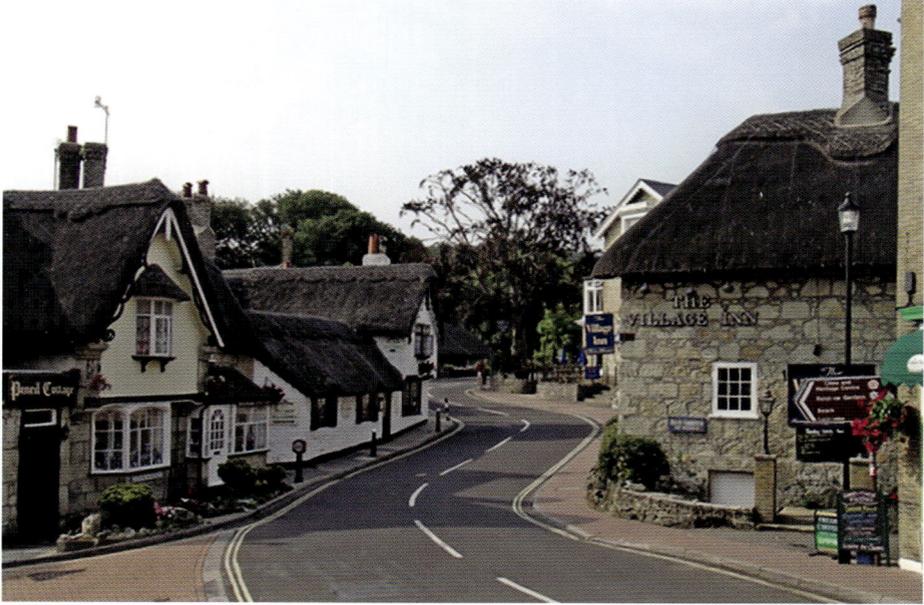

The picture-perfect Shanklin Old Village. (Courtesy of Steven Muster, CC BY-SA 2.0)

Shanklin is proud that Charles Darwin stayed at Norfolk House in 1858 whilst working on the *Origin of Species* and that the poet John Keats lived here. Shanklin Old Village is a glorious step into the past, with small streets and thatched roofs, and it's hard not to enjoy ambling along, stopping into the little gift shops, cafés and restaurants. Just outside of Shanklin is America Wood, owned by the Woodland Trust and a designated Site of Special Scientific Interest, which offers many footpaths to explore in amongst the trees.

Of course, for many, Shanklin will forever be associated with Shanklin Chine. A beautiful tree-lined gorge linking the Old Village to the sandy beaches, Shanklin Chine has been a visitor destination for centuries and was certainly one of the major factors in the area becoming a tourist hotspot over the last 200 years.

38. Shanklin Chine

Shanklin Chine can claim to be the oldest visitor attraction on the island, having officially opened its doors in 1817. For centuries, people have been marvelling at the natural beauty on display here, with the craggy ravine of the chine creating a dramatic landscape that is worth exploring.

The tree-lined gorge stretches from Shanklin Old Village towards the beach and the seafront esplanade, which appear at the end of your descent, a few hundred

metres below. Ten thousand years in the making, the chine has an abundance of wildlife, from plants to animals, and is a proper assault on the senses. The chirping of birds, the rustling of leaves and the sound of water splashing echoes all around as you take each step. The water you can hear is cascading from two waterfalls, one 29 feet above you and the other a staggering 45 feet high – they really are a sight to behold!

In the early eighteenth century, a few hardy souls ventured into the chine, but it wasn't until 1817, when William Colenutt created a path and opened it to the public, that many people were able to head on in and explore. Of course, the secluded nature of the chine means that prior to this it would have been used by smugglers. In fact, a tunnel was dug from the Chine Inn to the Old Village and eventually a Watch House was built for excise officers to stay in, in an effort to stop the trade. Once entry to the chine had been made easier, it drew in the great and the good of Victorian Britain, with Jane Austin, John Keats, Charles Dickins known to have enjoyed the chine. As more tourists came to the island in the late nineteenth and early twentieth centuries, more made their way to Shanklin Chine!

During the Second World War, 40 Commando Royal Marines took over the chine to use as an assault course – the undergrowth, steep sides and nearby beach providing a good range of opportunities for training. Specifically, they trained in preparation for their part in the Dieppe Raid of 1942, and a plaque in their memory of this action can be found here. The chine was also the location for PLUTO (Pipe Line Under The Ocean), where 56,000 gallons of petrol a day were pumped from Shanklin Chine, under the English Channel and into Normandy in the weeks and months that followed D-Day in June 1944. This ensured that the Allied forces were able to receive as much fuel as possible at that critically important time. There is a

Shanklin Chine has been mesmerising visitors for hundreds of years. (Courtesy of Shanklin Chine)

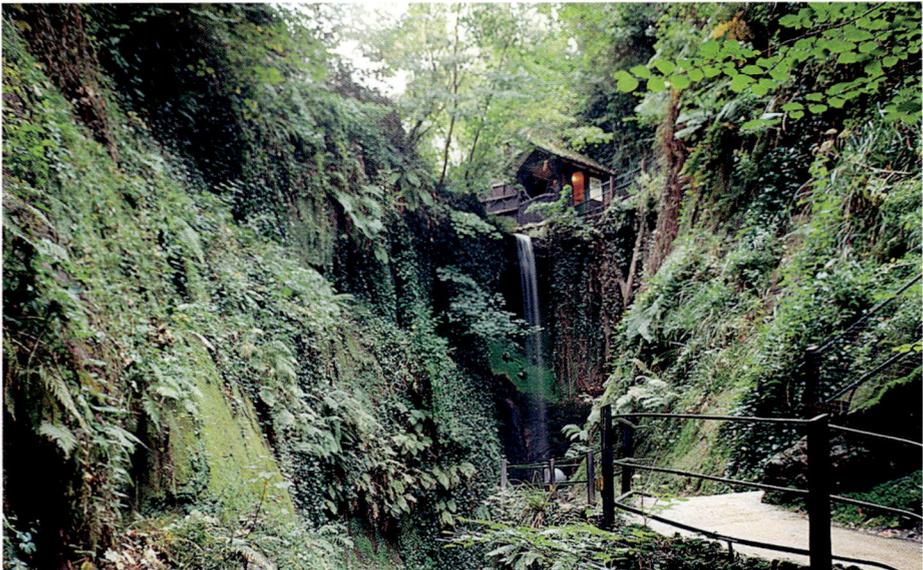

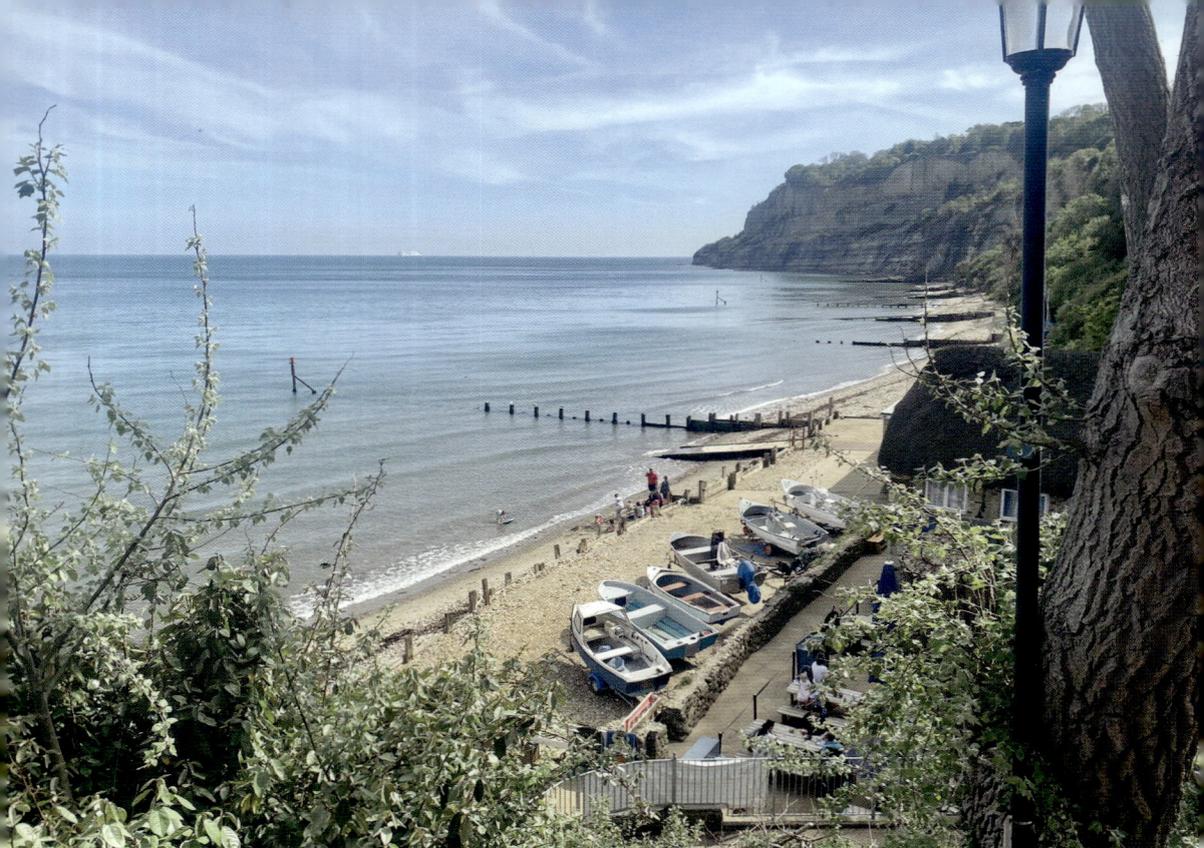

Above: A view down to the beach. (Courtesy of Shanklin Chine)

Left: The PLUTO. (Courtesy of Shanklin Chine)

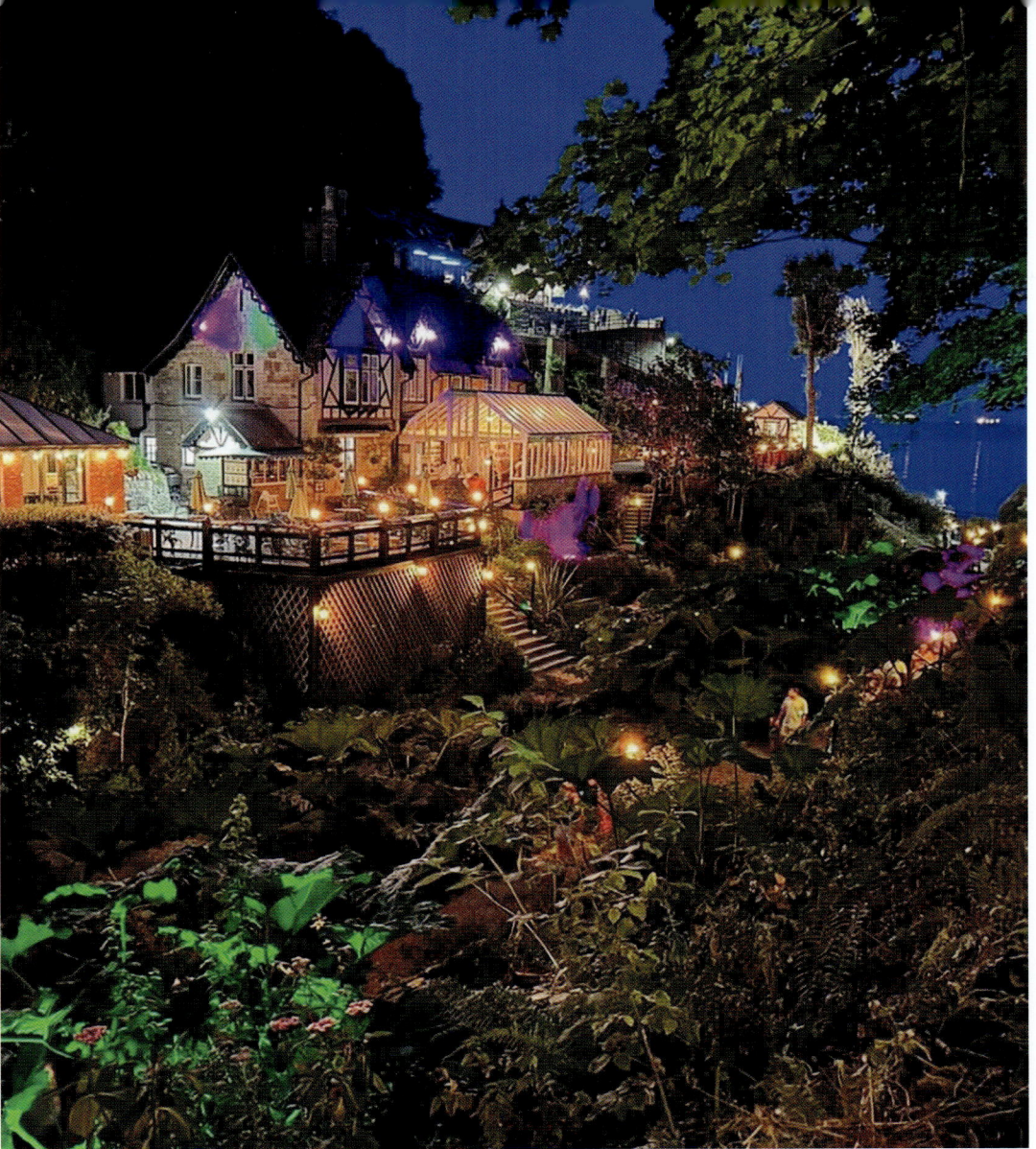

There is nothing quite like exploring the chine at night. (Courtesy of Shanklin Chine)

section of original pipe still in place and the onsite heritage centre, set in the original Chine Lodge, explains this feat more, as well as detailing the growth of Shanklin through the years.

It is one thing to explore the wonderous Shanklin Chine by day, but entirely another to do so by night! At dusk in the summertime, the narrow paths and streams are lit by hundreds of lights and it is impossible not to enjoy the magical experience of the Chine Lumiere. The on-site Victorian-style tearoom and garden is the perfect place to sit down and take in the atmosphere created at such an enchanting place.

39. Shipwreck Centre & Maritime Museum

The Shipwreck Centre and Maritime Museum is located within a craft village in Newport. It hasn't always been here though, as the museum was originally opened privately in 1978 in Bembridge, before moving to its current home in 2006. Now run by the Maritime Archaeology Trust, the museum is one of the largest of its kind in the country.

The vast majority of the artefacts and relics on display here come from the waters around the Isle of Wight itself, and each item from a shipwreck has its own unique story to tell – whether it is from an ancient galleon, a trading vessel or a wartime battleship. Material from First and Second World War submarines are on show, along with telescopes, compasses and cannons from much older vessels. There are a number of incredibly detailed models within the museum too – each taking hours and hours to complete. The history of the island is also touched upon, from prehistoric times and old trading routes to the stories of smuggling and shipwrecks around the island. Over the years the Isle of Wight has had many tragic moments, although none were as big as the SS *Mendi* being sunk in 1917 with the loss of over 640 native South African soldiers. However, not all ended in tragedy. When the

The Shipwreck Centre & Maritime Museum. (Courtesy of Jim Smitheon, CC BY-SA 2.0)

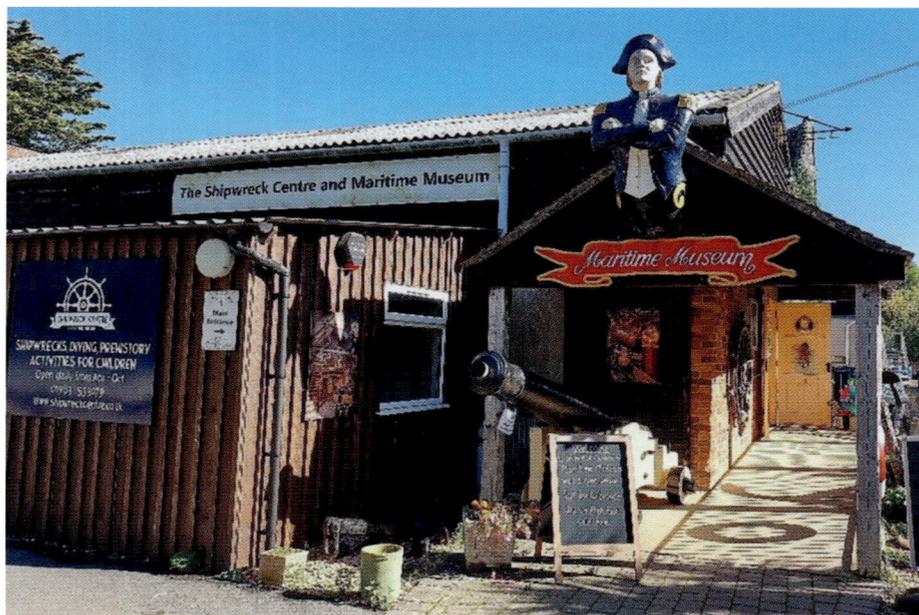

370-foot *Empress Queen* ran aground in 1916, all 110 people were rescued by the Bembridge lifeboat, and the stories of maritime heroism are often breathtaking.

Antique diving equipment is on display along with videos and explanations of more modern techniques, and for the children there are number of interactive trails and quizzes to participate in, allowing them to have fun whilst also appreciating the artefacts on display.

40. St Christopher Wall Painting, St Peter's Church, Shorwell

St Peter's Church, in the village of Shorwell in the south-west of the island, has a rather impressive wall painting of St Christopher that is thought to be over 550 years old. The church was constructed in the Middle Ages and the wall painting is seemingly the oldest remaining part – being around 150 years older than the stone pulpit. The painting seems to depict St Christopher carrying the Christ Child across a river and has been dated at 1470. Shorwell is an extremely charming village, with small roads and thatched roofs helping to explain why this was one of Queen Victoria's favourite places to visit when on the island.

St Peter's Church in Shorwell. (Courtesy of Garry Knight, CC BY 2.0)

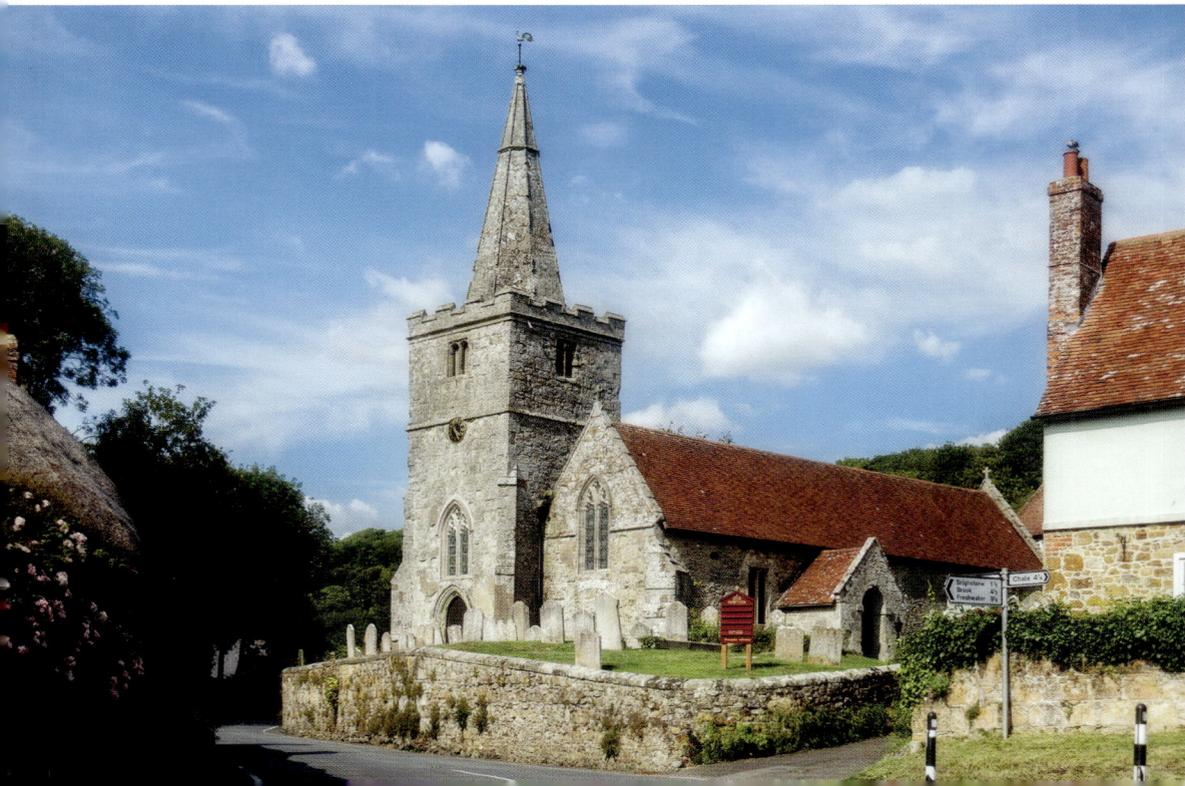

41. St Mildred's Church

St Mildred's Church can be found in the village of Whippingham, just south of East Cowes. A church was built here in 1804 on the site of a long-lost church, but just fifty years later it found itself sat at the centre of the newly created Osborne estate and it was torn down and rebuilt.

In keeping with his hands-on approach to everything linked to the new Osborne estate, Prince Albert took a keen interest in the redesigning of the new church, which was built in stages between 1854 and 1862. It is a towering and impressive design for a relatively small village, and can be clearly seen from the River Medina. Huge windows allow the interior to be flooded with light – they are miniature versions of the windows in the great Notre Dame Cathedral in Paris – and it is clear when inside that a lot of time and care was given to this church by Queen Victoria and the royal family.

The font dates from the 1860s and was a gift to the church from Queen Victoria, having been designed by her fourth daughter, Princess Louise. To the left of the chancel is the Royal Pew, which has its own separate entrance, and it is worth spending some time here absorbing the history. Although the pews were installed

St Mildred's Church. (Courtesy of MyPix, CC BY-SA 4.0)

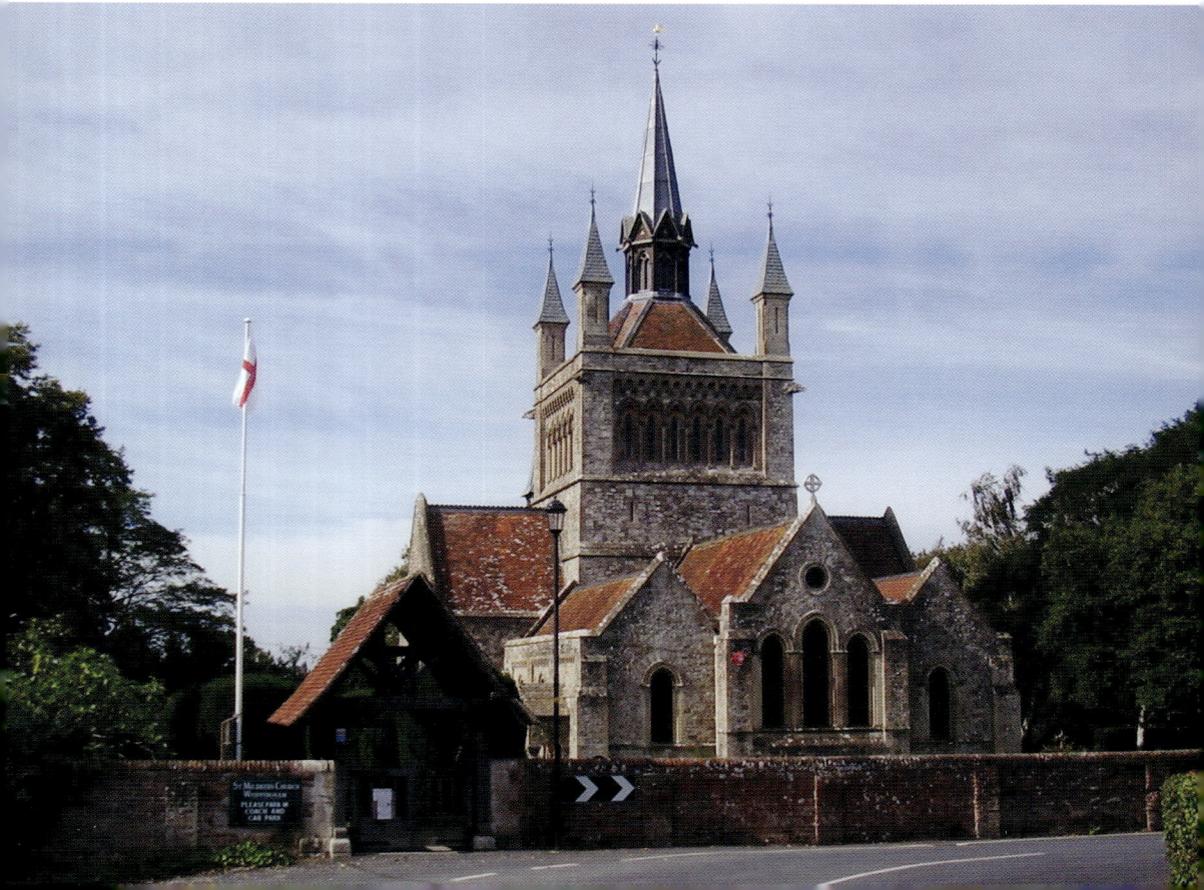

by King Edward VII, Queen Victoria's original chair is still present in the middle. It was here that she had memorial tablets placed on the wall for relations, with an elaborate one installed for her beloved Prince Consort, as well as one for her second daughter, Princess Alice. A number of memorials inside the transept were also erected by Queen Victoria in commemoration of those who worked for her.

There is also the Battenberg Chapel, which was turned into a shrine to Prince Henry of Battenberg who died in 1896. He had married Princess Beatrice, Queen Victoria's ninth and youngest child, in this very church in 1885. A large picture in this chapel was donated by Princess Beatrice in memory of her son, Prince Maurice of Battenberg, who was killed at Ypres during the First World War. When Prince Albert died in 1861, Queen Victoria turned to Princess Beatrice for company and she became her 'unofficial secretary'. When Queen Victoria died in 1901, Princess Beatrice began transcribing and editing her mother's diaries, which consumed most of her life. She lived at Osborne Cottage in East Cowes until 1913 and then moved into Carisbrooke Castle. She died in 1944 and was finally laid to rest in the Battenberg Chapel alongside her husband, as per her wishes, in 1945.

42. Tapnell Farm

The Isle of Wight is full of fun family days out and Tapnell Farm is one of them. Situated in the west of the island near Yarmouth, it is surrounded by countryside and has some glorious sea views. The different activities available here make it a good visit, whatever the weather.

Animals are obviously the main attraction, with plenty of small fluffy animals in the barn that you can get up close and personal with in 'Pets Corner'. Outside

The Aqua Park at Tapnell Farm Park. (Courtesy of Jim Smitheon, CC BY-SA 2.0)

in the paddocks, there are goats, pigs, donkeys and alpacas to visit and at Wallaby Walkabout, it's possible to help the keepers feed them and the meerkats!

Over the years, the farm has developed, and there are numerous other activities to keep the family here for a whole day! The indoor and outdoor play areas offer the younger guests the chance to blow-off some steam, whilst the Straw Bale Adventure Barn does exactly what it says – allowing you to have fun in the hay! With karts, huge jumping pillows, trim trails and crazy golf, there's plenty to keep you entertained.

The onsite café and restaurant are a safe bet for lunchtime, and for those seeking a larger adrenaline rush with a challenge, why not try archery, axe throwing, clay pigeon shooting or the aqua park – with giant slides and various obstacles to overcome!

43. The Longstone

Standing a staggering 4 metres high and around 2 metres wide, the Longstone is a simple yet thought-provoking place to visit. Located towards the west of the island, it marks the entrance to where a Neolithic long barrow was, and is approximately 6,000 years old! Long barrows were simple earth and stone structures, likely used in rituals and as a burial place. This one was aligned

The Longstone on Mottistone Down. (Courtesy of Jim Champion, CC BY-SA 2.0)

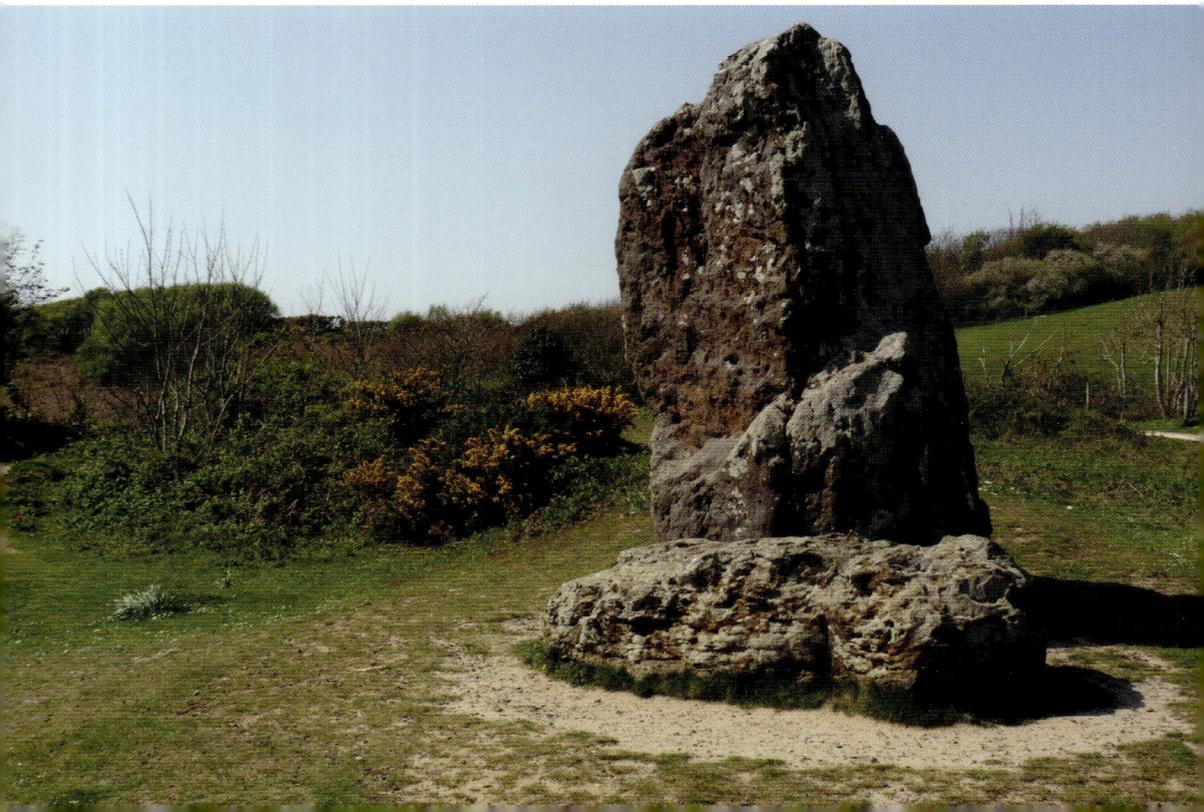

west–east and measured between 20 and 30 metres long, but is sadly long gone. The mound of earth was probably damaged over the centuries and the other stones of the long barrow moved elsewhere – possibly used for other construction projects. However, the gigantic Longstone remains and as it is the only megalithic monument on the Isle of Wight, it is now a Scheduled Monument. When seeing it today, it is incredible to think of the efforts Neolithic man went to in moving such a huge stone into position, and therefore just how important this place would have been to them.

44. The Needles

It doesn't get more iconic than this! There are very few landmarks around the world that are instantly recognisable and completely synonymous with their location, but The Needles are definitely one of them.

The row of three chalk stacks stick out of the blue waters and stand almost 100 feet in the air. Situated at the extreme western end of the island, it is hard to believe that a fourth stack once stood here, before collapsing in an eighteenth-century storm. Known as 'Lot's Wife', it was this stack that was the most needle shaped, but

The iconic Needles. (Author's collection)

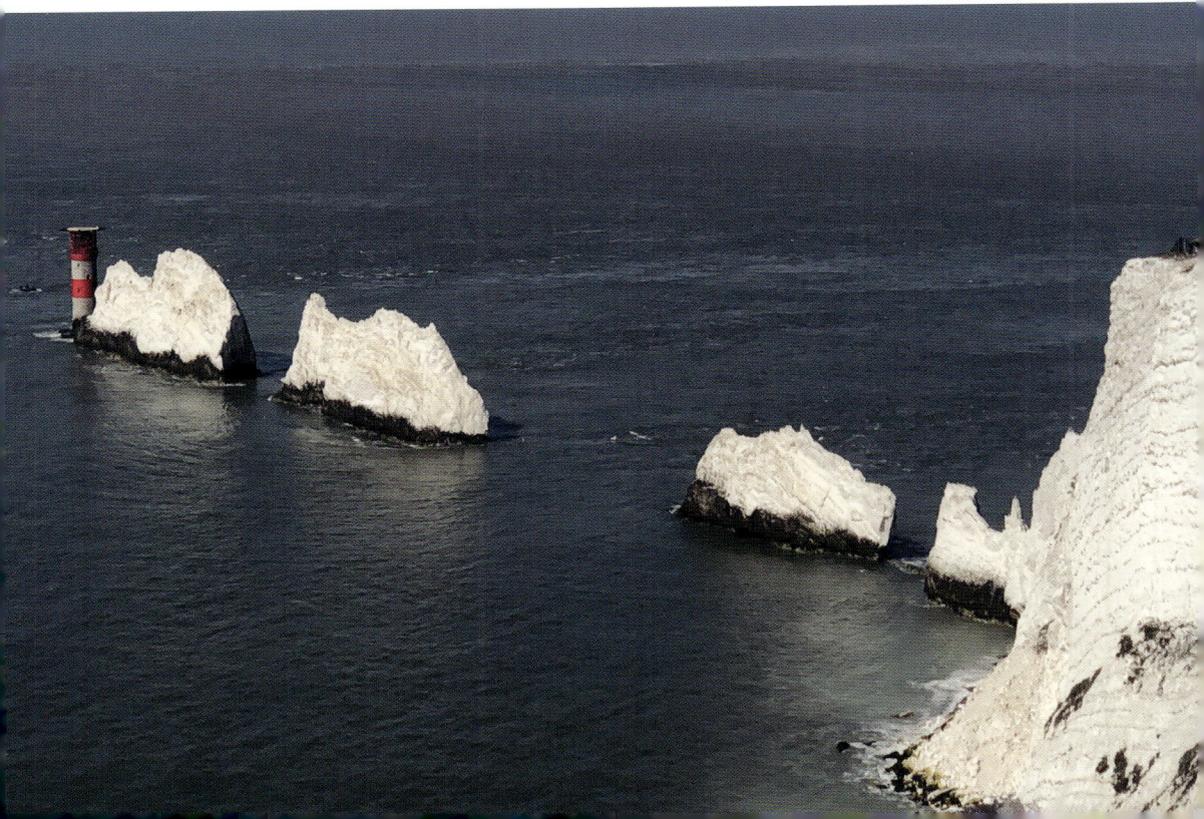

by the time of its collapse, the name had stuck. Although made of chalk, the stacks seem to be very resistant to erosion and they must be among the most photographed rocks in the world!

Of course, attached to The Needles, and just as iconic, is the red and white nineteenth-century lighthouse. Completed in 1859, it replaced a light tower on one of the cliffs, and rises nearly 110 feet high. It's hard to imagine, but for the first seven years it was left unpainted, before receiving a black stripe around the middle in 1886 to help it stand out from the surrounding cliffs during the day, and then it later received the red colouring it maintains today. This lighthouse originally had a four-man team working and living here, and although a helipad was built at the top in 1987, in 1994 it became fully automated. During times of poor visibility, the lighthouse foghorn sounds every fifteen seconds and the light can be seen up to 14 miles away at sea, helping to ensure safe passage for shipping.

It is possible to see The Needles from any of the surrounding cliffs, with the headland offering superb views of the gun batteries there. The Needles Landmark Attraction, famed for its sand shop and chairlift, also provides wonderful views from its position at the top of Alum Bay; it's from here that you might choose to get on the water and get a close-up view, either on a slow cruise aboard a traditional vessel or a fast cruise aboard a rigid inflatable boat. If you do, then it is possible to get some truly breathtaking views.

Whatever you do, The Needles are a sight worth seeing.

A different view of the Needles lighthouse. (Courtesy of Ped Saunders, CC BY 2.0)

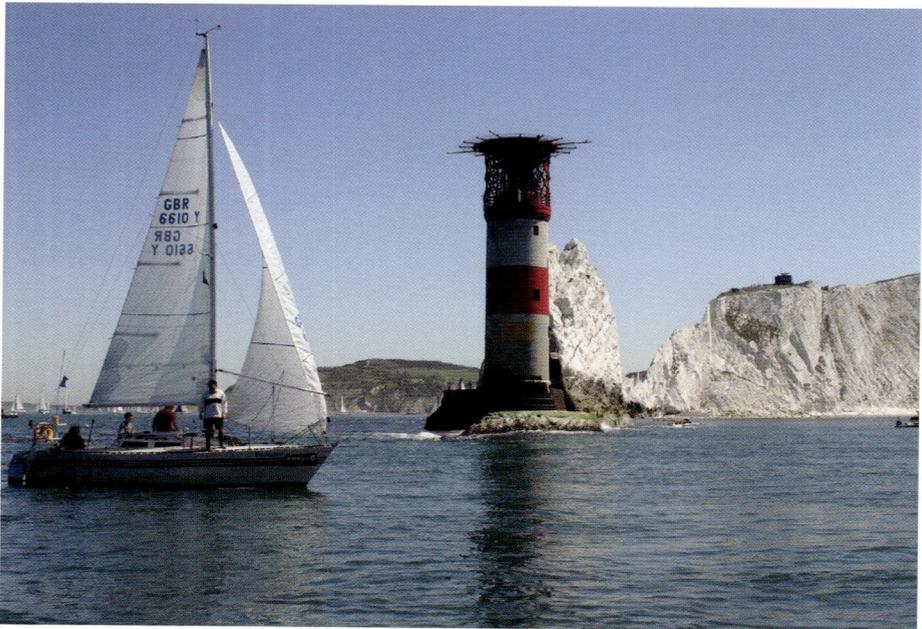

45. The Needles Old and New Batteries

The iconic location of The Needles on the extreme west of the island doesn't lessen the strategic position this headland had over the Solent and the western approach to the docks at Southampton and Portsmouth. It is because of this, and the perceived threat of French attack in the nineteenth century, that the Needles Old Battery was built in the 1860s.

Designed by Major James Edwards, it has an uninterrupted view out to the English Channel and right across the Solent from its vantage point 250 feet above sea level. Completed in 1860, it had six gun emplacements and was manned by volunteers. Extremely well protected on three sides by the steep chalk cliffs, a ditch was dug out on the landward side, with a movable bridge acting as the only entrance. Once inside the battery, all the usual associated buildings and rooms can be found, with the shell and cartridge store and laboratory in good condition. The guardroom, once the place where guards would check the credentials of everyone entering the battery, is now the visitor reception area and National Trust gift shop. There was even a lift down to the beach. A barrack building, fire command post and position finding cells are easily accessible within the battery.

The Needles Old Battery overlooking the famous landmark. (Author's collection with permission from the National Trust)

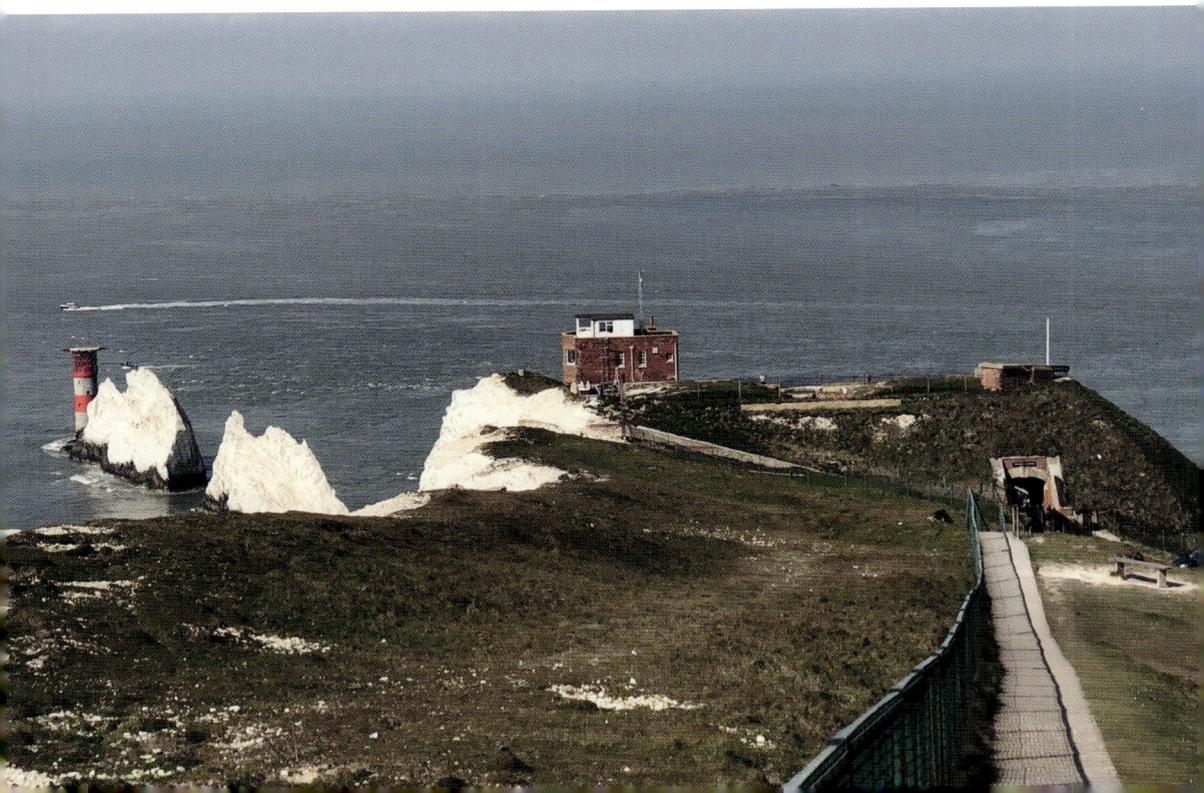

Above: Two 9-inch rifled muzzle loader guns are still in place on the Parade Ground. (Author's collection with permission from the National Trust)

Below: A searchlight dug into the chalk cliffs. (Author's collection with permission from the National Trust)

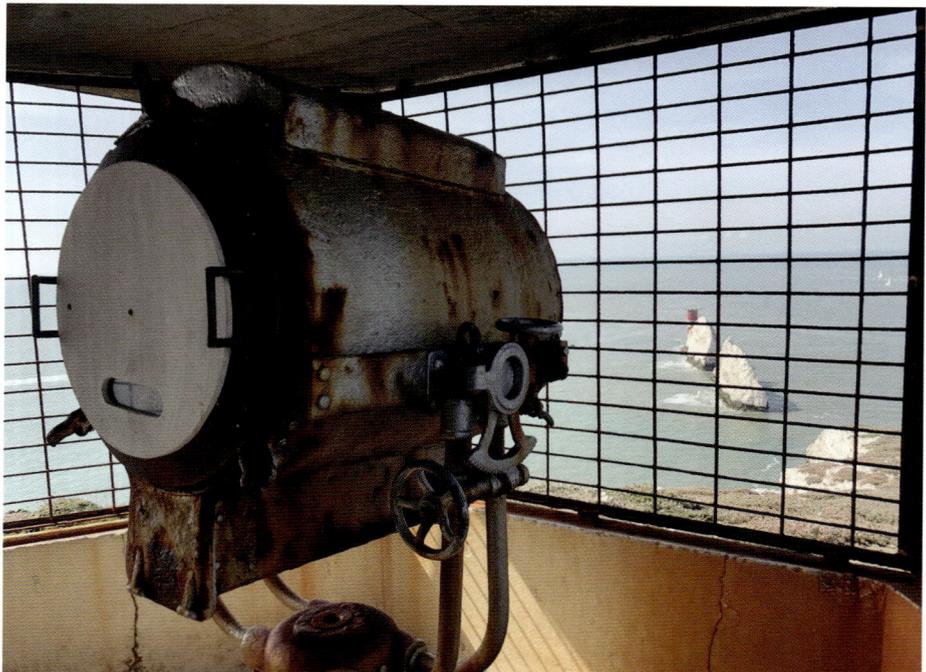

Two of the original 9-inch guns are in located on the Parade Ground. They could fire 3 miles out to sea and took around six minutes to be reloaded. In 1885, a tunnel was dug into the chalk, 4 metres below the surface of the Parade Ground that led to an area in the cliff face, overlooking the Needles lighthouse. Initially used to monitor mines being laid in the Solent, in 1899 it was made bigger to accommodate a searchlight – which is still there today.

Weapon technology advanced significantly as the twentieth century approached and it was decided that the Old Battery was too small to install the newer, much larger guns. With this in mind, a more modern battery was built further up the headland at High Down and by 1895, three large gun emplacements were completed at nearly 400 feet above sea level. They were to house 9.2-inch breech loading guns, with an underground shelter also constructed to hold over twenty men. At this point, the Old Battery became an observation and fire command post.

The New Battery was rearmed with Mark IX barrels for the First World War, but saw no significant action during the conflict. In the 1920s, the sites were used for territorial camps but were promptly remanned by eighty territorial soldiers just prior to the start of the Second World War. Anti-aircraft guns were added, along with a Bofors 40-mm gun due to the site being vulnerable to air attack. Throughout the conflict, the batteries helped provide protection to the shipping and ports within the Solent.

Listed for disposal after the war, things changed in the early 1950s with the development of long-range missiles. The New Battery was chosen as the test site for a guided weapon named *Black Knight* and later a satellite launch vehicle named

Concrete structures from the Highdown Test Site at the Needles New Battery. (Author's collection with permission from the National Trust)

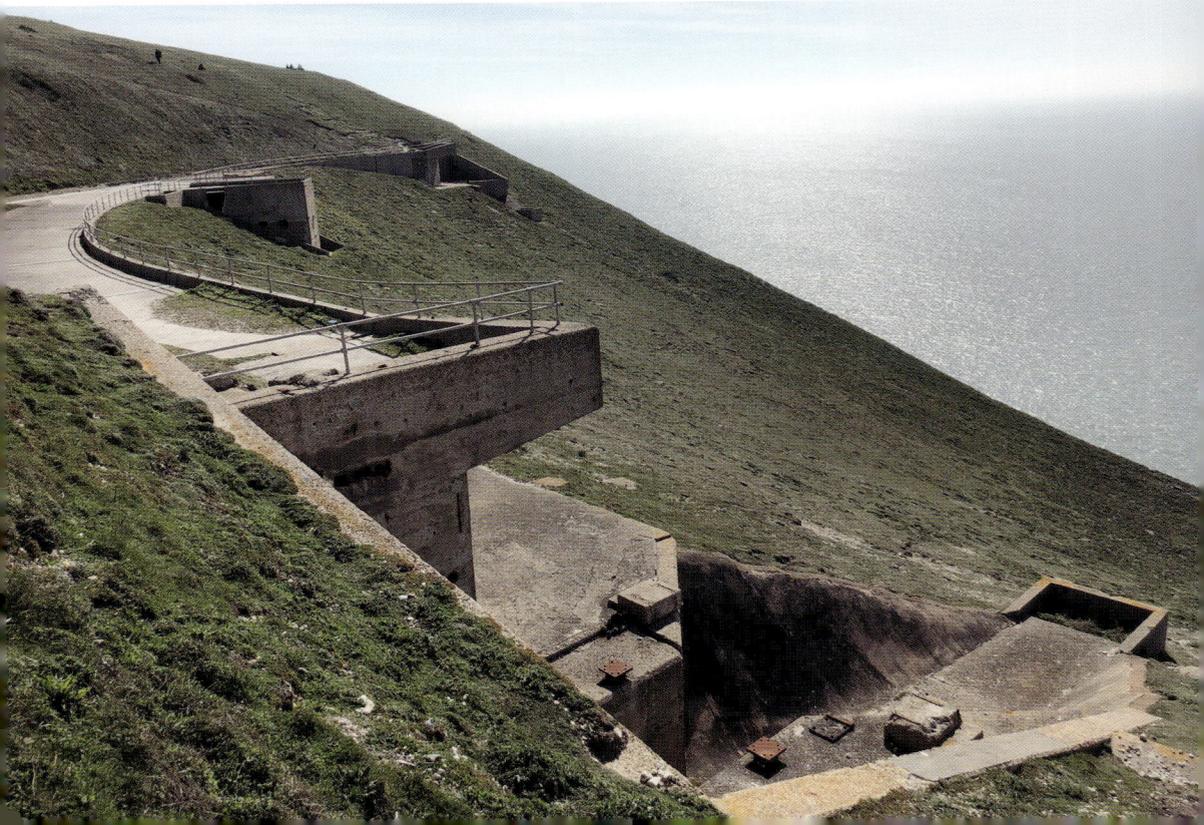

Black Arrow, due to its secluded location on edge of the island – facing out to sea away from anyone and as it already had underground rooms that could easily be expanded. Development of the site, now called Highdown, was completed in 1957 and pre-launch testing began that year.

The rockets were built in East Cowes and brought here for the static testing of their engines, before then being shipped to Woomera in Australia to be launched into space. Data and information from these static tests enabled changes and modifications to be made to the rockets, which were stored on site, before being placed in one of the two gantries and tested again. *Black Knight* was tested here for eleven years from 1957 to 1968, starting out as a single stage rocket, before being developed into a two stage rocket. The idea of making a satellite launch vehicle then developed into *Black Arrow*, which was tested here between 1968 and 1971. This was Britain's entry into the space race, and although unable to match the manpower and economic might of the United States or Soviet Union, it did achieve some success. A satellite named *Prospero* was successfully launched from Woomera in October 1971 and is still orbiting the earth today. Sadly, the British space programme was cancelled not long after this launch.

Although the vast majority of the above ground buildings were raised to the ground, the underground bunkers and the vast stretch of concrete that made up the static test site still remain.

Today, both the Old and New Batteries are managed by the National Trust and take you on a fascinating 100-hundred-year journey, when technological developments were being implemented at an incredible rate. It is astonishing to think that the secret work taking place at the Highdown testing site was just a stone's throw from one of the most iconic and well-known landmarks in the whole country.

46. The Wight Military and Heritage Museum

Located on the west side of the Medina River, the Wight Military and Heritage Museum has a huge collection of artefacts, weaponry and vehicles, mainly from the Second World War.

A large selection of small arms and machine guns from across the globe are on display, along with various uniforms, medals and miscellaneous objects that made up the everyday life of the men who used them. A number of scenes have been created using the items to give you a better idea of what it was like during certain periods. A Second World War street scene is particularly interesting as it allows you to process what life was like across the country during that conflict. A general store helps explain what rationing was like, whilst a Home Guard office and garage add to the experience.

There are so many vehicles on show it is hard to know where to start. Small and large, they are the eye-catching exhibits that draw you in. From trucks to ambulances and civilian cars to tanks, there's even aircraft on display!

There are plenty of vehicles on display at the Wight Military and Heritage Museum. (Courtesy of Jim Smitheon, CC BY-SA 2.0)

For those wanting a bit more, the museum has regular days where taking a ride in certain vehicles is possible and there is also an air rifle shooting range on site, for those wishing to try their hand at something a bit different. It is possible to have your photograph taken whilst in a tank and the weapon talks provided by the volunteers are always informative and humorous. If the weather is good, you can even operate the museum's bomb disposal robot around an outdoor course.

As a registered charity, it is delightful to see that the museum aims to be a focal point for ex-service personnel and disadvantaged youngsters on the island. There is a lot on display and so much to do here. Churchill's tearoom provides refreshments for what is likely to be an action-packed day.

47. Ventnor

Described by Charles Dickens as 'The prettiest place I ever saw in my life, home or abroad', Ventnor is yet another example of a Victorian-era seaside resort. A little over 5,000 people live here on the south of the island, with their houses on slopes that overlook a beautiful sandy beach.

The area has been used by humans for a long time, with evidence of Bronze Age and Roman settlements being here. By the early nineteenth century, Ventnor was nothing more than a fishing village, but the medicinal ideas of a good climate being good for your health soon had people flocking here from across the

country – especially with the development of the steam train. Hotels, hospitals and boarding houses encouraged those with ailments to visit, and Ventnor fast became a town.

With Queen Victoria's influence, the Isle of Wight became much more fashionable in the late nineteenth century and Ventnor looked to woo wealthy holidaymakers from Britain and abroad as a health resort. It worked, and the town was labelled as the 'English Mediterranean' and 'Mayfair by the Sea'. An iron pier was constructed in 1870 and thousands of visitors came here every year.

The town became a receiving centre for wounded soldiers from the First World War and in the 1930s, a number of art deco buildings were erected – like the Winter Gardens, which offer incredible views across Ventnor Bay and an extensive menu too. However, throughout the twentieth century, Ventnor struggled to compete with other more exotic destinations as world travel became more accessible.

Sadly, the pier fell into disrepair and was broken up in the 1990s, but that wasn't the end for the town. Ventnor Carnival week is a lively and entertaining experience and the nearby attractions of Blackgang Chine, Donkey Sanctuary and Botanical Gardens have helped to ensure that it is a sought-after destination.

Just as it did during the reign of Queen Victoria, Ventnor continues to entice visitors with its glorious uninterrupted views, beautiful beach and fresh air.

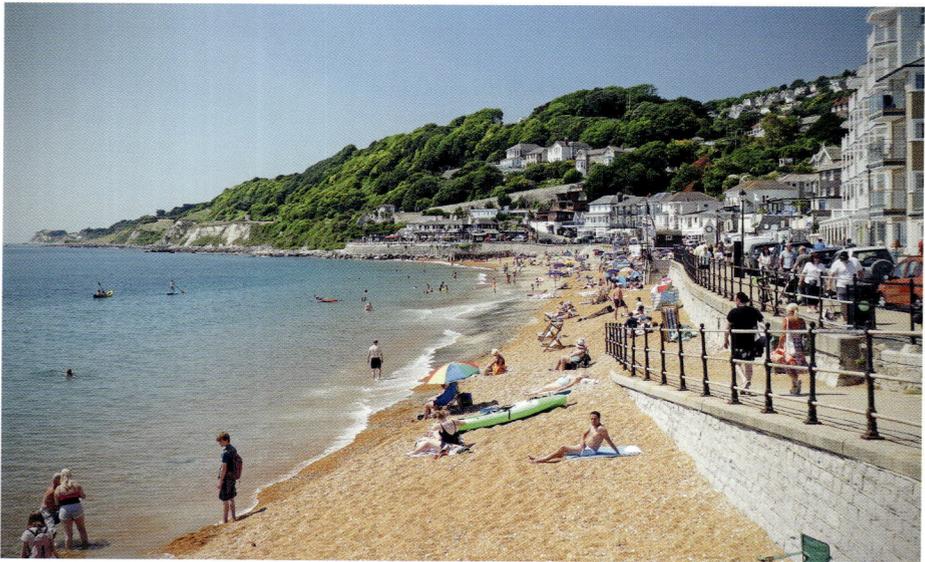

The beach at Ventnor is a magnet for tourists. (Courtesy of Andrew Gustar, CC BY-ND 2.0)

48. Ventnor Botanic Gardens

The microclimate created in Ventnor Bay has allowed this collection of temperate and sub-tropical trees to absolutely thrive. The sheltered position of the town, with the fresh air coming straight off the English Channel, has made the climate more Mediterranean than Isle of Wight!

This delightful garden hasn't always been here though. It is located on the former site of the National Cottage Hospital for Consumption and Diseases of the Chest, which was opened in 1869 as part of Ventnor's move to become a health resort town – and it's easy to understand why. The moist and sheltered climate, together with more sunny days than the rest of the Isle of Wight, made this the perfect place to convalesce from any number of ailments. The hospital offered well over a hundred south-facing rooms and remained open for nearly a century, closing in 1964 due to advances in medicinal drugs, having helped thousands of patients over the years.

The site was levelled and initially set up as a pleasure garden before Sir Harold Hillier, who could see the potential that the climate offered, founded the botanic garden in 1970. Over the last fifty years it has developed into a huge 22-acre site and today there is a staggering 6,000 species of plants growing here. Wandering the gardens allows you to discover many secluded spots, perfect for a family picnic and often with superb views out over the bay. The opportunity to simply walk and explore nature is

Ventnor Botanic Gardens. (Courtesy of Garry Knight, CC BY 2.0)

something we don't get the chance to do in today's hectic modern world, so it is worth making the most of it. You will find Britain's oldest palm trees, magnolias brought back from the Himalayas and an endless set of walkways to stroll down.

It is an assault on all the scenes: with the rustling of leaves and chirping of birds and crickets, the breeze across the face, and the fragrant scent of different flora tickling the nostrils. The changing seasons offer a variety of different scenes, and with the botanic gardens open all year round, it is worth visiting more than once.

49. Wildheart Animal Sanctuary

Located on the old site of the nineteenth-century Sandown Fort, built to help defend the sweeping beach of Sandown from potential French invasion, the Wildheart Animal Santuary is where the Isle of Wight Zoo used to be.

Starting out as a family-run operation, it now has charitable status and aims to not only be a rescue centre for animals, but help provide research and contribute to conservation across the world.

Wildheart Animal Sanctuary rescues animals from around the world and provides them with a safe refuge to live in. (Courtesy of Wildheart Animal Sanctuary)

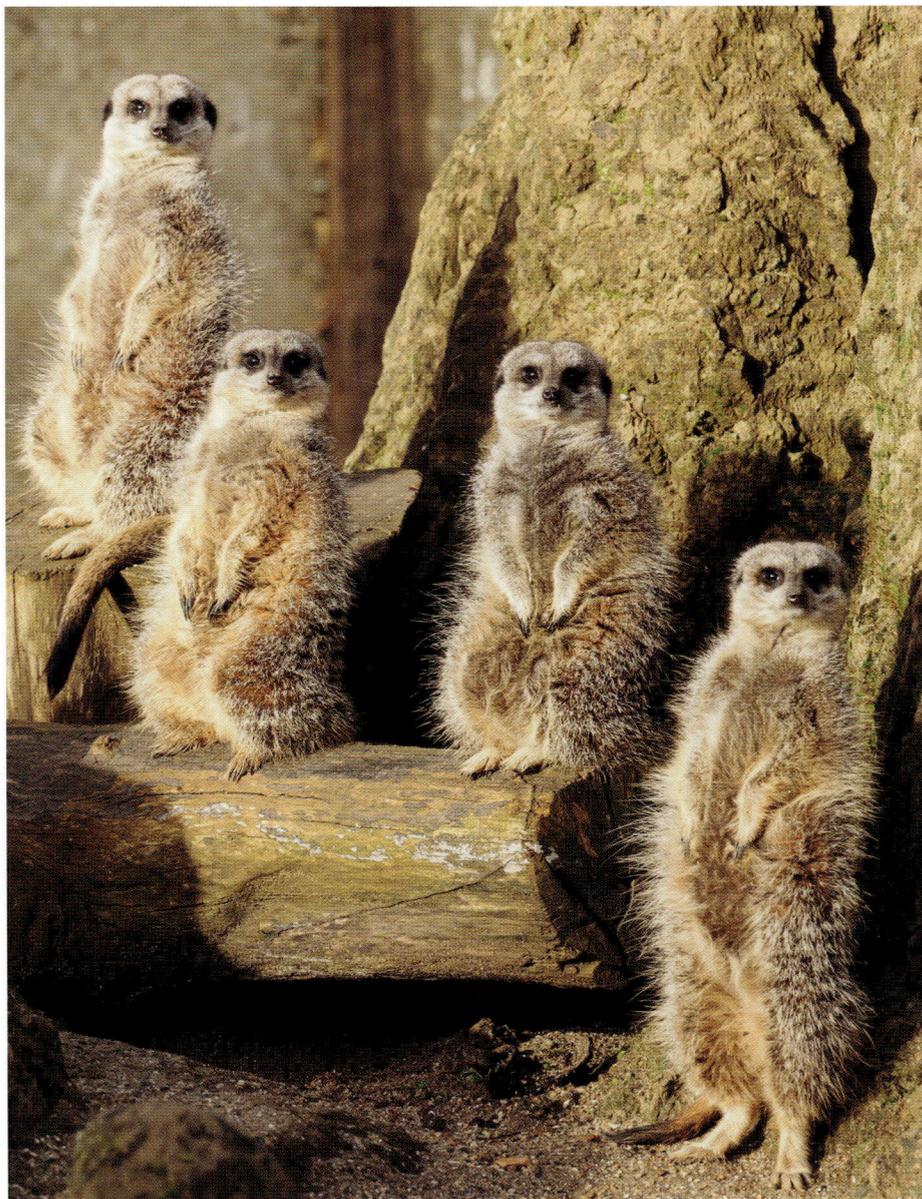

Who doesn't love a meerkat? (Courtesy of Wildheart Animal Sanctuary)

The sanctuary is well known as a home for rescued big cats, with lions and tigers living here – some of which were freed from a travelling circus. The primate rescue facility has monkeys and lemurs, all with different backgrounds, now in a safe and caring environment. Smaller mammals such as meerkats, raccoons and skunks, along with reptiles, birds and farm animals, all have their forever home here and are well looked after by the trained keepers.

There are five different species of lemurs here. (Courtesy of Wildheart Animal Sanctuary)

Every visitor to the sanctuary helps fund the numerous resources required to keep all of these animals in a healthy condition, but they also aim to educate the next generation in doing their bit for wildlife conservation and look after the planet. As a charitable trust, Wildheart have their sights on making an impact on creatures outside of their sanctuary, and as a result, they are providing resources and support to conservation programmes around the world, such as tigers in India and lemurs in Madagascar.

There is so much to explore here, with clear signposting and information about each creature on display. Every day, there are a number of animal encounters and keeper talks, as well as a playground and café to make any visit last the whole day.

50. Yarmouth Castle

Yarmouth Castle sits in an imposing position at the very edge of the town with the Solent lapping on two sides. It was constructed during the reign of King Henry VIII, who needed to strengthen the defences of England because of the threat of invasion from abroad. Completed in 1547, Yarmouth Castle was paired with Hurst Castle at the western end of the Solent in order to defend the vitally important docks at Southampton and Portsmouth.

Square in its design, the walls are around 100 feet high and two of them are directly by the sea. When first built, a moat ran along the other two walls, but this

Yarmouth Castle overlooks the Solent – and the modern-day ferry dock. (Author's collection with permission from English Heritage)

was eventually filled in and used as a dry ditch. Garrisoned with around eighteen men, there was a bastion that stuck out in order to cover both lengths of the moat. The vast majority of the weapons here were aimed at the sea, with heavy guns on the roof and smaller guns within the walls, although improvements were regularly made and the positions moved.

The English Civil War saw the castle initially held as Royalist, before the captain surrendered on the condition he will be allowed to continue in command. The Parliamentarian garrison grew to thirty by 1650, and seventy by 1654. In 1661 the garrison was disbanded, but in 1668 a naval veteran took it upon himself to recover what weapons he could and reinstate a smaller garrison. After filling in the moat, Sir Robert Holmes then took it upon himself to build a house on the edge of the infilled moat and today this remains as the George Hotel. The changes didn't stop there though, as the old entrance was blocked up and the current entrance made. Eight 6-pounder guns were here towards the end of the eighteenth century, before being replaced with four traversing guns in the early nineteenth century. The tracks for these can still be seen, along with one mounted gun, and the view from the top still reaches right across the Solent. By the twentieth century the castle was no longer used for defensive purposes.

A visit here is certainly an interesting one. As the surrounding buildings are so tightly around the exterior, it is hard to see the castle as you approach it through

Yarmouth Castle is small but well preserved. (Author's collection with permission from the National Trust)

the town. When you do get inside, the rooms are packed around a small central courtyard, with very little space at all. The largest part of the castle is the gun platform, and it is the perfect spot to have a rest and a bite to eat. From here, there is a clear view across the Solent to the mainland, and if you are lucky the ferry from Lymington may well be coming across, providing you with the chance to pretend you are a gunner.

Not the biggest defensive position on the island, Yarmouth Castle is all about location, and it is certainly worth exploring.

Acknowledgements

It feels like everyone has been to the Isle of Wight on holiday at some point in their childhood and it has been a real pleasure rediscovering locations and buildings that have been preserved in my memory. The Isle of Wight has so much to offer, and choosing just fifty places of interest was a fraught process. This book hasn't been without its challenges though – condensing the illustrious history of a centuries old castle into just a few hundred words is a hard thing to do. Investigating the different aspects of this book has led me to find out some incredible things and meet a number of wonderful people, all of whom have been willing to share their knowledge and expertise, and this is so important in passing on the history of our communities to the next generation.

I need to express my gratitude to the many organisations, people and photographers who have kindly shared their knowledge and allowed me to use their photographic work in my book: Karen Lawson, Images & Rights Manager at Royal Collection Trust (www.rct.uk); Steve Backhouse from the Isle of Wight Steam Railway (www.iwsteamrailway.co.uk); Jayne Merritt, Sophie Tickle and Rachel Dean from Vectis Ventures Limited (www.blackgangchine.com and www.robin-hill.com); Jayne Reynard from The Needles Landmark Attraction (www.theneedles.co.uk); Sue Wilkins at Dinosaur Isle (www.dinosaurisle.com); Kelly Wickes from Monkey Haven (www.monkeyhaven.org); Penny Dyer from Godshill Model Village (www.modelvillagegodshill.co.uk); Simon from Meridian 3 for the Quarr Abbey photographs (www.meridian3.co.uk); Jo from Shanklin Chine (www.shanklinchine.co.uk); Jacqueline Munday from the Lilliput Antique Doll & Toy Museum (www.lilliputmuseum.net); Lee Saudan from the Wild Heart Animal Sanctuary (www.wildheartanimalsanctuary.org); Jo-Anne King from the National Trust (www.nationaltrust.org.uk); and Kate MacLachlan from English Heritage (www.english-heritage.org.uk).

I would also like to thank Nick Grant, Nikki Embery, Jenny Bennett and all at Amberley Publishing for their help in making this book, and all my previous ones, become a reality, as well as my wife Laura and sons James and Ryan, who accompanied me on some wonderful trips to this beautiful island, and who can't wait to return and explore again.

About the Author

Andrew Powell-Thomas writes military history, local heritage and children's fiction books. He regularly speaks at events, libraries, schools and literary festivals, as well as making appearances on television and radio. It is possible to keep up with everything he is up to by following him on social media or by visiting his website at www.andrewpowell-thomas.co.uk.

Andrew's other titles available with Amberley Publishing:

Castles of Scotland
The West Country's Last Line of Defence: Taunton Stop Line
Historic England: Somerset
50 Gems of Somerset
50 Gems of Wiltshire
50 Gems of Jersey
Cornwall's Military Heritage
Devon's Military Heritage
Somerset's Military Heritage
Wiltshire's Military Heritage
Channel Islands' Military Heritage
Isle of Wight's Military Heritage
Castles and Fortifications of the West Country